BFI SILVER

Representing the very best in critical writing on films and film-makers, these beautifully presented new editions and reissues of classic titles from BFI Publishing feature new introductions by leading film critics or scholars. They assess the unique contribution of the work in question and its author to the field of film studies and to the wider public understanding of moving image culture.

ALSO AVAILABLE:
Fetishism and Curiosity: Cinema and the Mind's Eye
Godard
A Long Hard Look at 'Psycho'
Mamoulian
A Mirror for England: British Movies from Austerity to Affluence

Signs and Meaning in the Cinema
5th Edition

Peter Wollen

with a foreword by D. N. Rodowick

A BFI book published by Palgrave Macmillan

This publication © British Film Institute 2013
First published by Secker & Warburg in association with the British Film Institute 1969
Second edition published by Thames and Hudson 1970
Third edition published by Secker & Warburg, revised and enlarged 1972
Fourth edition published by the British Film Institute, revised and enlarged 1998
Copyright © Peter Wollen 1969, 1970, 1972, 1998, 2013
Foreword © David Rodowick 2013

This edition published in 2013 by
PALGRAVE MACMILLAN

on behalf of the

BRITISH FILM INSTITUTE
21 Stephen Street, London W1T 1LN
www.bfi.org.uk

There's more to discover about film and television through the BFI. Our world-renowned archive, cinemas, festivals, films, publications and learning resources are here to inspire you.

Palgrave Macmillan in the UK is an imprint of Macmillan Publishers Limited, registered in England, company number 785998, of Houndmills, Basingstoke, Hampshire RG21 6XS. Palgrave Macmillan in the US is a division of St Martin's Press LLC, 175 Fifth Avenue, New York, NY 10010. Palgrave Macmillan is the global academic imprint of the above companies and has companies and representatives throughout the world. Palgrave® and Macmillan® are registered trademarks in the United States, the United Kingdom, Europe and other countries.

Series cover design: keenan
Cover image: *The Passenger (Professione: reporter)* (Michelangelo Antonioni, 1974), © Compagnia Cinematografica Champion
Designed and set by couch
Printed in China

This book is printed on paper suitable for recycling and made from fully managed and sustained forest sources. Logging, pulping and manufacturing processes are expected to conform to the environmental regulations of the country of origin.

British Library Cataloguing-in-Publication Data
A catalogue record for this book is available from the British Library
A catalog record for this book is available from the Library of Congress

ISBN 978–1–84457–360–8 (pb)
ISBN 978–1–84457–361–5 (hb)

(previous page) Marlene Dietrich in *The Devil is a Woman*

Contents

Foreword

D. N. RODOWICK

Dear Peter,

Signs and Meaning in the Cinema is now more than forty years old. Can you imagine? I was so deeply touched when Laura and Leslie asked me to write a Foreword for the new edition. 'Foreword' is an interesting word, don't you think? It should be the word that comes before the book. Yet every word I could possibly imagine would have to follow upon and to take account of its enormous debt to what you have already thought and written. Foreword is also close to 'forward', which might mean that *Signs and Meaning* remains a very young book, still turned towards the future. In any case, it remains a work of restless intelligence whose meaning and significance are reinvented for each new generation of readers. In writing these words, it pains me deeply to think that we still exist on the same planet though not in the same world. The time has passed for us to continue the conversations that have been so meaningful for me throughout my own intellectual engagement with moving images and the critical thought they inspire. I suppose this letter is my way, perhaps my last lost opportunity, to continue that conversation.

I said that *Signs and Meaning* is a restlessly intelligent work, a text of constant reinvention, which leads me to wonder just what kind of book it is? It certainly belongs to a very small family of titles that I consider to be unclassifiable. As I glance at my bookshelves now, they are easily spied out. Each one has cracked or missing spines, their pages held together only by rubber bands, themselves brittle and breaking. Each page of these books is dog-eared and marked up almost to the point of illegibility with different

coloured inks, betraying a history of multiple encounters and silent conversations; multi-coloured bookmarks fly out in layers on all three open sides like tiny flags that welcome me to revisit and renew contact with the thoughts their words inspired. My shelves are crowded now, but there was a time when *Signs and Meaning* had only a few meaningful companions: the first volume of André Bazin's *What is Cinema?*, Siegfried Kracauer's *Theory of Film* and Stanley Cavell's *The World Viewed*. An odd family of books, no doubt, but all meaningful because they are peerless. These are books that refuse to become old or give themselves over to history, and whose sense and powers remain inexhaustible. Like *Signs and Meaning* they are books to think with, and I hope will always remain so.

Forty-three years. I too have reached an age where I think often about the history of the questions I have chosen to teach and to write about, which means that I am led inevitably to remember how my own life has threaded around and through those significant texts and encounters. I think I must have first read *Signs and Meaning in the Cinema* in 1976 while still an undergraduate at the University of Texas at Austin. Undoubtedly this was a contingent encounter. The first great wave of publishing 'little books' (as my friend Mark Betz calls them) was over, and the bookstores along 'The Drag' facing the university were overflowing with remaindered titles from Grove Press, Studio Vista/Dutton, Crown, Dover and the Praeger *Movie* series, as well as the BFI Cinema One series. First published in 1969 as volume 9 in the BFI series, *Signs and Meaning* already had a history when I encountered it. My first copy was the new and enlarged third edition augmented with the 1972 Conclusion. Was I then already in the second or third generation of readers? The book was in its fifth printing, yet its presence to me was surprising. What did I, what *could* I make of the title then? Almost all of these books were director studies, full of biographies and readings of films. Your book was about 'signs and meaning', and its main chapters were on Eisenstein's aesthetics, the auteur theory and the semiology of the cinema. Almost certainly, it was that last strange term, 'semiology', that caught my eye with what must have been an effect of startling defamiliarisation.

Life in the course of being lived, especially when one is young, appears to be a series of haphazard disconnected points, swerving dotted lines

zigzagging between chance encounters with no apparent order apart from breaks lucky and unlucky. And of course, whether those breaks were really strokes of misfortune or unanticipated opportunities only becomes apparent retrospectively. In 1974 I returned to undergraduate study after having tried for five or six years, with only very modest success, to be a professional songwriter and musician. Austin was supposed to be the place to make the music happen, but instead I was caught up with great passion in the intellectual life of the university, and equally so in the spirited cinephilic culture of student film societies and repertory theatres. At first, I thought that these two intensely experienced sides of student life were separate strands of my existence, running parallel to one another without ever touching. I also found it difficult to settle on a field of study. I seemed to be drawn haphazardly to courses in philosophy, linguistics, the history of art, comparative literature and cultural anthropology. Although initially an English major studying world drama, I found myself increasingly drawn not to literature, but rather to a series of figures whose work seemed to fit within no given cognate field: Claude Lévi-Strauss, Roman Jakobson and especially, Roland Barthes, who in turn led me to Freud, Marx, Saussure and Lacan. This is why *Signs and Meaning* made such a stunning impact on me: not only were my two passions brought together, suddenly they seemed inseparable.

So what I was interested in then was semiology or structuralism, I suppose. These were somewhat covert subjects at the time – tenure was denied to more than one assistant professor who had mentored me. Yet structuralist ideas and approaches were everywhere present where forward thinking in the humanities was taking place. Your first book gave me a name and point of identification for what I (and no doubt many other young people) was passionately interested in. But *Signs and Meaning* was much more than that for two reasons. First, despite my intense passion for cinema, and the proliferation of little books crowding the remainder bins, there were very few critical authors writing about film who sparked my imagination in the same way as, say, Roland Barthes's investigations of Balzac or the pleasure of the text. In fact, looking back, in film there were only three names that really counted for me then: Robin Wood, André Bazin and Peter Wollen. (Later, I could add Noël Burch, and most importantly, Christian Metz.) Again, this might be

thought a fairly odd band of brothers. Now I realise that what drew me to these three writers was not only their accounts of the intensity of cinematic experience, but also their passionate conviction that films were a pervasive yet under-examined cultural force, which had yet to find a critical context worthy of them despite a history of three-quarters of a century.

Falling upon *Signs and Meaning in the Cinema* at the time I did was something like a miracle. The book gave focus to my otherwise scattered interests, and in turn demonstrated, in an astonishingly foresighted way, that I belonged to a field. What this field should be called was then in doubt; perhaps it still is. At the time, film studies hardly existed, at least to my limited knowledge. Nor am I now certain that anyone then spoke of 'theory' in the humanities, much less film theory, as a coherent practice or activity. In this lies the second reason for the impact of *Signs and Meaning*: it began the pioneering process of laying out, for decades to come, a set of common concerns and questions for this still somewhat indefinable field, and it suggested something like a first canon for revisiting and renewing the place of the moving image in the broader contexts of aesthetics, culture and political theory. With its erudite examination of questions of aesthetics and politics, ideas of authorship, and questions of meaning and representation in language and in art, your own 1969 introduction reads as if it could have been written today. *Signs and Meaning* was one of the first books to make the case seriously for the importance of film for aesthetics, and as importantly, film's potential transformation of aesthetics as it then stood. You cleared the path towards understanding what it might mean to refer to the language of film, and in turn asked whether film is a language at all. Indeed, like the early Christian Metz, before the rest of us you understood clearly that the interest of semiology was not to bring linguistics to the study of film. Rather, the study of film was the best hope for transforming and expanding the field of linguistics by examining signs and meaning in the cinema as a new poetic discourse forged in an open, yet quite specific, multi-modal and multi-sensory system of signs. Suddenly, the serious study of film had a new critical canon that included Sergei Eisenstein, Bertolt Brecht and André Bazin, as well as what was for me then a rather exotic group of names: Juri Tynanov, Viktor Shklovsky and of course Roman Jakobson, along with other influential writers of Russian Formalism

and the *Left Front of the Arts*, and then Ferdinand de Saussure, Louis Hjelmslev, André Martinet, Charles Sanders Peirce and indeed many, many others, including Roland Barthes and Christian Metz. You remapped as well the canon of films deserving serious attention, reassessing and revaluing classic Hollywood cinema, placing Ford and Hawks alongside of Godard, Dreyer and the whole history of international experimental film past and present. What impressed me most, then and now, was your daring in writing a book unafraid of asserting unashamedly the importance of cinema for the history of art and the history of philosophy. While many battles have been won here, I fear the struggle is still ongoing.

I am still thinking about the unclassifiability of *Signs and Meaning in the Cinema*, which is also perhaps to account for its power as an open text, capable of responding to new questions and problems at new historical moments. It is a book of many lives reinvented for each new generation of readers. So again, what kind of book is it? Or rather, what kind of book has it been, and could it still be?

Is *Signs and Meaning in the Cinema* a book of film theory? It did not start out that way. Even in the 1972 edition the word goes unmentioned in the entire text. Philosophical aesthetics was your primary touchstone at the time, giving way gradually to semiology. In the original conclusion from 1969, you recommend a fundamental reform of university curricula, where faculties of film, music, design and art history should become as widespread and of an equal stature to those of literary criticism. At the same time, you make a powerful case for a thorough reassessment of the field of aesthetics and its emancipation from within philosophy – a radical act that perhaps would reorganize the field of philosophy itself, causing it to disappear into 'theory'.

In 1969 and 1972, you also knew better than most that semiology was not a new approach, but rather that it had a long, complex and distinguished history, intertwining with that of aesthetics and dating back at least to the Renaissance. It should not be surprising that aesthetics has such a prominent place in *Signs and Meaning*, since very few texts of the late 1960s and early 70s make any reference to 'theory' as a special form of activity, including influential film books like Jean Mitry's magisterial *Aesthetics and Psychology of Cinema* and Noël Burch's *Praxis du cinéma*, which only later was given the

awkwardly translated title, *Theory of Film Practice*. Even when the 1972 Conclusion is taken into account, I think your first perspective was not only to make the case that film could be the object of serious study, but also that larger questions of aesthetics and politics could be enriched by the concepts and methods of semiology, and in particular, within or alongside a semiology of moving images.

Perhaps this is also a way of noting how your book signalled an important turn in 1969 from aesthetic to structuralist approaches to art, culture and film. And then, yet another shift is announced in the 1972 Conclusion. Having paved the way for examining film in the context of structuralism in 1969, and at a time when we had hardly absorbed these lessons, the 1972 Conclusion marks a key turning point in the discourse of signification, opening it out towards post-structuralism and the concerns of political modernism, where you would make path-breaking interventions throughout the 1970s and 80s. The 1969 edition was crucially concerned with recovering a history that could deepen and expand practices of criticism; hence your early and now missing Appendices on 'Style and Stylistics' and 'Pantheon Directors'.

However, the suppression of these appendices and the addition of a new conclusion signals a new birth, or new terms of existence, for *Signs and Meaning in the Cinema* in 1972. The opening lines of your retrospective conclusion itself remarks that *Signs and Meaning* was written at the beginning of a transitional period that has not yet concluded. You characterise this period as beginning to come to terms with cinema's delayed encounter with modernism, meaning both what was modern in art (abstraction's challenge of representation and the transparency of meaning), and modern in thought (especially the dual emergence of semiology and psychoanalysis). The first avant-garde in film (Léger and Murphy, Man Ray, Buñuel, Eggeling, Richter and others) thus runs parallel to the nascent discourses of semiology and Formalism, all framed by the aspirations of the Soviet revolution. Fifty years later, the student and worker revolutions of 1968, along with the international anti-colonialist struggle, also appear alongside newly emerging cinemas: the North American and European experimental cinemas of the 1960s and 70s, but also Dušan Makavejev, Godard and Gorin's Dziga Vertov Group, Glauber Rocha, Jean-Marie Straub and Danièle Huillet, Alexander Kluge and indeed

many others. This new cinema then calls for a concomitant transformation of critical thought that challenges earlier conceptions of aesthetics, linguistics and semiology. In 1972, you reframe the whole of your argument in anticipation of a new critical space (can we now call it theory?) that recasts the semiological foundations of art and challenges the instrumental model of communication. Without mentioning them as such, the style and thought of the 1972 Conclusion recall crucial ideas from Julia Kristeva and the later Barthes, who also rejected aesthetics, the instrumentality of signs and the tyranny of work over text, to evoke Barthes's distinction. Significance and meaning are things that are made, not found or located. Listen again to this key passage: 'All previous aesthetics have accepted the universality of art founded either in the universality of "truth" or of "reality" or of "God". The modern movement for the first time broke this universality into pieces and insisted on the singularity of every act of reading a text, a process of multiple decodings, in which a shift of code meant going back over signals previously "deciphered" and vice versa, so that each reading was an open process, existing in a topological rather than a flat space, controlled yet inconclusive.' This is not yet a call for theory, perhaps, but it does require a transformation of both aesthetics and linguistics, and a new conception of text. 'The text is thus no longer a transparent medium,' you wrote in 1972, 'it is a material object which provides the conditions for the production of meaning, within constraints which it sets itself. It is open rather than closed; multiple rather than single; productive rather than exhaustive. Although it is produced by an individual, the author, it does not simply represent or express the author's ideas, but exists in its own right.' In 1969, your text pointed the way to structuralism; in 1972, and indeed before most of us had heard the term, the path swerves towards a political post-structuralism, where the new cinemas offer a conception of the poetic text as open and contradictory, and thus generative of inexhaustible new meanings. These ideas would in turn inspire your own films, especially those made in partnership with Laura Mulvey.

But you were not done reinventing yourself, Peter. Or at least *Signs and Meaning* had not finished its restless series of mutations in response to new times and new problems. Only in 1998 did you begin to refer retrospectively to *Signs and Meaning*'s self-awareness of new theoretical developments, but

now at a time when the age of Theory was passing into history. Authorship was always the most difficult or problematic concept in your first book and its multiple incarnations, leading perhaps to the removal of its most cinephilic expressions in the suppression of the conclusion and two appendices in 1972. Yet twenty-six years later, your love for a form of film criticism that is equally attentive to style and politics returns in the republication of Lee Russell's essays on Sam Fuller, Jean Renoir, Stanley Kubrick, Louis Malle, Budd Boetticher, Alfred Hitchcock, Josef von Sternberg, Jean-Luc Godard and Roberto Rossellini, which first appeared in *New Left Review* between 1964 and 1967. This welcome gesture was not simply a return to the past, but rather a reassessment of what history and memory could now mean after the age of Theory. From the era of aesthetics to that of structuralism and then post-structuralism and postmodernism, *Signs and Meaning in the Cinema* has been a book that constantly reimagines itself and gains new powers by responding to new contexts. Lee Russell's interview with Peter Wollen was thus one of your most brilliant and original strokes. More than a mechanism for memory, this last interview was one last stab at reaffirming and undermining the concept of authorship, in a way that now opened a moment or hesitation of postmodern doubt: only through Lee Russell could Peter Wollen recover a forgotten or sublimed past; only through Peter Wollen could Lee Russell be called into existence as an avatar of former lives. Each voice gently questions the other, opening spaces of doubt, hesitation, thoughtfulness and humour. And there is also the suggestion here that there are still many lives of Peter Wollen yet to be discovered in your militant political work and critical essays on politics, not to mention your path-breaking curatorial activities that led to new assessments of Frida Kahlo, Tina Modotti, and the Lettrist and Situationist challenges to art and culture. After anticipating all the major shifts of the last four decades – from philosophical aesthetics to structuralism, post-structuralism and postmodernism – you also participated in many influential ways in the turn from theory to history. Or more importantly, you made apparent in your thought and writing the presence of history in theory and the force of history in theory. (In retrospect, this attentiveness to the necessity of bringing philosophy, history and criticism into the same critical space and style is already apparent in the first iteration of *Signs and Meaning*.) You were

reframing critical approaches to the history of art not only through your thought and writing, but also in the practice of art through your many works of experimental fiction, screenwriting and film-making, not only with Laura Mulvey, but also as the author (I say it unashamedly) of astounding works like *Friendship's Death*.

I saw that film beautifully projected in 35mm at what was probably our last meeting. The occasion was a centennial celebration of Brecht and the arts at New York University in 1998, where I was asked to moderate a public conversation with you about the influence of Brecht on your work. I remembered that we celebrated our renewed friendship at a French restaurant in SoHo, where I was thrilled to find a Bandol bottled on the Île de Porquerolles, the location of Anna Karina and Jean-Paul Belmondo's Rousseauesque interlude in *Pierrot le fou*.

But perhaps it is better to end with our first encounter. I remember that I was a lowly graduate student from Iowa, giving my first professional paper at the Conference of the Society for Cinema Studies in 1981. The topic was 'Politics, Theory and the Avant-Garde'. This paper was my first attempt to think through my critique of what I would later call political modernism. Mine was the first of three papers, and questions would wait until all had presented. Perhaps I would be blissfully forgotten? But on concluding my presentation, the chair leaned over with a mischievous grin and whispered, 'You've got a lot of nerve giving that paper with Peter Wollen in the room!' As it turns out, I never got the chance to speak again. At the end of the panel, an audience member aimed a reactionary diatribe at my arguments for having the temerity to talk about ideology in relation to art. Indeed, semiology and ideology were still controversial then. I was saved by a rather tall and elegant British gentleman standing in the back of the room, who gently and quite thoroughly demolished my antagonist. Afterwards, he introduced himself as Peter Wollen.

I next saw you, Peter, perhaps a year later at a conference in Minneapolis. I think I must have hounded you mercilessly until you agreed to sit down with me for an hour to talk about my dissertation research. After listening to my no doubt incoherent thoughts, and then sitting in silent meditation for a while, you took a napkin and began making up a list and

drawing a map of London. In point of fact, these were my marching orders. Here you were again, the consummate historian of theory! I was to speak to each person on the list exactly in the order that they appeared on the list. (The first name was Laura Mulvey, and therein lies another story of friendship and generosity.) I still have that faded napkin stashed away somewhere. But the moral of the story is that that chance encounter with *Signs and Meaning in the Cinema* in 1976 was for me the first step on a long journey through film and philosophy. And this was a journey taken in the company of many close friends, most of whom I knew through you, or because of my friendship with you. Toward the end of his life, tragically cut short, Christian Metz paid homage to Roland Barthes, whom he called his only real master. Metz describes this debt to Barthes as a care for the claims of theory, of thinking theoretically, while maintaining a certain flexibility or openness: not to be attached to a theory, or even theory itself, but to change positions according to need and circumstances. Metz calls this a kind of practical philosophy, indeed an ethics that Barthes transmitted by example as the will to furnish, in the very movement of research, an amiable and open space. This idea of theory as generosity is how I choose to think of you, Peter. Not as a teacher or mentor, but rather as an exemplar, or better, a philosophical friend.

I find it difficult to bring this letter to a close and to confront the fact of conversations lost or never started. But friendship does not die, as I hope these words attest. And as you taught as well as Lacan, the letter can and does arrive at its intended destination, just as *Signs and Meaning* fell unpredictably into my hands at just the moment when I needed it most, and has always returned to inspire me when thought and imagination were failing. I believe somehow that these words will not be lost to you, because even if they do not find you, they may reach the hearing of those closest to you: Audrey, Chad and Zoe, and Leslie and Laura.

With affection and solidarity,
David Rodowick
Somerville, 3 March 2012

Introduction

The general purpose of this book is to suggest a number of avenues by which the outstanding problems of film aesthetics might be fruitfully approached. My guiding principle has been that the study of film does not necessarily have to take place in a world of its own, a closed and idiosyncratic universe of discourse from which all alien concepts and methods are expelled. The study of film must keep pace with and be responsive to changes and developments in the study of other media, other arts, other modes of communication and expression. For much too long film aesthetics and film criticism, in the Anglo-Saxon countries at least, have been privileged zones, private reserves in which thought has developed along its own lines, haphazardly, irrespective of what goes on in the larger realm of ideas. Writers about the cinema have felt free to talk about film language as if linguists did not exist and to discuss Eisenstein's theory of montage in blissful ignorance of the Marxist concept of dialectic.

Breadth of view is all the more important because, by right, film aesthetics occupies a central place in the study of aesthetics in general. In the first place, the cinema is an entirely new art, not yet so much as a hundred years old. This is an unprecedented challenge to aesthetics; it is difficult to think of an event so momentous as the emergence of a new art: an unprecedented challenge and an astonishing opportunity. Lumière and Méliès achieved, almost within our lifetime, what Orpheus and Tubal-Cain have been revered for throughout the millennia, the mythical founders of the art of music, ancient, remote and awe-inspiring. Secondly, the cinema is not simply a new art; it is also an art which combines and incorporates others, which operates on different sensory bands, different channels, using different codes

Lumière poster; Georges Méliès

and modes of expression. It poses in the most acute form the problem of the relationship between the different arts, their similarities and differences, the possibilities of translation and transcription: all the questions asked of aesthetics by the Wagnerian notion of the *Gesamtkunstwerk* and the Brechtian critique of Wagner, questions which send us back to the theory of synaesthesia, to Lessing's *Laocoön* and Baudelaire's *correspondances.*

Yet the impact of the cinema on aesthetics has been almost nil. Universities still continue to parade a derelict phantom of aesthetics, robbed of immediacy and failing in energy, paralysed by the enormity of the challenge which has been thrown down. Many writers on aesthetics have gone so far as to refuse the cinema any status whatever; they have averted their gaze and returned to their customary pursuits. Various attempts have been made to renovate aesthetics, but these have sprung mostly from contact with other academic disciplines – psychological testing, statistical sociology, linguistic philosophy – rather than from developments in the arts themselves. It is incredible that writers on aesthetics have not seized on the cinema with enthusiasm. Perhaps, at times, Pudovkin, Eisenstein or Welles may be mentioned but, on the whole, there is a depressing ignorance, even unconcern.

In the 1920s the Russians – Kuleshov, Pudovkin, Eisenstein – managed to force themselves on the attention. The situation in which they worked, of course, was unique. The Bolshevik Revolution had swept away and destroyed the old order in education as in everything else; academic conservatism was in full-scale retreat. Experts on aesthetics came into close contact with the artistic avant-garde; this was the heyday of Russian Formalism: the collaboration between poets and novelists on the one hand, and literary critics and theorists on the other, is now well known. Indeed, many of the leading critics were also poets and novelists. The cinema was obviously affected by this. Many of the Formalists – the novelist and literary theorist Tynyanov, for instance – also worked in the cinema as scriptwriters. With the breakdown of the old academic system, there was not a slackening of intellectual pace, but actually an intensification. There was the crystallisation of an authentic intelligentsia, rather than an academic hierarchy: like all intelligentsias, it was built round a revival of serious journalism and polemic. Literary theorists, such as Victor Shklovsky in particular, issued manifestos, wrote broadsides, collaborated

enthusiastically on magazines like *Lef*. This was, of course, only an interim period: a new kind of heavy academicism soon descended.

It is possible to dismiss Eisenstein as an autodidact, to slight him for his lack of serious academic training – or rather training in the wrong subject – but few are now willing to take this risk. It is quite clear that, despite his own lack of rigour and the difficult circumstances in which he worked, Eisenstein was the first, and probably still the most important, major theorist of the cinema. The main task now is to reassess his voluminous writings, to insert them into a critical frame of reference and to sift the central problematic and conceptual apparatus from the alarms and diversions. Of course, the first wave of popular works on film aesthetics, in almost every country, shows the very powerful influence Eisenstein exerted, in part, evidently, because of his prestige as a director. The key idea, which seized the imagination, was the concept of montage. There are any number of pedestrian expositions of Eisenstein's views about this. And, of course, a counter-current has reacted against this orthodoxy, stressing the sequence instead of the shot and the moving as against the stationary camera. It seems to me that what is needed now is not an outright rejection of Eisenstein's theories but a critical reinvestigation of them, a recognition of their value, but an attempt to see them in a new light, not as the tablets of the law, but as situated in a complex movement of thought, both that of Eisenstein himself and that of the cultural milieu in which he worked.

It is not possible to be definitive about Eisenstein at this stage. The 1920s in the Soviet Union is an extraordinarily complex period – not only complex but startlingly and breathtakingly original. The huge political and social upheavals of the period produced an unprecedented situation in the arts, in culture in general, in the movement of thought and ideology. In the section on Eisenstein in this book, I have tried to shift the terrain of discussion and to indicate, in broad outlines, what I take to be the main drift of Eisenstein's thought and to locate it in its setting. But all this is necessarily very provisional.

The main stumbling-block for film aesthetics, however, has not been Eisenstein, but Hollywood. Eisenstein, as we have seen, was part of a general movement which included not only film directors, but also poets, painters and

Russian and American bourgeoisie: *October*; *All That Heaven Allows*

Italian peplum and Japanese science fiction: *Maciste the Mighty*; *Rodan*

architects. It is relatively easy to assimilate the Russian cinema of the 1920s into the normal frame of reference of art history. Hollywood, on the other hand, is a completely different kind of phenomenon, much more forbidding, much more challenging. There is no difficulty in talking about Eisenstein in the same breath as a poet like Mayakovsky, a painter like Malevich, or a theatre director like Stanislavsky. But John Ford or Raoul Walsh? The initial reaction, as we well know, was to damn Hollywood completely, to see it as a threat to civilised values and sensibilities. The extent of the panic can be seen by the way in which the most bourgeois critics and theorists manage to find *Battleship Potemkin* far preferable to any Metro-Goldwyn-Mayer musical or Warner Bros. thriller. They actually prefer the depiction of the bourgeoisie in *Strike* or *October*, hideous, bloated and cruel, to its depiction in the movies of Vincente Minnelli or Douglas Sirk, which appals them much more. This attitude seems to have very strong roots. It is not surprising that Jean

Vienna in Hollywood: Wilder's *The Emperor Waltz*

Terence Fisher's *The Mummy*

Domarchi gave as his title to a review of *Brigadoon*: 'Marx would have liked Minnelli.' (It is possible to doubt whether *Brigadoon* is the most apposite choice, but it is not hard to see Domarchi's point.)

Of course, the reaction to Hollywood was always exaggerated. There are two points which need to be separated out. Firstly, Hollywood is by no means monolithically different; the American cinema is not utterly and irretrievably other. To begin with, all cinemas are commercial; producers and financiers act from the same motives everywhere. The main difference about American films is that they have succeeded in capturing the foreign as well as the home market. We only see the tip of the French, Italian or Japanese cinema, or East European too, for that matter, but we see a much more broad slab of Hollywood. When we do see more of a foreign cinema, it is usually dismissed in just the same way as American movies: Italian peplums or Japanese science fiction, for example. Then, a very large number of American directors actually worked in Europe first: Hitchcock is the most obvious

example, but we should also consider Sirk, Siodmak, Lang, Ulmer. Tourneur studied in Paris, Welles in Ireland, Siegel in England. There is a whole 'Viennese' school of Hollywood directors. One of the more extraordinary convergences of Viennese culture was that between Sternberg and Neutra, the architect of the Sternberg house in San Fernando Valley. The whole battle for and against ornament, which exploded in Vienna, is expressed in the work of these two Viennese in exile.

In the section of this book on the auteur theory, I have tried to outline the theoretical basis for a critical investigation and assessment of the American cinema, as a model of the commercial cinema. I have restricted myself to American examples – Ford and Hawks – but I cannot see any reason in principle why the auteur theory should not be applied to the European cinema. The British cinema, for instance, is in obvious need of reinvestigation; we can see the beginnings of a reassessment in the French studies of Terence Fisher and O. O. Green's *Movie* article on Michael Powell. The same is true for the Italian and French cinema. It is very striking, for instance, how Godard and Truffaut are still treated with widespread critical respect, even indulgence, whereas we hear very little today about Chabrol, who seems to have evaporated in the same magical way that was once presumed to have overcome Hitchcock and Lang. Our ideas about the Japanese cinema must be extraordinarily distorted and blinkered.

I do not in any way want to suggest that it is only possible to be an auteur in the popular cinema. It is simply that working for a mass audience has its advantages as well as its drawbacks, in the same way, *mutatis mutandis*, that working for a limited audience of *cognoscenti* does. Erwin Panofsky put the point very forcefully:

While it is true that commercial art is always in danger of ending up as a prostitute, it is equally true that non-commercial art is always in danger of ending up as an old maid. Non-commercial art has given us Seurat's *Grande Jatte* and Shakespeare's sonnets, but also much that is esoteric to the point of incommunicability. Conversely, commercial art has given us much that is vulgar or snobbish (two aspects of the same thing) to the point of loathsomeness, but also Durer's prints and Shakespeare's plays.

I would not myself use *esoteric* and *vulgar* as the pertinent pair of contraries, but the main gist is clear enough. The reason for constantly stressing the auteur theory is that there is an equally constant, and spontaneous, tendency to exaggerate the significance and value of the art film. Despite all that is fashionable about a taste for horror movies, it is still much less unquestioned than a taste for East European art movies. What has happened is that a determined assault on the citadels of taste has managed to establish the American work of Hitchcock, Hawks, perhaps Fuller, Boetticher, Nicholas Ray. But the main principles of the auteur theory, as opposed to its isolated achievements, have not been established, certainly not outside a very restricted circle.

However, there are even more difficult problems for film aesthetics than those raised by the popular cinema, by Hollywood and Hawks. In Chapter 3 of this book I try to set out some guidelines for a semiology of the cinema, the study of the cinema as a system of signs. The underlying object of this is to force a reinvestigation of what is meant when we talk about the language of film; in what sense is film a language at all. A great deal of work in this field has already been done on the continent of Europe, in France, Italy, Poland, the former Soviet Union. The Anglo-Saxon countries are still comparatively innocent of this. I have tried to combine an introductory account of the main issues, the main problems which have been found to arise, with an original intervention in the European debate. The problems which semiologists confront can quickly become complex; I fear it is true to say over-complex and pedantic. The important thing is to remember that pedantry is a necessary by-product at a certain stage of any scientific advance; pedantry becomes dangerous when it is conservative.

There are two reasons why semiology is a vital area of study for the aesthetics of film. Firstly, any criticism necessarily depends upon knowing what a text means, being able to read it. Unless we understand the code or mode of expression which permits meaning to exist in the cinema, we are condemned to massive imprecision and nebulosity in film criticism, an unfounded reliance on intuition and momentary impressions. Secondly, it is becoming increasingly evident that any definition of art must be made as part of a theory of semiology. Forty years ago the Russian Formalist critics insisted

that the task of literary critics was to study not literature but 'literariness'. This still holds good. The whole drift of modern thought about the arts has been to submerge them in general theories of communication, whether psychological or sociological, to treat works of art like any other text or message and to deny them any specific aesthetic qualities by which they can be distinguished, except of the most banal kind, like primacy of the expressive over the instrumental or simply institutionalisation as art. The great breakthrough in literary theory came with Jakobson's insistence that poetics was a province of linguistics, that there was a poetic function, together with an emotive, conative, phatic function and so on. The same vision of aesthetics as a province of semiology is to be found in the Prague school in general and in the work of Hjelmslev and the Copenhagen school. We must persevere along this road.

Two and a half centuries ago Shaftesbury (1671–1713), the greatest English writer on aesthetics and the semiology of the visual arts, wrote as follows, in his preliminary notes for a treatise on Plastics:

Remember here [as prefatory] to anticipate the nauseating, the puking, the delicate, tender-stomached, squeamish reader [pseudo- or counter-critic], *delicatulus*. 'Why all this?' and 'can't one taste or relish a picture without this ado?' Thus kicking, spurning at the speculation, investigating, discussion of the *je ne sais quoy*.

 Euge tuum et belle: nam belle hoc excute totum,

 Quid non intus habet?

So the 'I like,' 'you like,' who can forbear? who does forbear?

Therefore. Have patience. Wait the tale. Let me unfold etc.

I confidently hope that the '*je ne sais quoy*' is not so deeply entrenched today as it was in Shaftesbury's time and that there is less resistance, more awareness of the importance of speculation, investigation and discussion.

1: Eisenstein's Aesthetics

Even today the Bolshevik Revolution reverberates through our lives. During those heroic days Eisenstein was a student at the Institute of Civil Engineering in Petrograd. He was nineteen years old. He was not prepared for the overthrow of the existing order of society, the collapse of his culture and ideology and the dissolution of his family as his parents departed into exile. The Revolution destroyed him, smashed the co-ordinates of his life, but it also gave him the opportunity to produce himself anew. It swept aside the dismal prospect of a career in engineering, his father's profession, and opened up fresh vistas. In the span of ten years, as we know, Eisenstein was to win world fame, first in the theatre, then in the cinema. In order to achieve this, he was compelled to become an intellectual, to construct for himself a new world-view, a new ideological conception both of society and of art. He had to become a student of aesthetics in order to work in the cinema; he could take nothing for granted. And, of course, we cannot separate the ideas which he developed from the matrix in which they were formed, the matrix of the Bolshevik Revolution.

The ideology of the new order of society was proclaimed as political, revolutionary and scientific, and it was in this image that Eisenstein sought to construct his art and his aesthetics. When, through a chance meeting with a childhood friend, he became a scenery-painter and set-designer at the Proletcult Theatre in Moscow, he quickly recognised that the theatre should be a vehicle for political propaganda, a laboratory for avant-garde experiment and, in the words of his mentor, the actor and director Vsevolod Meyerhold,

a machine for acting, manned by technicians, rather than a temple with a priesthood. In this, of course, he was not alone. He identified himself with the artistic avant-garde which he found, a dynamic avant-garde whose ideas were forged, among others, by Meyerhold, the poet and playwright Mayakovsky, the painters Kasimir Malevich and Vladimir Tatlin. Under their leadership the pre-Revolutionary movements of Futurism and Symbolism were reassessed and transformed. Art was to be a branch of production, in the service of the Revolution. Thus Constructivism was born.

Eisenstein's first production in the theatre took place in 1923. The play, an adaptation of a nineteenth-century work by Ostrovsky, was organised not into acts and scenes but as a programme of attractions, as in the music-hall or the circus. The stage was laid out like a gymnasium, with a tightrope, vaulting-horses and parallel bars. Caricatures of Lord Curzon, Marshal Joffre, Fascists and other political figures were lampooned in satirical sketches. There was a parody of a religious procession, with placards reading 'Religion is the opium of the people'. Clowns and 'noise bands' assaulted the audience, under whose seats fireworks exploded. At one point a screen was unrolled and a film diary projected. It was this travesty of Ostrovsky, produced incongruously enough in the ballroom of the ex-Villa Morossov, which was the occasion for Eisenstein's first theoretical writing, published in the magazine *Lef*. In this manifesto he outlined his concept of the montage of attractions.

Eisenstein's production of *The Wise Man*

At this point the greatest influence exerted on Eisenstein was that of Meyerhold. Meyerhold, already a successful theatre director before the Revolution, emerged after it as a leader of the avant-garde. He was motivated by a deep distaste for the methods of Stanislavsky and the Moscow Arts Theatre, later, of course, to be enshrined as the apogee of Stalinist art. Meyerhold's original antipathy sprang from his hostility to Naturalism, part of his inheritance from Symbolism, which until Futurists such as Mayakovsky burst upon the scene was the leading foreign, imported counter-trend to the dominant domestic insistence on civic and social themes, going back from Tolstoy to Belinsky. In 1910 Meyerhold had set up an experimental studio where he worked under the pseudonym Dr Dapertutto, a name taken from the *Tales* of Hoffmann. Hoffmann, and German Romanticism in general, had an enormous influence on Meyerhold and on the whole Russian intelligentsia of the time. (Adaptations of Hoffmann's *Tales* were put on in the theatre by almost every leading Russian director, they were made into ballets, they provided the name for the Serapion Brotherhood, they are alluded to in Mayakovsky's *The Backbone Flute*, they were among the favourite works not only of Meyerhold but also of Fokine and, indeed, Eisenstein.) In particular, Meyerhold drew from Hoffmann (especially *The Princess Brambilla*) an enhanced interest in the *commedia dell'arte*, which he saw as the main element in a theatrical anti-tradition comprising the fantastic, the marvellous, the popular, the folkloric: a non-verbal, stylised, conventional theatre which he could use as a weapon against Stanislavsky's Naturalism and psychologism. The links with the Futurists' adoption of the circus are quite evident: the two trends, towards pantomime and towards acrobatics, quickly merged.

Later a second fault, more obvious to a Constructivist than a Symbolist, was detected in Stanislavsky: his mysticism. Stanislavsky's closest collaborators, Mikhail Chekhov and Sullerzhitsky, were both absorbed in the Russian mystical tradition. Sullerzhitsky had been a 'Wrestler of God' who helped move his religious sect from the Caucasus to Canada, then returned to Russia where he was given a job as a stage-hand by Stanislavsky. He came to influence Stanislavsky enormously, infecting him with a naïve infatuation with Tolstoy, Hindu philosophy and yoga. Chekhov too developed the yogic strain

(*next page*) Stanislavsky's production of *Armoured Train 14-69*

Stanislavsky with Max Reinhardt

in the Stanislavsky system, what he called its 'Pythian quality'. One student actor has described how 'we indulged in *prana*, stretching out our hands and emitting rays from the tips of our fingers. The idea was to get the person at whom your fingers pointed to feel the radiation.' These antics were out of key with the epoch of the machine, the mass, urbanism and Americanism. Meyerhold attacked them.

His own system, bio-mechanics, he conceived as a combination of military drill with algebra. The human body was seen almost as a robot, whose muscles and tendons were like pistons and rods. The key to success as an actor lay in rigorous physical training. This system was given a psychological underpinning by Pavlovian reflexology: 'The actor must be able to respond to stimuli.' The good actor – and anybody physically fit could become a good actor – was one with a 'minimum of reaction time'. There were other

important ingredients in Meyerhold's system: Taylorism, the study of workers' physical movements, invented in America to increase production and popularised after the Revolution in Russia, with Lenin's approval ('Let us take the storm of the Revolution in Soviet Russia, unite it to the pulse of American life and do our work like a chronometer!' read one slogan of the time); Dalcroze's eurhythmics, influential on Massine's choreography; the *commedia dell'arte*; Douglas Fairbanks; the German Romantic cult of the marionette (Kleist, Hoffmann); the Oriental theatre (during his Dr Dapertutto period Meyerhold had invited Japanese jugglers to his studio). Further ammunition was provided by the psychology of William James; another anti-Stanislavskian, Evreinov, was struck by James's examples of how when we count up to ten, anger disappears, and how whistling brings courage in its train; Eisenstein cites James's dictum that 'we weep not because we are sad; we are sad because we weep' – which was taken to prove the primacy of physiological gesture over psychological emotion.

A Russian journalist described the work of the Proletcult Theatre in 1923, the year *The Wise Man* was produced:

A big training of proletarian actors is taking place. In the first place, it is a physical training, embracing sport, boxing, light athletics, collective games, fencing and bio-mechanics. Next it includes special voice training and beyond this there is education in the history of the class struggle. Training is carried on from ten in the morning till nine at night. The head of the training workshop is Eisenstein, the inventor of the new circus stage.

Eisenstein's debt to Meyerhold even extended to paying particular attention to the movements of cats and tigers, which in Meyerhold's view exemplified the secrets of bodily plasticity.

Besides working for Meyerhold, Eisenstein had also collaborated for a spell with Foregger, in his studio of satirical theatre, where he designed Picasso-influenced sets and costumes and gleaned the idea of the 'noise band', which expressed the sounds of a mechanical, industrial epoch rather than those of the decadent artisanal orchestra, and also went to Petrograd with the film director Sergei Yutkevich where he did some designing for FEKS (Factory of the Eccentric Actor), run by Kozintsev, Trauberg and Krijitsky.

The idea of 'American eccentricism' can, like so much else, be traced back to the Futurist Manifesto; the FEKS group were fascinated with what Radlov, another Petrograd director, ex-pupil of Dr Dapertutto, called 'a new aspect of the comic outlook on life, created by Anglo-American genius': all kinds of slapstick, comic policemen, rooftop chases, rescues by rope from aeroplanes, underground hatchways, etc. Radlov introduced contortionists into his plays and replaced Pantaloon in the *commedia dell'arte* by Morgan, the Wall Street banker. Eisenstein and Yutkevich worked with FEKS on what was billed as 'Electrification of Gogol, Music Hall, Americanism and Grand Guignol'. 'The tempo of the revolution', believed Kozintsev, 'is that of scandal and publicity.' For Foregger they did sets based on the 'urbanistic' *Parade*; Yutkevich has described the main influences on Forregger at this time as being *commedia dell'arte*, French cancan, ragtime, jazz, Mistinguett. (Jazz was also seen as 'urbanistic' as well as exotic; this was the time when Bechet and Ladnier received a tumultuous welcome in the Soviet Union, only exceeded by that given to Douglas Fairbanks and Mary Pickford.)

The set for Meyerhold's production of *Dawns*

Eisenstein, with considerable bravado, attempted in his *Lef* manifesto to give theoretical coherence to all these fantastic and bizarre influences which lay behind his production of 'Ostrovsky's' *The Wise Man*. He chose as his slogan the idea of 'Montage of Attractions'. Some years later he described how he invented this phrase:

Don't forget it was a young engineer who was bent on finding a scientific approach to the secrets and mysteries of art. The disciplines he had studied had taught him one thing: in every scientific investigation there must be a unit of measurement. So he set out in search of the unit of impression produced by art! Science knows 'ions', 'electrons' and 'neutrons'. Let there be 'attraction' in art. Everyday language borrowed from industry a word denoting the assembling of machinery, pipes, machine tools. This striking word is 'montage' which means assembling, and though it is not yet in vogue, it has every qualification to become fashionable. Very well! Let units of impression combined into one whole be expressed through a dual term, half-industrial and half-music-hall. Thus was the term 'montage of attractions' coined.

Douglas Fairbanks in *The Nut*

Clown drawn by Eisenstein

Some more information can be added to this: Yutkevich suggests that the word 'attraction' may well have been suggested to Eisenstein by the roller coaster in the Petrograd Luna Park, which carried that name. Probably the idea of montage was suggested by the photomontages of Rodchenko, another of the *Lef* group, and George Grosz and John Heartfield in Berlin. But this would only take things back one step: Raoul Hausmann, speaking of Berlin Dadaism, explained, 'We called this process photomontage because it embodied our refusal to play the part of the artist. We regarded ourselves as engineers and our work as construction: we *assembled* [in French *monter*] our work, like a fitter.' Of course contacts between Berlin and Russia, between Dadaism and Constructivism, were very close at that time.

Half-industrial and half-music-hall: this expresses perfectly the curious artistic admixture of the time. Eisenstein, it will be seen, was very much swept

along by the currents of the epoch. This is hardly surprising: only nineteen at the time of the Bolshevik Revolution, he had been impelled into a vortex for which he was not prepared, an epoch of overwhelming force and change, unprecedented, unpredictable. It was not until this molten magma hardened into the lava of Stalinism that Eisenstein had time really to take stock of his situation. However, already there were some original traits to be seen. In particular, there was his quite idiosyncratic approach to the emotional structure of works of art. Looking back, he was to describe his project in *The Wise Man* in these typical words: 'A gesture expanded into gymnastics, rage is expressed through a somersault, exaltation through a *salto mortale*, lyricism on "the mast of death".' He wrote that he dreamed of a theatre 'of such emotional saturation that the wrath of a man would be expressed in a backward somersault from a trapeze'. This dream of emotional saturation was to stay with Eisenstein all his life. It became a preoccupation with the idea of ecstasy.

Eisenstein was influenced by two powerful, but in many ways incompatible, teachers of psychology: Freud and Pavlov. In his *Lef* manifesto we can see plainly Freud's influence in his observations on the difficulty of fixing 'the boundary line where religious pathos moves into sadist satisfaction during the torture scenes of the miracle plays'. This interest in the overlapping of sexual and religious ecstasy is a recurrent feature in Eisenstein's work. Pera Attasheva recounts how Eisenstein was delighted to find at Mont-Saint-Michel two postcards in which the same model posed as Ste Thérèse de Lisieux and, heavily made up, in the arms of a sailor. In Mexico he wrote of 'The Virgin of Guadelupe worshipped by wild dances and bloody bullfights. By tower-high Indian hair-dresses, and Spanish mantillas. By exhausting hours-long dances in sunshine and dust, by miles of knee-creeping penitence, and the golden ballets of bullfighting cuadrillas.' One theme of the unfinished *Que Viva Mexico!* seems to have been this intermingling of sexual, religious and sadistic ecstasy.

However, during the 1920s, Pavlov became of even greater importance to Eisenstein. As the idea of montage developed in his mind, he tended to replace the idea of attractions by that of stimuli, or shocks. This merged with two other currents: the extremist assault on the spectator and the demands of political agitation; after *The Wise Man* Eisenstein's next production, *Listen Moscow*, was called an 'agit-guignol'. Eisenstein had always been concerned

Ecstasy: two drawings by Eisenstein

Que Viva Mexico!

with the agitational aspects of his work: during the Civil War of 1921 he had worked on an agit-train as a poster-artist, drawing political cartoons and caricatures, decorating banners and so on. This attitude to art was one of the dominating trends of the time; Mayakovsky boasted that his slogans urging people to shop at Mosselprom were poetry of the highest calibre and he designed and wrote jingles for countless posters and publicity displays; it led eventually to Mayakovsky's doctrine of the social command. The problem of art became that of the production of agitational verse: 'I want the pen to equal the gun, to be listed with iron in industry. And the Politburo's agenda: Item I to be Stalin's report on "The Output of Poetry".' In a curious way this was a return of the Russian intelligentsia to its old civic preoccupations: though of course those who had been through Futurism *en route* did not see eye to eye with those who had just kept trudging along with naturalistic writers like Chernyshevsky and Dobrolyubov.

Before he embarked on his first film, *Strike*, Eisenstein directed one more play, *Gasmasks*, devised by Tretyakov. For this production he abandoned the mock-Spanish ex-Villa Morossov for the Moscow Gas Factory, a setting suitable for the modern age, comparable with Mayakovsky's Brooklyn Bridge or Tatlin's *Monument to the Third International*. (Tatlin, taking his view that the artist was an engineer worker to its logical conclusion, actually went to work in a metallurgical factory near Petrograd.) Also relevant here was Tretyakov's preference for 'factography', as it came to be known, for which he propagandised in *Lef*. Literature became seen as a matter of diaries, travelogues, memories and so on, dealing with the raw material of life itself. Tretyakov developed the 'bio-interview', a technique like that of Oscar Lewis's *Children of Sanchez*; he wrote angrily, 'There is no need for us to wait for Tolstoys, because we have our own epics. Our epics are the newspapers.' It seemed only logical that if the theatre was to become a factory, the factory should become a theatre. The stage first broke through the proscenium arch, then outburst the brick-and-mortar integument of the theatre itself. Already the theatre had taken to the streets in great mass pageants, reminiscent of the *fêtes* of the French Revolution. Next they must enter the factory itself. Unfortunately, the experiment was not a great success. As Eisenstein ruefully described, the giant turbo-generators dwarfed the actors. However, it

October: reflexes of struggle

prepared the way for the next step: out of the drama altogether and into the cinema.

Strike was made in 1924; Eisenstein was then twenty-six. *Strike*, like *Listen Moscow*, was to be an agit-guignol. He planned to produce a chain of shocks: 'Maximum intensification of aggressive reflexes of social protest is seen in *Strike*, in mounting reflexes without opportunity for release or satisfaction or, in other words, concentration of reflexes of struggle, and heightening of the potential expression of class feeling.' Thus the concept of montage was retained, but that of attractions dropped, except in the reductive sense of shocks or provocations. The film was made up in effect of poster-like, often caricatural vignettes, planned for maximum emotional impact. The next year, Eisenstein wrote that:

The science of shocks and their 'montage' in relation to these concepts should suggest their form. Content, as I see it, is a series of connecting shocks arranged in a certain sequence and directed at the audience. ... All this material must be arranged and organised in relation to principles which would lead to the desired reaction in correction proportion.

The dominant influence of Pavlov is manifest.

In order to transpose his system of montage from theatre to cinema Eisenstein made use of the discoveries that had been made by Kuleshov and Vertov. Before the Revolution Kuleshov had been a designer at the Khanzhankov Studio, where he already began writing theoretical articles stressing the visual aspects of film. In 1920, after a period in the Red Army, he became a teacher at the State Film School, where he set up his own workshop; Eisenstein studied there for three months in 1923. It was there that he carried out his famous experiments in editing. The first was a demonstration of creative geography or 'artificial landscape', placing the White House in Moscow. The second was a synthetic composition of a woman out of the lips of one, the legs of another, the back of a third, the eyes of a fourth and so on. The third showed how the expression perceived on an actor's face – grief, joy, etc. – is determined by the shots which precede and follow it. For Kuleshov the third demonstration was, of course, a blow against Stanislavsky; he insisted,

when he made his film *Mr West in the Land of the Bolsheviks* in 1923–4, that 'the most difficult task was to show that new actors, specifically trained for film work, were far better than the psychological-theatrical film-stars'. He hated Naturalism and always referred to actors as 'models'. The importance of Kuleshov's experiments was that they showed how, by editing, the anti-Naturalist, anti-psychologist trend in the theatre could also be introduced into cinema, using scientific, laboratory-tested and specifically cinematic methods. The second major influence was Dziga Vertov, the leading film documentarist of the period who, like Eisenstein, was a contributor to *Lef*, where he had developed his theories of 'kino-pravda' and the 'kino-eye'. However, perhaps more important was Vertov's use of editing. Eisenstein was to tell Hans Richter a few years later that Vertov should be credited with the invention of musical rhythm in the cinema, governing the tempo of the film by the measured pace of the cutting, and hence with a decisive breakthrough in montage principles. Moreover, Vertov (or rather Rodchenko, who

Vertov's *Kino-Pravda*

collaborated with him) was the first to realise the importance of the titles and to integrate them into the film as an element in its construction, rather than as troublesome interruptions. In *Battleship Potemkin* especially, the titles, on which Tretyakov worked, played an important role. The documentary tendency Eisenstein was hostile towards; he liked to repeat: 'I don't believe in kino-eye, I believe in kino-fist.'

During his work on *Strike* Eisenstein also elaborated his theory of 'typage' in the choice of actors. Like Kuleshov, like the whole theatrical tradition in which he worked, he rejected orthodox stage acting. Instead he preferred to cast his films simply by the physiological, particularly facial, characteristics he felt suited the part. He would often spend months looking for the right person. A man who he saw shovelling coal in the hotel at Sevastopol where they were shooting was drafted into the cast to play the surgeon in *Battleship Potemkin*. For *The General Line* his cameraman Tissé recalls:

The General Line: typage. Chukhmarev (left) as the kulak

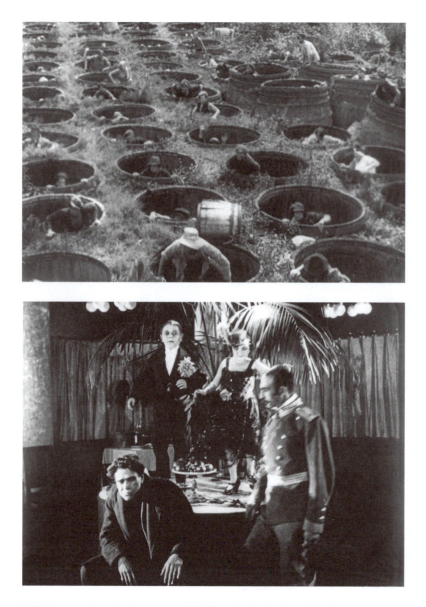

Strike: Lumpenproletarians jumping out of their barrels; the dwarfs and the police spy as an owl

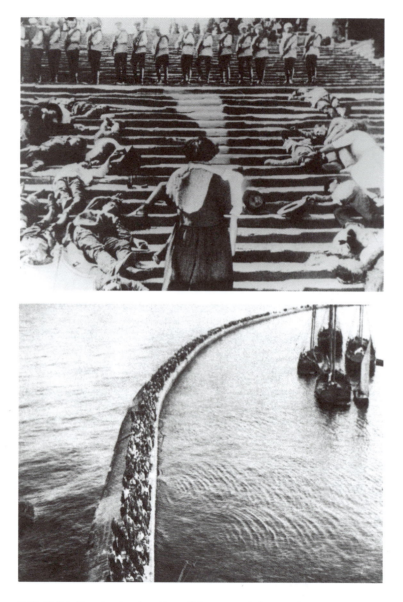

Battleship Potemkin: agit-guignol, and beautifully composed photography

The kulak's role was played by Chukhmarev, a Moslem and former meat contractor for the army. Father Matvei was found in Leningrad; before the war he had played the cello at the Marinsky Theatre, was drafted into the army and later joined the Red Army and suffered concussion in the fighting at Kronstadt. The lovely sad wife in the scene of the divided hut was found in Neveshkovo, a village of Old Believers.

The heroine was found on a State Farm at Konstantinovka. Eisenstein has described how he developed the idea of typage from his thoughts about the *commedia dell'arte* with its stock types who are immediately recognised by the audience. He wanted faces which would immediately give the impression of the role. Later he became interested in Lavater's system of physiognomics; probably Leonardo da Vinci had an influence too.

However, *Strike* still retained important elements from Eisenstein's past in the theatre. The guignol strain played a key part, particularly in the closing sequence, where the subjection of the workers is paralleled by the slaughter of cattle in an abattoir. The film is suffused with parody, a cartoonist's approach, squibs, lampoons, and so on, in the eccentric music-hall tradition. The critic Victor Shklovsky commented on the similarities to Keaton, both the fascination with machinery and the effective use of 'the eccentricity of his material and the sharpness of the contrasts'. A kind of Hoffmannesque grotesque is evident in *Strike* with the police spies who are metamorphosed into animals: monkey, bulldog, fox and owl. The lumpenproletarian strike-breakers jumping out of their barrels, as Shklovsky comments, are like devils jumping out of hell in a mystery play. The peculiar dwarfs who appear reveal a theatrical, almost Gothic, outlook, far from what was regarded as Realism. But as Eisenstein became more engrossed in the cinema this residue from the theatrical past began to fall away. *October* was the last film to have a very strong theatrical flavour, where the scenes of the storming of the Winter Palace were evidently echoes of the enormous pageants which had taken place in Petrograd, when tens of thousands had swarmed through the streets and squares, re-enacting the events of the October Revolution. In a quite different way *Ivan the Terrible* looks back to the theatre, but no longer to the theatre of FEKS or the Proletcult. Yet I think that these three films – *Strike*, *October* and *Ivan the Terrible* – are certainly Eisenstein's best, most extraordinary

achievements. He was at his strongest when he was working within the theatrical tradition which exerted such influence on him in the 1920s: his more purely cinematic work lacks the bite, the lampooning edge which was his strength. In *Battleship Potemkin*, the most successful sequence, the famous massacre on the Odessa Steps, is really an extension of the agit-guignol he had worked at in the Proletcult Theatre; other sequences of the film, beautifully composed photography, heroic postures, etc., look forward to the artistic disaster of *Alexander Nevsky*.

During the years from 1924 to 1929, when Eisenstein left Russia for a tour abroad, he worked more intensively than at any time during his career, and also made a great effort to elaborate his aesthetic theories more systematically, in particular his theory of montage. It is popularly believed that Eisenstein conceived of montage as the basis of a film language, a cinematic rather than a verbal code, with its own appropriate, even necessary, syntax. In fact, at this stage, Eisenstein was rather sparing in his remarks on film language and usually very vague. At a later date, as we shall see, he delved into linguistic theory, but throughout the 1920s his ideas of language and linguistics seem to have been extremely sketchy, though through *Lef* he was in contact with a number of the Formalist linguists.

What did interest Eisenstein, however, was the dialectic. He constantly stresses that montage is a dialectical principle. Eisenstein seems to have absorbed his notion of the dialectic in rather a haphazard manner. Certainly, the dominant influence must have been Deborin, the editor of *Under the Banner of Marxism*, the leading philosophical magazine of the time in the Soviet Union. Deborin was a militant Hegelian, engaged during the second half of the 1920s in a fierce controversy with the Mechanist school, militant materialists, whose hard core were leaders in the campaign of the godless against religion. Inclined towards Positivism, they regarded the dialectic as so much mumbo-jumbo. Deborin was able to counter their attacks by pointing to Engels's *The Dialectics of Nature* and Lenin's *Philosophical Notebooks*, first published in Russia during the 1920s, in part on Deborin's initiative. Eisenstein frequently quotes from these two works; he seems to have been particularly fond of an excerpt from Lenin's *Philosophical Notebooks*, 'On The Question of Dialectics', first published in *Bolshevik* in 1925. One sentence struck him

forcefully: 'In any proposition we can (and must) disclose as in a "nucleus" ("cell") the germs of all the elements of dialectics.' Eisenstein was able to link this to his concept of the shot as the cell, or later, as his views grew more complex, the molecule of montage.

Clearly there were some difficulties in Eisenstein's position, of which he began to grow uncomfortably aware. The problem was to reconcile his 'idealist' preoccupation with the dialectic with the materialist inheritance he carried with him from the Proletcult Theatre: the stress on the machine, on gymnastics and eurhythmics, on Pavlovian reflexology. The dialectic, Lenin stressed, was knowledge: 'the living tree of vital, fertile, genuine, powerful, omnipotent, objective, absolute human knowledge'. In the past Eisenstein described how cinema was 'confronted with the task of straining to the utmost the aggressive emotions in a definite direction' (that is, an agitational task whose ideological roots lay in reflexology), but 'the new cinema must include deep reflective processes'. At first Eisenstein's ideas on this subject were rather abstract and vague. He criticised Kuleshov and Pudovkin for seeing the unit of the shot as being like a brick; making a film was like laying bricks end to end. Pudovkin, wrote Eisenstein, 'loudly defends an understanding of montage as a *linkage* of pieces. Into a chain. Again "bricks". Bricks arranged in a series to *expound* an idea.' He goes on: 'I confronted him with my viewpoint on montage as a *collision*. A view that from the collision of two given factors *arises* a concept. ... So montage is conflict. As the basis of every art is conflict (an "imagist" transformation of the dialectical principle).'

But how did a concept arise from a collision? Neither Pavlov nor Deborin were very helpful on this subject. Marxism did not have a satisfactory aesthetics. Its most clamorous aestheticians were particularly hostile to the background from which Eisenstein had emerged, Futurism and Constructivism, and to which he still adhered. In fact, Eisenstein proved unable to solve the problems confronting him and eventually tacitly abandoned them. Primarily, a work of art remained for him 'a structure of pathos', which produced emotional effects in the spectator. The problem was to get the maximum effect. 'If we want the spectator to experience a maximum emotional upsurge, to send him into ecstasy, we must offer him a suitable "formula" which will eventually excite the desirable emotions in him.'

This was a simple physiological approach; conflict, on various levels and dimensions, on the screen excited emotions in the spectator, which would either strengthen his political and social consciousness or jolt him out of his ideological preconceptions to look at the world anew. What baffled Eisenstein was how new concepts could be precisely conveyed. He built up a model, first with four and then with five levels of montage (metric, rhythmic, tonal, overtonal, intellectual), in which, in each case, every level except the last could be described as 'purely physiological'. The last (intellectual montage) was to direct not only the emotions but 'the whole thought process as well'. Eisenstein conceded that his method might be 'more suitable for the expression of ideologically pointed theses', but explained that this was only a 'first embryonic step'. Ahead lay 'the synthesis of art and science' and the dream of a film of *Capital*, the summit of Eisenstein's ambitions.

This search for the synthesis of art and science led Eisenstein into a line of argument to which there could be no satisfactory conclusion. He became

Battleship Potemkin: gymnastics

increasingly interested in the idea that verbal speech is a kind of secondary process and that the primary, underlying level of thought is sensuous and imagistic. He was impressed by the notion that the origins of language were in metaphor and in conjunction with magic and mystic rituals. He came to believe that the language of primitive peoples was more imagistic and metaphoric than the tongues of advanced nations. He saturated himself in the writings of anthropologists such as Frazer, Lévy-Bruhl and Malinowsky, and regarded myth as the primary function of thought; logical thought, in the more usual sense, came to be seen as a kind of shrivelled myth. It was in myth that the synthesis of art and science could be seen. This idea, of course, is at the root of *Que Viva Mexico!* Eisenstein also became interested in the concept of 'affective logic', based on the observation that most people, in colloquial speech, did not utter complex and logically formed sentences so much as bursts of disjointed phrases which the hearer was able to connect. Finally, he was deeply impressed by the work of James Joyce and was persuaded that

October: conflict within the frame

October: sequence in the Czarina's bedroom

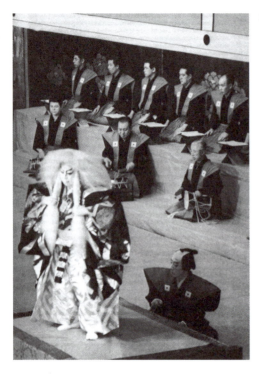

Kabuki theatre

inner speech was closer to sensuous and imagistic thought than externalised, verbal speech. In some sense, the cinema might correspond to interior monologue; the drift of Joyce's literary innovations was towards a kind of cinematisation of language. Of course, it is easy now to point out how many of his mentors have been discredited, how our concepts of myth and of the syntax of colloquial speech have been transformed, how it has been shown that inner speech is not less but more sophisticated and advanced than externalised speech. But at the time Eisenstein was working, and in the isolated conditions in which he worked, there was nothing abnormal about his line of thought. It did, however, bring him into error and confusion.

An important moment in the development of his ideas occurred when the Kabuki troupe of Ichikawa Sadanji visited Russia in 1928. Eisenstein, who had long been interested in Japan, was enormously impressed. He felt that

there was a kinship of principle between Kabuki acting, the Japanese written ideogram, and his great discovery of montage.

How grateful I was to fate for having subjected me to the ordeal of learning an Oriental language [while in the army], opening before me that strange way of thinking and teaching me word pictography. It was precisely this 'unusual' way of thinking that later helped me to master the nature of montage, and still later, when I came to recognise this 'unusual', 'emotional' way of thinking, different from our common 'logical' way, this helped me to comprehend the most recondite methods of art.

Under the influence of the Kabuki theatre Eisenstein began to see montage as an activity of mental fusion or synthesis, through which particular details were united at a higher level of thought, rather than a series of explosions as in a combustion engine, as it had once seemed. Eisenstein was fascinated by the use of conventions, masks and symbolic costumes in Oriental theatre. He became interested in Japanese ideas of picture composition. Under the spell of the East, montage was defused for Eisenstein. Finally, the Japanese theatre suggested to Eisenstein the concept of a 'monistic ensemble' which came to dominate his thought more and more, culminating in the Wagnerian excesses of his stage production of the *Valkyrie*. He was struck by the way sound and gesture were correlated in the Kabuki theatre; this was a subject which became more and more crucial to him as it became clear that the sound film was to be the form of the future. Again, quite in the tradition of Meyerhold, he reacted against the idea that the sound film must mean the dominance of the spoken word and looked for a different way of combining the visual and aural components of the cinema. In the Kabuki theatre Eisenstein felt that the line of one sense did not simply accompany the other, the two were totally interchangeable, inseparable elements of a monistic ensemble.

This interest in the relationships between the different senses converged with Eisenstein's growing proneness to use musical analogies and terminology to explain what he was trying to achieve in the cinema. Thus, while pondering over the editing of *The General Line*, he came to the conclusion that his montage should concentrate not on the dominant in each shot (tonal montage) but on the overtones. At the same time he put increased stress on finding the

correct rhythm. And, when he discussed the relationships between the different senses and different lines of development, he introduced the idea of counterpoint and later of polyphony (noise bands, which in a way survived until *Battleship Potemkin*, with the 'music of the machines' passage in Meisel's score, now disappeared entirely). This stress on the 'synchronisation of the senses', and on analogies with music, set the stage for the full-scale reflux of Symbolism which overwhelmed Eisenstein's thought during the 1930s.

Eisenstein's visit to Western Europe, the United States and Mexico had a shattering effect on his life. Firstly, there was the terrible catastrophe of *Que Viva Mexico!*, a film to which he became obsessively attached, which he was unable to finish and over which he lost all control. Secondly, there was the completely changed political and cultural atmosphere which greeted him when he returned to the Soviet Union, suspicious of Eisenstein for his enthusiasm for Western culture and hostile to the drift of his ideas about cinema and aesthetics in general. Eisenstein had left Russia during 'the spinal year' of 1929, when the collectivisation of the peasants had reached the vital point of no return, when the first Five Year Plan had reached the moment of fate. Russia was thrown into a frenzy to reach production goals, to destroy the kulaks, to enforce collectivisation. At the time Eisenstein left, the shock waves had not yet broken with their full force upon the intelligentsia. By the time he returned, party control had been made rigid, a standard and requisite ideology introduced and many of the artistic and academic stars of 1929 quenched and discredited. Eisenstein took up a post at the Institute of Cinematographic Studies where he conducted a series of lecture courses, read voluminously and worked in isolation at a projected *magnum opus* of film aesthetics.

Eisenstein had continual problems even in this relative isolation: indeed, in part because of it. He was accused of withdrawing into an ivory tower, charges which he countered by describing himself as at work in a laboratory on the theoretical problems without whose solution practice would be premature, unoriented. Quite clearly, however, the tendency of his theoretical work ran counter to the main lines of Stalinist aesthetics. His views on Joyce, for instance, were well known. He had met Joyce, and Joyce had once said that if *Ulysses* were to be filmed it should be by either Eisenstein or Ruttmann. Consequently, when in 1933 Vsevolod Vishnevsky made a defence of Joyce in an article

entitled 'We Must Know the West', he cited Eisenstein as a great Soviet artist who recognised the importance of Joyce. Vishnevsky's defence unleashed a controversy which raged until the 1934 Congress of Soviet Writers. Radek there gave his notorious report, one section of which was entitled 'James Joyce or Socialist Realism?' It was not hard to guess the answer: a taste for Joyce was denounced as a craving to flee from Magnetogorsk. Eisenstein, however, refused to submit. In his lectures at the Institute he observed:

For two years there were discussions about translating Joyce for scientific purposes, but this plan was abandoned after the speech by Radek. Because of this the mass of Russian writers will lose a great deal. I was furious at Radek's speech. When I analysed it I found it to be a quite conventional interpretation of Joyce.

Joyce, concluded Eisenstein hopefully, 'extends the line commenced by Balzac'.

The main onslaught on Eisenstein, however, was to come over his films of the 1920s and the issue of Realism. Perhaps the strangest feature of the Stalinist attack is the way in which it has echoed down the years:

The artist takes the village outside of its real relations, outside of its living connections. He thinks in terms of things. He disintegrates reality into disconnected, unrelated pieces. This makes quite illusory Eisenstein's construction which is proclaimed in principle as arch-realistic. This film, arising from the desire to express a most urgent page of living reality, full of throbbing interest, proves to be a production torn away from reality itself.

Ivan Anisimov's denunciation of *The General Line* prefigures in an eerie and uncanny way a whole series of criticisms still to come, from Robert Warshow and, more seriously, from Charles Barr and Christian Metz. Anisimov even joins Warshow in attacking Eisenstein for 'collectivism', for making films without individual characters. It is strange to see how the philistinism of the Stalinist regime in the 1930s finds its belated double in the United States of the Cold War two decades later. 'Realism' has always been the refuge of the conservative in the arts, together with a preference for propaganda of a comforting rather than disturbing kind. Thus *Alexander Nevsky*, Eisenstein's worst film, made during the 1930s under the impact of

Stalinist criticism, was his most successful propaganda film. Film, Charles Barr has written, 'cannot show the essence, but it can suggest the essence by showing the substance'. Undeformed, undisintegrated, merely suggestive versions of 'reality' are always the best propaganda for the *status quo.*

Meanwhile, however, Eisenstein was pursuing his researches. The dominant strand throughout the rest of his life was to be the investigation of the 'synchronisation of the senses', a return to the Symbolist infatuation with Baudelaire's *correspondances*, a frequent subject for debate in Russia in the two decades before the Revolution.

Comme de longs échos qui de loin se confondent
Dans une ténébreuse et profonde unité,
Vaste comme la nuit et comme la clarté,
Les parfums, les couleurs et les sons se répondent.
Il est des parfums frais comme des chairs d'enfants,
Doux comme les hautbois, verts comme les prairies ...

Eisenstein went even further than Baudelaire by including taste. In his discussion of the Kabuki theatre he wrote:

Not even what is eaten in this theatre is accidental! I had no opportunity to discover if it is ritual food eaten. Do they eat whatever happens to be there or is there a definite menu? If the latter, we must also include in the ensemble the sense of taste.

Eisenstein allowed no scientific scruples to stand in his way; indeed, by an astute reading of Pavlovian reflexology, he was able to validate his ideas scientifically to his own satisfaction. The *Laocoön* was summarily dismissed:

And yet we cannot reduce aural and visual perceptions to a common denominator. They are values of different dimensions. But the visual overtone and the sound overtone are values of a single measured substance. Because, if the frame is a visual perception and the tone is an aural perception, visual as well as aural overtones are a totally physiological sensation. And consequently they are of one and the same kind ... for both, a new uniform formula must enter our vocabulary: 'I feel'.

After this, however clumsily it may have been expressed, the way was open for every kind of interpenetration and admixture of categories.

Eisenstein's writings on synaesthesia are of great erudition and considerable interest, despite their fundamentally unscientific nature. For example, he quotes numerous Baroque and Romantic authorities, who speculated about the colour symbolism of the vowels long before Rimbaud. He sees himself in the tradition of Wagner and the *Gesamtkunstwerk* and quotes copiously from the French Symbolists. In particular, we can detect the influence of René Ghil, a close friend of V. Y. Bryusov, the poet and evangel of Russian Symbolism, and a frequent and respected contributor to Bryusov's review *Scales*. Another source for Eisenstein's speculations on colour symbolism is Kandinsky. Though he explicitly dissociates himself from Kandinsky's mysticism and spiritualism, his general tone and the trend of his investigations vividly recalls Kandinsky's programme for the Inkhuk (Institute of Artistic Culture). Clinging as hard as he can to the anchor of reflexology, Eisenstein explains that the colour stimulus acts 'as in a

Battleship Potemkin: 'I feel'

conditioned reflex which recalls a whole complex, in which it had once played a part, to the memory and the senses'. He also finds a crumb of scientific comfort in the theory of vibrations.

Another important forerunner whom Eisenstein cites is Scriabin, who wrote a colour score alongside the sound score for his *The Poem of Fire*. Scriabin also planned a stupendous *Mystery* with gestures, colours, perfumes, etc. Eisenstein used Scriabin, together with Debussy, to justify his theory of overtonal montage and also saw himself as the vector of Scriabin's dream of a synthesis of the arts. (He does not discuss the occult and peculiarly Russian brand of Theosophy which underlay this dream.) The idea of synthetic theatre was one much voiced during the 1920s. Eisenstein adopted it and went so far as to write that the cinema was destined to fulfil the prophecies of Edward Gordon Craig and Adolphe Appia, the great Symbolist and Wagnerian theoreticians of the pre-Revolutionary theatre. The logical extension of this, of course, was his production of the *Valkyrie* at the Bolshoi Opera in 1940. (In defence of Eisenstein it should be said that he was not entirely dominated by Symbolist and

Walt Disney's first *Silly Symphony*

Wagnerian thought; he also hailed Walt Disney as a master of synaesthesia.) The *Valkyrie*, according to Eisenstein's painstaking biographer, Marie Seton, had this aim: 'Men, music, light, landscape, colour and motion brought into one integral whole by a single piercing emotion, by a single theme and idea.' He himself wrote of his efforts to achieve 'a fusion between the elements of Wagner's score and the wash of colours on the stage'. This led directly on to *Ivan the Terrible*.

The result of this overwhelming Symbolist reflux was that the monistic ensemble gradually became no more than an organic whole and the dialectic was reduced to the interconnection of the parts. At the same time Eisenstein became interested in ideas of harmony, mathematical proportion and the golden section as part of a search for Classicism. As far back as *The General Line* his cameraman Tissé recalls, 'we resolved to get away from all trick-camerawork and to use simple methods of direct filming, with the most severe attention to the composition of each shot'. (For the Odessa Steps sequence of *Battleship Potemkin*, Eisenstein had strapped a camera to a somersaulting acrobat.) This interest in geometry was not that of the Constructivist, derived from the machine, but relied on insights into the nature of art. Eisenstein was especially fond of citing the geometry of the works of Leonardo da Vinci. It seems at times a component of that obsession with science which he was never able to control, reminiscent almost of René Ghil. 'In his attempt to create the logarithmic tables of art there is something akin to alchemy,' observed one critic, and it is hard not to see much of Eisenstein's later writing as an attempt to shore up, scientifically and intellectually, an art increasingly preoccupied with emotional saturation, ecstasy, the synchronisation of the

Eisenstein and Daumier

The operatic splendour of *Ivan the Terrible*

senses, myth and primitive thought ('Folk images equal human knowledge,' he said, apropos of *Que Viva Mexico!*). Indeed, there is something essentially Symbolist in his whole view of the near-identity of art and philosophy, though in his case philosophy was a bizarre mixture of Hegel with Pavlov.

One final strand in Eisenstein's aesthetics should be noted: his lifelong interest in caricature, in lampoon, in the grotesque. This derives in part from Meyerhold, Hoffmann and the seventeenth-century French etcher Callot. The artists Eisenstein revered were Daumier, Toulouse-Lautrec and Sharaku ('the Japanese Daumier'). In Mexico he added Posada to this pantheon: the Dance of Death sequence which was to close the film owes its provenance to Posada as well as Hoffmann and Callot. Later he became obsessed by El Greco, about whom he planned to write a book. This reflects both an interest in caricature, or at least hyperbole, and the fascination of the strange sado-spiritual atmosphere of the Toledo of the Inquisition, similar to that that he felt in Mexico. (Hence too his series of semi-caricatural drawings of the Stigmata

Ivan the Terrible

A print by Sharaku

and his admiration for Lawrence.) Eisenstein began his artistic career as a caricaturist on an agit-train; he ended it designing the strange, distorted costumes for *Ivan the Terrible*, twisting the actor Cherkassov out of shape till he collapsed from exhaustion. (In more than one way *Ivan the Terrible* returns, in a different form, to the ideas of the 1920s: there is even the gigantic Mayakovskian theme of the battle with God, strangely distended.)

It is instructive to compare Eisenstein with Brecht. They both started out in the same cultural milieu, with the same kind of orientation: the influence of Meyerhold (relayed to Brecht through Piscator), the interest in Oriental art, in music-hall, in sport; their commitment to Marxism and the Bolshevik Revolution; their Americanism, Behaviourism, hatred of Naturalism. Brecht might have echoed Eisenstein's words:

Ivan the Terrible: Cherkassov

Ivan the Terrible: a sketch by Eisenstein

Ivan the Terrible: Cherkassov

The Moscow Art Theatre is my deadly enemy. It is the exact antithesis of all I am trying to do. They string their emotions together to give a continuous illusion of reality. I take photographs of reality and then cut them up so as to produce emotions. ... I am not a realist, I am a materialist. I believe that material things, that matter gives us the basis of all our sensations. I get away from realism by going to reality.

There are friendships in common. They both sought the same goal: the elusive unity of science with art. But at the end of the 1920s they took different paths. Brecht protested to Tretyakov against the idea of 'pathetic overtones'; he devoted himself to attacking Wagner, to insisting that the senses, as the *Laocoön* had showed, must be clearly differentiated, that the different components in a work of art should be specified and be kept clearly apart. Brecht tried to find an artistic form for rational argument; Eisenstein repeatedly tried to cram and squeeze concepts into an artistic form he had already semi-intuitively (even 'ecstatically') elaborated: in the end, he decided

Berthold Brecht (above) and his production of *Dreigroschenoper*

thought and image were at one in myth and inner speech, abandoning rational argument for 'affective logic'. But it would be too easy simply to praise Brecht at Eisenstein's expense. Brecht always stayed with words, with verbal discourse, and was never compelled to face the problems of working in a predominantly non-verbal, iconic rather than symbolic medium.

Scientific concepts can, in fact, only be expressed within a symbolic code. Eisenstein's whole orientation, however, prevented him from pursuing the search for a symbolic language. In so far as he was interested in semiology his kinship is not so much with Saussure and structural linguistics, as Christian Metz supposes, as with Charles Morris and his Behaviourist semiotic. Eisenstein soon disowned his early experiments with non-diegetic metaphor, the necessary beginning for any movement towards the establishment of paradigmatic sets, such as the Gods sequence in *October*, though, as Godard has since shown in *Une Femme mariée* and *La Chinoise*, this was not a dead-end street at all. Probably too he underestimated the importance of the support

Rin-Tin-Tin on set

verbal discourse can and must give on the soundtrack. (Strangely, he was much more aware of the importance of subtitles during the silent era.) His emphasis on the emotional impact of the cinema tended all the time to draw him away from the symbolic.

Paradoxically, it was his conviction of the scientific basis of art which in the end led him into a full-scale retreat from the expression of scientific concepts through film. His acceptance of Pavlovian reflexology was unquestioning and rigid. (While he was in the United States he even felt moved to contrast Rin-Tin-Tin unfavourably with Pavlov's laboratory-trained dogs.) At an epistemological level, he was never able to resolve clearly what he intended by the Marxism to which he was fervently committed. It fell into two unrelated shells, and lacked a binding core. On the one hand was a 'scientistic' materialism, which sought physiological explanations for all human activity. On the other hand, there was a purely formal and abstract concept of the Hegelian dialectic, mechanically applied and eventually degenerating into an empty stereotype.

Eisenstein liked to compare himself with Leonardo da Vinci, as a great artist who saw his art as scientific and became, in time, more interested in aesthetic theory than in art itself. (He even compared his failure to complete *Que Viva Mexico!* with the catastrophe of the Sforza Monument.) His aspirations were greater than his achievement. Nevertheless, he was one of the few writers on aesthetics in this century to show any awareness of the cataclysmic reassessment of aesthetics which must take place. He was an original, unrelenting and comprehensive thinker. The fact that he fell short of his own gigantic appreciation of his worth should not lead us to forget that he towers above his contemporaries. He still has an enormous amount to teach us.

2: The Auteur Theory

The *politique des auteurs* – the auteur theory, as Andrew Sarris calls it – was developed by the loosely knit group of critics who wrote for *Cahiers du cinéma* and made it the leading film magazine in the world. It sprang from the conviction that the American cinema was worth studying in depth, that masterpieces were made not only by a small upper crust of directors, the cultured gilt on the commercial gingerbread, but by a whole range of authors, whose work had previously been dismissed and consigned to oblivion. There were special conditions in Paris which made this conviction possible. Firstly, there was the fact that American films were banned from France under the Vichy government and the German Occupation. Consequently, when they reappeared after the Liberation they came with a force – and an emotional impact – which was necessarily missing in the Anglo-Saxon countries themselves. And, secondly, there was a thriving ciné-club movement, due in part to the close connections there had always been in France between the cinema and the intelligentsia: witness the example of Jean Cocteau or André Malraux. Connected with this ciné-club movement was the magnificent Paris Cinémathèque, the work of Henri Langlois, a great auteur, as Jean-Luc Godard described him. The policy of the Cinémathèque was to show the maximum number of films, to plough back the production of the past in order to produce the culture in which the cinema of the future could thrive. It gave French cinéphiles an unmatched perception of the historical dimensions of Hollywood and the careers of individual directors. The auteur

theory grew up rather haphazardly; it was never elaborated in programmatic terms, in a manifesto or collective statement. As a result, it could be interpreted and applied on rather broad lines; different critics developed somewhat different methods within a loose framework of common attitudes. This looseness and diffuseness of the theory has allowed flagrant misunderstandings to take root, particularly among critics in Britain and the United States. Ignorance has been compounded by a vein of hostility to foreign ideas and a taste for travesty and caricature. However, the fruitfulness of the auteur approach has been such that it has made headway even on the most unfavourable terrain. A straw poll of British critics, conducted in conjunction with a Don Siegel Retrospective at the National Film Theatre, revealed that, among American directors most admired, a group consisting of Budd Boetticher, Samuel Fuller and Howard Hawks ran immediately behind Ford, Hitchcock and Welles, who topped the poll, but ahead of Billy Wilder, Josef von Sternberg and Preston Sturges.

Of course, some individual directors have always been recognised as outstanding: Charles Chaplin, John Ford, Orson Welles. The auteur theory does not limit itself to acclaiming the director as the main author of a film. It implies an operation of decipherment; it reveals authors where none had been seen before. For years, the model of an author in the cinema was that of the European director, with open artistic aspirations and full control over his films. This model still lingers on; it lies behind the existential distinction between art films and popular films. Directors who built their reputations in Europe were dismissed after they crossed the Atlantic, reduced to anonymity. American Hitchcock was contrasted unfavourably with English Hitchcock, American Renoir with French Renoir, American Fritz Lang with German Fritz Lang. The auteur theory has led to the revaluation of the second, Hollywood careers of these and other European directors; without it, masterpieces such as *Scarlet Street* or *Vertigo* would never have been perceived. Conversely, the auteur theory has been sceptical when offered an American director whose salvation has been exile to Europe. It is difficult now to argue that *Brute Force* has ever been excelled by Jules Dassin or that Joseph Losey's later work is markedly superior to, say, *The Prowler*.

Alfred Hitchcock's *Vertigo*

In time, owing to the diffuseness of the original theory, two main schools of auteur critics grew up: those who insisted on revealing a core of meanings, of thematic motifs, and those who stressed style and *mise en scène*. There is an important distinction here, which I shall return to later. The work of the auteur has a semantic dimension, it is not purely formal; the work of the *metteur en scène*, on the other hand, does not go beyond the realm of performance, of transposing into the special complex of cinematic codes and channels a pre-existing text: a scenario, a book or a play. As we shall see, the meaning of the films of an auteur is constructed *a posteriori*; the meaning – semantic, rather than stylistic or expressive – of the films of a *metteur en scène* exists *a priori*. In concrete cases, of course, this distinction is not always clear-cut. There is controversy over whether some directors should be seen as auteurs or *metteurs en scène*. For example, though it is possible to make intuitive ascriptions there have been no really persuasive accounts as yet of Raoul Walsh or William Wyler as auteurs, to take two very different directors. Opinions might differ about Don Siegel or George Cukor. Because of the difficulty of fixing the distinction in these concrete cases, it has often become blurred; indeed, some French critics have tended to value the *metteur en scène* above the auteur. MacMahonism sprang up, with its cult of Walsh, Lang, Losey and Preminger, its fascination with violence and its notorious text: 'Charlton Heston is an axiom of the cinema.' What André Bazin called 'aesthetic cults of personality' began to be formed. Minor directors were acclaimed before they had, in any real sense, been identified and defined.

Yet the auteur theory has survived despite all the hallucinating critical extravaganzas which it has fathered. It has survived because it is indispensable. Geoffrey Nowell-Smith has summed up the auteur theory as it is normally presented today:

One essential corollary of the theory as it has been developed is the discovery that the defining characteristics of an author's work are not necessarily those which are most readily apparent. The purpose of criticism thus becomes to uncover behind the superficial contrasts of subject and treatment a hard core of basic and often recondite motifs. The pattern formed by these motifs ... is what gives an author's work its particular structure, both defining it internally and distinguishing one body of work from another.

Jules Dassin's *Brute Force*; Joseph Losey's *The Prowler*

It is this 'structural approach', as Nowell-Smith calls it, which is indispensable for the critic.

The test case for the auteur theory is provided by the work of Howard Hawks. Why Hawks, rather than, say, Frank Borzage or King Vidor? Firstly, Hawks is a director who has worked for years within the Hollywood system. His first film, *Road to Glory*, was made in 1926. Yet throughout his long career he has only once received general critical acclaim, for his wartime film, *Sergeant York*, which closer inspection reveals to be eccentric and atypical of the main corpus of Hawks's films. Secondly, Hawks has worked in almost every genre. He has made Westerns (*Rio Bravo*), gangsters (*Scarface*), war films (*Air Force*), thrillers (*The Big Sleep*), science fiction (*The Thing from Another World*), musicals (*Gentlemen Prefer Blondes*), comedies (*Bringing Up Baby*), even a biblical epic (*Land of the Pharaohs*). Yet all these films (except perhaps *Land of the Pharaohs*, which he himself was not happy about) exhibit

Budd Boetticher's *The Bullfighter and the Lady*

the same thematic preoccupations, the same recurring motifs and incidents, the same visual style and tempo. In the same way that Roland Barthes constructed a species of *homo racinianus*, the critic can construct a *homo hawksianus*, the protagonist of Hawksian values in the problematic Hawksian world.

Hawks achieved this by reducing the genres to two basic types: the adventure drama and the crazy comedy. These two types express inverse views of the world, the positive and negative poles of the Hawksian vision. Hawks stands opposed, on the one hand, to John Ford and, on the other hand, to Budd Boetticher. All these directors are concerned with the problem of heroism. For the hero, as an individual, death is an absolute limit which cannot be transcended: it renders the life which preceded it meaningless, absurd. How then can there be any meaningful individual action during life? How can individual action have any value – be heroic – if it cannot have transcendent value, because of the absolutely devaluing limit of death? John Ford finds the

Only Angels Have Wings: the communal sing-song

answer to this question by placing and situating the individual within society and within history, specifically within American history. Ford finds transcendent values in the historic vocation of America as a nation, to bring civilisation to a savage land, the garden to the wilderness. At the same time, Ford also sees these values themselves as problematic; he begins to question the movement of American history itself.

Boetticher, on the contrary, insists on a radical individualism. 'I am not interested in making films about mass feelings. I am for the individual.' He looks for values in the encounter with death itself: the underlying metaphor is always that of the bullfighter in the arena. The hero enters a group of companions, but there is no possibility of group solidarity. Boetticher's hero acts by dissolving groups and collectivities of any kind into their constituent individuals, so that he confronts each person face to face; the films develop, in Andrew Sarris's words, into 'floating poker games, where every character takes turns at bluffing about his hand until the final showdown'. Hawks, unlike Boetticher, seeks transcendent values beyond the individual, in solidarity with others. But, unlike Ford, he does not give his heroes any historical dimension, any destiny in time.

For Hawks the highest human emotion is the camaraderie of the exclusive, self-sufficient, all-male group. Hawks's heroes are cattlemen, marlin-fishermen, racing-drivers, pilots, big-game hunters, habituated to danger and living apart from society, actually cut off from it physically by dense forest, sea, snow or desert. Their aerodromes are fog-bound; the radio has cracked up; the next mail-coach or packet-boat does not leave for a week. The élite group strictly preserves its exclusivity. It is necessary to pass a test of ability and courage to win admittance. The group's only internal tensions come when one member lets the others down (the drunk deputy in *Rio Bravo*, the panicky pilot in *Only Angels Have Wings*) and must redeem himself by some act of exceptional bravery, or occasionally when too much 'individualism' threatens to disrupt the close-knit circle (the rivalry between drivers in *Red Line 7000*, the fighter pilot among the bomber crew in *Air Force*). The group's security is the first commandment: 'You get a stunt team in acrobatics in the air – if one of them is no good, then they're all in trouble. If someone loses his nerve catching animals, then the whole bunch can be in

trouble.' The group members are bound together by rituals (in *Hatari!* blood is exchanged by transfusion) and express themselves univocally in communal sing-songs. There is a famous example of this in *Rio Bravo*. In *Dawn Patrol* the camaraderie of the pilots stretches even across the enemy lines: a captured German ace is immediately drafted into the group and joins in the sing-song; in *Hatari!* hunters of different nationality and in different places join together in a song over an intercom radio system.

Hawks's heroes pride themselves on their professionalism. They ask: 'How good is he? He'd better be good.' They expect no praise for doing their job well. Indeed, none is given except: 'The boys did all right.' When they die, they leave behind them only the most meagre personal belongings, perhaps a handful of medals. Hawks himself has summed up this desolate and barren view of life:

It's just a calm acceptance of a fact. In *Only Angels Have Wings*, after Joe dies, Cary Grant says: 'He just wasn't good enough.' Well, that's the only thing that keeps people going. They just have to say: 'Joe wasn't good enough, and I'm better than Joe, so I go ahead and do it.' And they find out they're not any better than Joe, but then it's too late, you see.

In Ford films, death is celebrated by funeral services, an impromptu prayer, a few staves of 'Shall we gather at the river?' – it is inserted into an ongoing system of ritual institutions along with the wedding, the dance, the parade. But for Hawks it is enough that the routine of the group's life goes on, a routine whose only relieving features are 'danger' (*Hatari!*) and 'fun'. Danger gives existence pungency: 'Every time you get real action, then you have danger. And the question, "Are you living or not living?" is probably the biggest drama we have.' This nihilism, in which 'living' means no more than being in danger of losing your life – danger entered into quite gratuitously – is augmented by the Hawksian concept of having 'fun'. The word 'fun' crops up constantly in Hawks's interviews and scripts. It masks his despair.

When one of Hawks's élite is asked, usually by a woman, why he risks his life, he replies: 'No reason I can think of makes any sense. I guess we're just crazy.' Or Feathers, sardonically, to Colorado in *Rio Bravo*: 'You haven't

even the excuse I have. We're all fools.' By 'crazy' Hawks does not mean psychopathic: none of his characters are like Turkey in Peckinpah's *The Deadly Companions* or Billy the Kid in Penn's *The Left-Handed Gun*. Nor is there the sense of the absurdity of life which we sometimes find in Boetticher's films: death, as we have seen, is for Hawks simply a routine occurrence, not a *grotesquerie*, as in *The Tall T* ('Pretty soon that well's going to be chock-a-block') or *The Rise and Fall of Legs Diamond*. For Hawks 'craziness' implies difference, a sense of apartness from the ordinary, everyday, social world. At the same time, Hawks sees the ordinary world as being 'crazy' in a much more fundamental sense, because devoid of any meaning or values. 'I mean crazy reactions – I don't think they're crazy, I think they're normal – but according to bad habits we've fallen into they seemed crazy.' Which is the normal, which the abnormal? Hawks recognises, inchoately, that to most people his heroes, far from embodying rational values,

John Ford's *The Searchers*: a funeral service

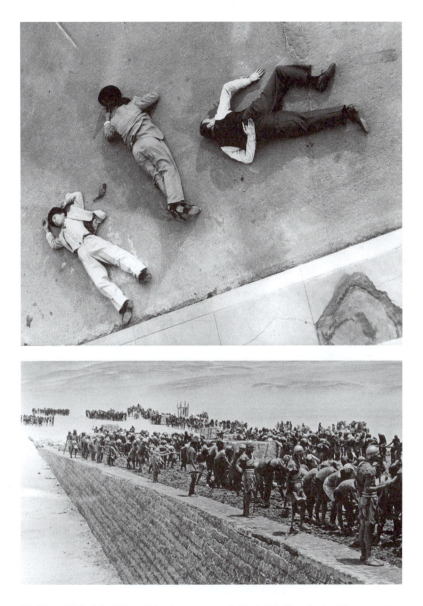

The Rise and Fall of Legs Diamond: death as a *grotesquerie*; *Land of the Pharaohs*: the dehumanised crowd

are only a dwindling band of eccentrics. Hawks's 'kind of men' have no place in the world.

The Hawksian heroes, who exclude others from their own élite group, are themselves excluded from society, exiled to the African bush or to the Arctic. Outsiders, other people in general, are perceived by the group as an undifferentiated crowd. Their role is to gape at the deeds of the heroes whom, at the same time, they hate. The crowd assembles to watch the showdown in *Rio Bravo*, to see the cars spin off the track in *The Crowd Roars*. The gulf between the outsider and the heroes transcends enmities among the élite: witness *Dawn Patrol* or Nelse in *El Dorado*. Most dehumanised of all is the crowd in *Land of the Pharaohs*, employed in building the Pyramids. Originally the film was to have been about Chinese labourers building a 'magnificent airfield' for the American army, but the victory of the Chinese Revolution forced Hawks to change his plans. ('Then I thought of the building of the Pyramids; I thought it was the same kind of story.') But the

His Girl Friday: the tormented insurance salesman

presence of the crowd, of external society, is a constant covert threat to the Hawksian élite, who retaliate by having 'fun'. In the crazy comedies ordinary citizens are turned into comic butts, lampooned and tormented: the most obvious target is the insurance salesman in *His Girl Friday*. Often Hawks's revenge becomes grim and macabre. In *Sergeant York* it is 'fun' to shoot Germans 'like turkeys'; in *Air Force* it is 'fun' to blow up the Japanese fleet. In *Rio Bravo* the geligniting of the badmen 'was very funny'. It is at these moments that the élite turns against the world outside and takes the opportunity to be brutal and destructive.

Besides the covert pressure of the crowd outside, there is also an overt force which threatens: woman. Man is woman's 'prey'. Women are admitted to the male group only after much disquiet and a long ritual courtship, phased round the offering, lighting and exchange of cigarettes, during which they prove themselves worthy of entry. Often they perform minor feats of valour. Even then though they are never really full members. A typical dialogue sums up their position:

WOMAN: You love him, don't you?
MAN (embarrassed): Yes ... I guess so. ...
WOMAN: How can I love him like you?
MAN: Just stick around.

The undercurrent of homosexuality in Hawks's films is never crystallised, though in *The Big Sky*, for example, it runs very close to the surface. And he himself described *A Girl in Every Port* as 'really a love story between two men'. For Hawks men are equals, within the group at least, whereas there is a clear identification between women and the animal world, most explicit in *Bringing Up Baby*, *Gentlemen Prefer Blondes* and *Hatari!* Man must strive to maintain his mastery. It is also worth noting that, in Hawks's adventure dramas and even in many of his comedies, there is no married life. Often the heroes were married, or at least intimately committed, to a woman at some time in the distant past but have suffered an unspecified trauma, with the result that they have been suspicious of women ever since. Their attitude is 'Once bitten, twice shy'. This is in contrast to the films of Ford, which almost always

include domestic scenes. Woman is not a threat to Ford's heroes; she falls into her allotted social place as wife and mother, bringing up the children, cooking, sewing, a life of service, drudgery and subordination. She is repaid for this by being sentimentalised. Boetticher, on the other hand, has no obvious place for women at all; they are phantoms, who provoke action, are pretexts for male modes of conduct, but have no authentic significance in themselves. 'In herself, the woman has not the slightest importance.'

Hawks sees the all-male community as an ultimate; obviously it is very retrograde. His Spartan heroes are, in fact, cruelly stunted. Hawks would be a lesser director if he was unaffected by this, if his adventure dramas were the sum total of his work. His real claim as an author lies in the presence, together with the dramas, of their inverse, the crazy comedies. They are the agonised exposure of the underlying tensions of the heroic dramas. There are two principal themes, zones of tension. The first is the theme of regression: of regression to childhood, infantilism, as in *Monkey Business*, or regression to

Women and the animal world: *Hatari!* and *Gentlemen Prefer Blondes*

savagery: witness the repeated scene of the adult about to be scalped by painted children, in *Monkey Business* and in *The Ransom of Red Chief*. With brilliant insight, Robin Wood has shown how *Scarface* should be categorised among the comedies rather than the dramas: Camonte is perceived as savage, childlike, subhuman. The second principal comedy theme is that of sex reversal and role reversal. *I Was a Male War Bride* is the most extreme example. Many of Hawks's comedies are centred round domineering women and timid, pliable men: *Bringing Up Baby* and *Man's Favorite Sport?* for example. There are often scenes of male sexual humiliation, such as the

Scarface: Camonte with monkey

trousers being pulled off the hapless private eye in *Gentlemen Prefer Blondes*. In the same film the Olympic team of athletes are reduced to passive objects in an extraordinary Jane Russell song number; big-game hunting is lampooned, like fishing in *Man's Favorite Sport*; the theme of infantilism crops up again: 'The child was the most mature one on board the ship, and I think he was a lot of fun.'

Whereas the dramas show the mastery of man over nature, over woman, over the animal and childish, the comedies show his humiliation, his regression. The heroes become victims; society, instead of being excluded and despised, breaks in with irruptions of monstrous farce. It could well be argued that Hawks's outlook, the alternative world which he constructs in the cinema, the Hawksian heterocosm, is not one imbued with particular intellectual subtlety or sophistication. This does not detract from its force. Hawks first attracted attention because he was regarded naïvely as an action director. Later, the thematic content which I have outlined was detected and revealed. Beyond the stylemes, semantemes were found to exist; the films were anchored in an objective stratum of meaning, a plerematic stratum, as the Danish linguist Hjelmslev would put it. Thus the stylistic expressiveness of Hawks's films was shown to be not purely contingent, but grounded in significance.

Something further needs to be said about the theoretical basis of the kind of schematic exposition of Hawks's work which I have outlined. The 'structural approach' which underlies it, the definition of a core of repeated motifs, has evident affinities with methods which have been developed for the study of folklore and mythology. In the work of Olrik and others, it was noted that in different folk tales the same motifs reappeared time and time again. It became possible to build up a lexicon of these motifs. Eventually Propp showed how a whole cycle of Russian fairytales could be analysed into variations of a very limited set of basic motifs (or moves, as he called them). Underlying the different, individual tales was an archi-tale, of which they were all variants. One important point needs to be made about this type of structural analysis. There is a danger, as Lévi-Strauss has pointed out, that by simply noting and mapping resemblances, all the texts which are studied (whether Russian fairy tales or American movies) will be reduced to one, abstract and impoverished. There must be a moment of synthesis as well as a

moment of analysis: otherwise, the method is Formalist, rather than truly Structuralist. Structuralist criticism cannot rest at the perception of resemblances or repetitions (redundancies, in fact), but must also comprehend a system of differences and oppositions. In this way, texts can be studied not only in their universality (what they all have in common) but also in their singularity (what differentiates them from each other). This means, of course, that the test of a structural analysis lies not in the orthodox canon of a director's work, where resemblances are clustered, but in films which at first sight may seem eccentricities.

In the films of Howard Hawks a systematic series of oppositions can be seen very near the surface, in the contrast between the adventure dramas and the crazy comedies. If we take the adventure dramas alone it would seem that Hawks's work is flaccid, lacking in dynamism; it is only when we consider the crazy comedies that it becomes rich, begins to ferment: alongside every dramatic hero we are aware of a phantom, stripped of mastery, humiliated, inverted. With other directors, the system of oppositions is much more complex: instead of there being two broad strata of films there are a whole series of shifting variations. In these cases, we need to analyse the roles of the protagonists themselves, rather than simply the worlds in which they operate. The protagonists of fairy tales or myths, as Lévi-Strauss has pointed out, can be dissolved into bundles of differential elements, pairs of opposites. Thus the difference between the prince and the goose-girl can be reduced to two antinomic pairs: one natural, male versus female, and the other cultural, high versus low. We can proceed with the same kind of operation in the study of films, though, as we shall see, we shall find them more complex than fairy tales.

It is instructive, for example, to consider three films of John Ford and compare their heroes: Wyatt Earp in *My Darling Clementine*, Ethan Edwards in *The Searchers* and Tom Doniphon in *The Man Who Shot Liberty Valance*. They all act within the recognisable Ford world, governed by a set of oppositions, but their *loci* within that world are very different. The relevant pairs of opposites overlap; different pairs are foregrounded in different movies. The most relevant are garden versus wilderness, ploughshare versus sabre, settler versus nomad, European versus Indian, civilised versus savage,

Gentlemen Prefer Blondes: Jane Russell and the 'passive' Olympic team

book versus gun, married versus unmarried, East versus West. These antinomies can often be broken down further. The East, for instance, can be defined either as Boston or Washington and, in *The Last Hurrah*, Boston itself is broken down into the antipodes of Irish immigrants versus Plymouth Club, themselves bundles of such differential elements as Celtic versus Anglo-Saxon, poor versus rich, Catholic versus Protestant, Democrat versus Republican, and so on. At first sight, it might seem that the oppositions listed above overlap to the extent that they become practically synonymous, but this is by no means the case. As we shall see, part of the development of Ford's career has been the shift from an identity between civilised versus savage and European versus Indian to their separation and final reversal, so that in *Cheyenne Autumn* it is the Europeans who are savage, the victims who are heroes.

The master antinomy in Ford's films is that between the wilderness and the garden. As Henry Nash Smith has demonstrated, in his magisterial book *Virgin Land*, the contrast between the image of America as a desert and as a garden is one which has dominated American thought and literature, recurring in countless novels, tracts, political speeches and magazine stories. In Ford's films it is crystallised in a number of striking images. *The Man Who Shot Liberty Valance*, for instance, contains the image of the cactus rose, which encapsulates the antinomy between desert and garden which pervades the whole film. Compare with this the famous scene in *My Darling Clementine*, after Wyatt Earp has gone to the barber (who civilises the unkempt), where the scent of honeysuckle is twice remarked upon: an artificial perfume, cultural rather than natural. This moment marks the turning point in Wyatt Earp's transition from wandering cowboy, nomadic, savage, bent on personal revenge, unmarried, to married man, settled, civilised, the sheriff who administers the law.

Earp, in *My Darling Clementine*, is structurally the most simple of the three protagonists I have mentioned: his progress is an uncomplicated passage from nature to culture, from the wilderness left in the past to the garden anticipated in the future. Ethan Edwards, in *The Searchers*, is more complex. He must be defined not in terms of past versus future or wilderness versus garden compounded in himself, but in relation to two other protagonists: Scar,

My Darling Clementine: Wyatt Earp at the barber's

the Indian chief, and the family of homesteaders. Ethan Edwards, unlike Earp, remains a nomad throughout the film. At the start, he rides in from the desert to enter the log-house; at the end, with perfect symmetry, he leaves the house again to return to the desert, to vagrancy. In many respects, he is similar to Scar; he is a wanderer, a savage, outside the law: he scalps his enemy. But, like the homesteaders, of course, he is a European, the mortal foe of the Indian. Thus Edwards is ambiguous; the antinomies invade the personality of the protagonist himself. The oppositions tear Edwards in two; he is a tragic hero. His companion, Martin Pawley, however, is able to resolve the duality; for him, the period of nomadism is only an episode, which has meaning as the restitution of the family, a necessary link between his old home and his new home.

Ethan Edwards's wandering is, like that of many other Ford protagonists, a quest, a search. A number of Ford films are built round the theme of the quest for the Promised Land, an American re-enactment of the

The Searchers: Ethan Edwards returns to the wilderness

biblical Exodus, the journey through the desert to the land of milk and honey, the New Jerusalem. This theme is built on the combination of the two pairs: wilderness versus garden and nomad versus settler; the first pair precedes the second in time. Thus, in *Wagonmaster*, the Mormons cross the desert in search of their future home; in *How Green Was My Valley* and *The Informer*, the protagonists want to cross the Atlantic to a future home in the United States. But, during Ford's career, the situation of home is reversed in time. In *Cheyenne Autumn* the Indians journey in search of the home they once had in the past; in *The Quiet Man*, the American Sean Thornton returns to his ancestral home in Ireland. Ethan Edwards's journey is a kind of parody of this theme: his object is not constructive, to found a home, but destructive, to find and scalp Scar. Nevertheless, the weight of the film remains oriented to the future: Scar has burned down the home of the settlers, but it is replaced and we are confident that the homesteader's wife, Mrs Jorgensen, is right when she says: 'Some day this country's going to be a fine place to live.' The wilderness will, in the end, be turned into a garden.

The Man Who Shot Liberty Valance has many similarities with The Searchers. We may note three: the wilderness becomes a garden – this is made quite explicit, for Senator Stoddart has wrung from Washington the funds necessary to build a dam which will irrigate the desert and bring real roses, not cactus roses; Tom Doniphon shoots Liberty Valance as Ethan Edwards scalped Scar; a log-home is burned to the ground. But the differences are equally clear: the log-home is burned after the death of Liberty Valance; it is destroyed by Doniphon himself; it is his own home. The burning marks the realisation that he will never enter the Promised Land, that to him it means nothing; that he has doomed himself to be a creature of the past, insignificant in the world of the future. By shooting Liberty Valance he has destroyed the only world in which he himself can exist, the world of the gun rather than the book; it is as though Ethan Edwards had perceived that by scalping Scar, he was in reality committing suicide. It might be mentioned too that, in *The Man Who Shot Liberty Valance*, the woman who loves Doniphon marries Senator Stoddart. Doniphon when he destroys his log-house (his last words before doing so are 'Home, sweet home!') also destroys the possibility of marriage. The themes of *The Man Who Shot Liberty Valance* can be expressed in another way.

The Man Who Shot Liberty Valance:
the showdown

Ransom Stoddart represents rational–legal authority, Tom Doniphon represents charismatic authority. Doniphon abandons his charisma and cedes it, under what amounts to false pretences, to Stoddart. In this way charismatic and rational–legal authority are combined in the person of Stoddart and stability thus assured. In *The Searchers* this transfer does not take place; the two kinds of authority remain separated. In *My Darling Clementine* they are combined naturally in Wyatt Earp, without any transfer being necessary. In many of Ford's late films – *The Quiet Man, Cheyenne Autumn, Donovan's Reef* – the accent is placed on traditional authority. The island of Ailakaowa, in *Donovan's Reef*, a kind of Valhalla for the homeless heroes of *The Man Who Shot Liberty Valance*, is actually a monarchy, though complete with the Boston girl, wooden church and saloon, made familiar by *My Darling Clementine*. In fact, the character of Chihuahua, Doc Holliday's girl in *My Darling Clementine*, is spilt into two: Miss Lafleur and Lelani, the native princess. One represents the saloon entertainer, the other the non-American in opposition to

the respectable Bostonians, Amelia Sarah Dedham and Clementine Carter. In a broad sense, this is a part of a general movement which can be detected in Ford's work to equate the Irish, Indians and Polynesians as traditional communities, set in the past, counterposed to the march forward to the American future, as it has turned out in reality, but assimilating the values of the American future as it was once dreamed.

It would be possible, I have no doubt, to elaborate on Ford's career, as defined by pairs of contrasts and similarities, in very great detail, though – as always with film criticism – the impossibility of quotation is a severe handicap. My own view is that Ford's work is much richer than that of Hawks and that this is revealed by a structural analysis; it is the richness of the shifting relations between antinomies in Ford's work that makes him a great artist, beyond being simply an undoubted auteur. Moreover, the auteur theory enables us to reveal a whole complex of meaning in films such as *Donovan's Reef*, which a recent filmography sums up as just 'a couple of Navy men who

The Man Who Shot Liberty Valance

Donovan's Reef: the Polynesians; *Cheyenne Autumn*: the Indians

have retired to a South Sea island now spend most of their time raising hell'. Similarly, it throws a completely new light on a film like *Wings of Eagles*, which revolves, like *The Searchers*, round the vagrancy-versus-home antinomy, with the difference that when the hero does come home, after flying round the world, he trips over a child's toy, falls down the stairs and is completely paralysed so that he cannot move at all, not even his toes. This is the macabre *reductio ad absurdum* of the settled.

Perhaps it would be true to say that it is the lesser auteurs who can be defined, as Nowell-Smith put it, by a core of basic motifs which remain constant, without variation. The great directors must be defined in terms of shifting relations, in their singularity as well as their uniformity. Renoir once remarked that a director spends his whole life making one film; this film, which it is the task of the critic to construct, consists not only of the typical features of its variants, which are merely its redundancies, but of the principle of variation which governs it, that is its esoteric structure, which can only manifest itself or 'seep to the surface', in Lévi-Strauss's phrase, 'through the repetition process'. Thus Renoir's 'film' is in reality a 'kind of permutation group, the two variants placed at the far ends being in a symmetrical, though inverted, relationship to each other'. In practice, we will not find perfect symmetry, though as we have seen, in the case of Ford, some antinomies are completely reversed. Instead, there will be a kind of torsion within the permutation group, within the matrix, a kind of exploration of certain possibilities, in which some antinomies are foregrounded, discarded or even inverted, whereas others remain stable and constant. The important thing to stress, however, is that it is only the analysis of the whole *corpus* which permits the moment of synthesis when the critic returns to the individual film.

Of course, the director does not have full control over his work; this explains why the auteur theory involves a kind of decipherment, decryptment. A great many features of the films analysed have to be dismissed as indecipherable because of 'noise' from the producer, the cameraman or even the actors. This concept of 'noise' needs further elaboration. It is often said that film is the result of a multiplicity of factors, the sum total of a number of different contributions. The contribution of the director – the 'directorial factor', as it were – is only one of these, though perhaps the one which carries

the most weight. I do not need to emphasise that this view is quite the contrary of the auteur theory and has nothing in common with it at all. What the auteur theory does is to take a group of films – the work of one director – and analyse their structure. Everything irrelevant to this, everything non-pertinent, is considered logically secondary, contingent, to be discarded. Of course, it is possible to approach films by studying some other feature; by an effort of critical ascesis we could see films, as Sternberg sometimes urged, as abstract light-show or as histrionic feasts. Sometimes these separate texts – those of the cameraman or the actors – may force themselves into prominence so that the film becomes an indecipherable palimpsest. This does not mean, of course, that it ceases to exist or to sway us or please us or intrigue us; it simply means that it is inaccessible to criticism. We can merely record our momentary and subjective impressions.

Myths, as Lévi-Strauss has pointed out, exist independently of style, the syntax of the sentence or musical sound, euphony or cacophony. The myth functions 'on an especially high level where meaning succeeds practically in "taking off" from the linguistic ground on which it keeps rolling'. *Mutatis mutandis*, the same is true of the auteur film. 'When a mythical schema is transmitted from one population to another, and there exist differences of language, social organisation or way of life which make the myth difficult to communicate, it begins to become impoverished and confused.' The same kind of impoverishment and confusion takes place in the film studio, where difficulties of communication abound. But none the less the film can usually be discerned, even if it was a quickie made in a fortnight without the actors or the crews that the director might have liked, with an intrusive producer and even, perhaps, a censor's scissors cutting away vital sequences. It is as though a film is a musical composition rather than a musical performance, although, whereas a musical composition exists *a priori* (like a scenario), an auteur film is constructed *a posteriori*. Imagine the situation if the critic had to construct a musical composition from a number of fragmentary, distorted versions of it, all with improvised passages or passages missing.

The distinction between composition and performance is vital to aesthetics. The score, or text, is constant and durable; the performance is occasional and transient. The score is unique, integrally itself; the

performance is a particular among a number of variants. The score, in music, consists partly of a message to be translated from one channel to another (from 'the stream of ink' to the 'stream of air') and partly of a set of instructions. In some modern scores, by Lamonte Young or George Brecht, there are only instructions; others, by Cornelius Cardew, for instance, are literary texts, which have to be translated between codes (verbal and musical) as well as between channels. But the principle remains the same. Both messages and instructions must necessarily refer back to a common code, so that they are intelligible to the performer. The performance itself, however, is not coded; hence its ungeneralised particularity. The distinctive marks of a performance, like those of somebody's accent or tone of voice, are facultative variants. A coded text consists of discrete units; a performance is continuous, graded rather than coded. It works more like an analogue computer than a digital one; it is similar to a clock rather than a calendar, a slide-rule rather than an abacus. The intelligibility of a performance of a piece of music is of a different kind to the intelligibility of a score. Here we confront the distinction made by Galvano della Volpe, referred to elsewhere in this book, between the realm in which de jure criticism is possible and the realm in which criticism can only be de facto, 'the kingdom of more or less', as Nicholas Ruwet has called it in his study of the semiology of music.

Linguists have often striven to restrict their field of study to the coded aspects of texts and to expel graded features, such as accents, grunts, rasps, chuckles, wails and so on. Charles F. Hockett, for example, has written that:

the embedding medium of linguistic messages ... shows a continuous scale of dynamics, organised to some extent in any given culture; one may speak softly, or more loudly, or more loudly still, or anywhere in between – with no theoretic limit to the fineness of gradation. But ... in general ... if we find continuous-scale contrasts in the vicinity of what we are sure is language, we exclude them from language (though not from culture).

Other linguists have contested this epistemological asceticism. Thomas A. Sebeok, for instance, has argued against Hockett and others, and demanded a radical rethinking of the relationship between coded and graded features of language. His own work in zoo-linguistics, communication among animals,

has led him to the conclusion that discrete units cannot be absolutely separated from their 'embedding medium'; if linguists expel continuous phenomena from their field of study they cannot then account, for instance, for linguistic change. Similar conclusions could be reached by considering the relations between composition and performance. There is no unbridged abyss between the two.

Painting provides a particularly interesting example. At one time, during the Renaissance and Mannerist periods, many paintings were initially composed and designed by an iconographic programmer, expert in mythology or biblical studies, and then executed by the painter. Some of these programmes have survived. Thus, for example, the marvellous Farnese Palace at Caprarola was decorated throughout according to a scheme elaborated by three humanist scholars, Annibale Caro, Onophrio Panvinio and Fulvio Orsini. The scheme was extremely detailed. For the ceiling of the study, the Stanza della Solitudine, Caro outlined the following programme, in a letter to Panvinio:

Thus in one of the large pictures of the middle I would show the solitude of Christians: and in the middle of this I would represent Christ Our Lord, and then on the sides in the following order, St Paul the Apostle, St John the Baptist, St Jerome, St Francis, and others if it can contain more, who would come out from the desert at different places and would go and meet the people to preach the evangelical doctrine, showing the desert on one side of the painting and the people on the other. In the opposite picture, I would show, as a contrast, the solitude of the pagans ...

and so on. A letter also survives from Caro to Taddeo Zuccaro, the painter. Evidently, this kind of iconographic programming has its similarities with a scenario.

Gradually, however, the painter emancipated himself from the iconographic programmer. We can see the beginnings of this, indeed, even in the case of Caprarola; Caro complained to Panvinio that either the programme 'must be adapted to the disposition of the painter, or his disposition to your subjects, and since it is obvious that he has refused to adapt himself to you, we must, perforce, adapt ourselves to him to avoid disorder and confusion'. That was in 1575. Fourteen years later, in 1589, the sculptor

Giambologna proved even more headstrong: he sent a bronze to his patron which, he remarked, 'might represent the Rape of Helen, or perhaps of Proserpine, or even one of the Sabines'. According to a contemporary he made sculptures 'solely to show his excellence in art and without having any subject in mind'. This was unusual at the time. Most painters submitted to some kind of iconographical programming for many years after Giambologna made his break for freedom. During the seventeenth century, it was still widely felt that verbal language and Alciati's 'syntax of symbols' were mutually translatable. Shaftesbury, as late as 1712, was programming a complicated allegorical 'draught or tablature' of the Judgment of Hercules. This was to be painted by Paulo de Matthaeis, but it was made perfectly clear that he was to be the subordinate partner in the enterprise.

Shaftesbury came down clearly on the side of design and repeatedly diminished the importance of colouring, which he regarded as 'false relish, which is governed rather by what immediately strikes the sense, than by what consequentially and by reflection pleases the mind, and satisfies the thought and reason'. Painting, as such, gave no more pleasure than 'the rich stuffs and coloured silks worn by our ladies'. Elsewhere he wrote that:

the good painter (*quatenus* painter) begins by working first *within*. Here the imagery! Here the plastic work! First makes forms, fashions, corrects, amplifies, contracts, unites, modifies, assimilates, adapts, conforms, polishes, refines etc., forms his *ideas*: then his hand: his strokes.

Shaftesbury was trying to hold back a tide much too strong for him. Painting succumbed to

the *je ne sais quoi* to which idiots and the ignorant of the art would reduce everything. 'Tis not the *dokei*, the I like and you like. But why do I like? And if not with reason and truth I will refuse to like, dislike my fancy, condemn the form, search it, discover its deformity and reject it.

Shaftesbury's platonising and allegorising were swept away by the full flood of Romanticism.

Yet even during the nineteenth century we can still see traces of the old attitudes. The Pre-Raphaelites worked from extremely detailed programmes; even Courbet painted what he called a 'real allegory'. Gauguin programmed his paintings but according to a system effectively opaque to anybody but himself. And, at the beginning of this century, Marcel Duchamp rebelled against what he called 'retinal' painting and the validation of the painter's touch – *la patte*, his 'paw'. The *Large Glass* was based upon the complicated notes and diagrams which Duchamp later published in the *Green Box*: 'It had to be planned and drawn as an architect would do it.' In a similar spirit, László Moholy-Nagy produced paintings by telephone, dictating instructions about the use of graph paper and standardised colours. Thus the wheel came full circle. The painter, after the long and successful struggle to emancipate himself from the iconographer, reacted against the outcome and strove to turn himself into a designer in his own right. One dimension of the history of painting lies in this shifting interaction between composition and performance.

However, it is not only in painting that the performer has made efforts to emancipate himself from the designer. Even in music, which seems the most stable art in this respect, there have been intermittent periods in which improvisation has been highly valued. And, of course, jazz provides a striking example. To begin with, jazz musicians improvised on tunes which they took from a repertory: march tunes, popular songs. Later they began to write their own tunes and use these as a basis for improvisation. Finally, they began to become primarily composers and only secondarily performers. The legal battle over whether Ornette Coleman should be categorised as a classical or a popular musician recalls the very similar battles which took place during the Renaissance over the disputed status of the painter, whether he was an artist or an artificer. Conversely, an opposite movement has taken place within legitimate music, allowing the performers much greater freedom to interpret and improvise. Thus the score of Cornelius Cardew's *Treatise* only partially and sporadically refers back to a common code; it oscillates between a discrete and continuous notation, between the coded and the graded.

Closer to the cinema has been the experience of the theatre. The polemic of Ben Jonson against Inigo Jones might well be that of a scriptwriter against a director more concerned with visual values:

... O Showes! Showes! Mighty Showes!
The Eloquence of Masques! What need of prose
Or Verse, or Sense t'express Immortall you?
You are the Spectacles of State! 'Tis true
Court Hieroglyphicks! and all Artes affoord
In the mere perspective of an Inch board!
You aske noe more then certeyne politique Eyes,
Eyes that can pierce into the Misteryes
Of many Coulors! read them! and reveale
Mythology there painted on slit deale!
Oh, to make Boardes to speake! There is a taske!
Painting and Carpentry are the Soule of Masque!
Pack with your pedling Poetry to the State!
This is the money-gett, Mechanick Age!

The accusation of commercialism and mechanicality is all too familiar. Ben Jonson's complaint is based on an assumption of the superiority of verbal language, the inadequacy of emblems and images. The theatre has oscillated between two modes of communication. A very similar impulse to that which motivated masque, a downgrading of the literary text, made itself felt at the end of the nineteenth and the beginning of the twentieth centuries, springing in part from the theory and practice of Wagner, developed at Bayreuth. Edward Gordon Craig stressed the non-verbal dimensions of the theatre and the sovereignty of the director; his theories made a particular impact in Germany and in Russia, where he was invited to work. In Russia, we can trace a direct link from Craig, through Meyerhold to the work of Eisenstein, first at the Proletcult Theatre, then in the cinema. In Germany, Max Reinhardt was the analogue to Meyerhold; he had an equivalent kind of effect on the German Expressionist cinema: even Sternberg has acknowledged his admiration of Reinhardt. For Meyerhold, words were no longer sacrosanct: plays were ruthlessly altered and adapted. There was a counter-stress on the specifically theatrical modes of expression: mime, *commedia dell'arte*, set design, costume, acrobatics and the circus, the performing art *par excellence*. Meyerhold and Reinhardt insisted on full control. Ironically, when Reinhardt did make a film,

A Midsummer Night's Dream in Hollywood, he was made to share the direction with an established cinema director, William Dieterle. None the less his work in theatre pointed forward to the cinema.

Even in literature, it should be said, the relationship between composition and performance occasionally varies. Most literary works used to be spoken aloud and this persisted, even with prose, until quite recently: Benjamin Constant read *Adolphe* aloud numerous times before it ever saw print; Dickens had immensely successful recital tours. There is still a strong movement in favour of reading poetry aloud. Of course, literacy and printing have diminished the social importance of this kind of performance. Ever since St Ambrose achieved the feat of reading to himself, the performance of literary works has been doomed to be secondary. Yet, during the nineteenth century, as literacy rose, the fall of public readings was accompanied by its converse, a rising interest in typography. The typographer has become,

Reinhardt and Dieterle's *A Midsummer Night's Dream*

potentially, a kind of interpreter of a text, like a musician. Early instances of creative typography can be seen in *Tristram Shandy* and the work of Baroque poets such as Quarles and Herbert. But the modern movement springs from the convergence of Morris's concern over typography and book design, spread through the Arts and Crafts guilds and Art Nouveau, with the innovations of Mallarmé. In the first decades of the century there was a great upsurge of interest in typography – Pound, Apollinaire, Marinetti, El Lissitsky, Picabia, De Stijl, the Bauhaus – which is still bearing fruit today. A worldwide Concrete Poetry movement has grown up, in which poets collaborate with typographers.

The cinema, like all these other arts, has a composition side and a performance side. On the one hand there is the original story, novel or play and the shooting script or scenario. Hitchcock and Eisenstein draw sequences in advance in a kind of strip-cartoon form. On the other hand, there are the various levels of execution: acting, photography, editing. The director's position is shifting and ambiguous. He both forms a link between design and performance and can command or participate in both. Different directors, of course, lean in different directions. Partly this is the result of their backgrounds: Mankiewicz and Fuller, for instance, began as scriptwriters; Sirk as a set-designer; Cukor as a theatre director; Siegel as an editor and montage director; Chaplin as an actor; Klein and Kubrick as photographers. Partly too it depends on their collaborators: Cukor works on colour design with Hoyningen-Huene because he respects his judgment. And most directors, within limits, can choose who they work with.

What the auteur theory demonstrates is that the director is not simply in command of a performance of a pre-existing text; he is not, or need not be, only a *metteur en scène*. Don Siegel was asked on television what he took from Hemingway's short story for his film, *The Killers*; Siegel replied that 'the only thing taken from it was the catalyst that a man has been killed by somebody and he did not try to run away'. The word Siegel chose – 'catalyst' – could not be bettered. Incidents and episodes in the original screenplay or novel can act as catalysts; they are the agents which are introduced into the mind (conscious or unconscious) of the auteur and react there with the motifs and themes characteristic of his work. The director does not subordinate himself to

another author; his source is only a pretext, which provides catalysts, scenes which fuse with his own preoccupations to produce a radically new work. Thus the manifest process of performance, the treatment of a subject, conceals the latent production of a quite new text, the production of the director as an auteur.

Of course, it is possible to value performances as such, to agree with André Bazin that Olivier's *Henry V* was a great film, a great rendering, transposition into the cinema, of Shakespeare's original play. The great *metteurs en scène* should not be discounted simply because they are not auteurs: Vincente Minnelli, perhaps, or Stanley Donen. And, further than that, the same kind of process can take place that occurred in painting: the director can deliberately concentrate entirely on the stylistic and expressive dimensions of the cinema. He can say, as Josef von Sternberg did about *Morocco*, that he purposely chose a fatuous story so that people would not be distracted from the play of light and shade in the photography. Some of Busby Berkeley's extraordinary sequences are equally detached from any kind of dependence on the screenplay: indeed, more often than not, some other director was entrusted with the job of putting the actors through the plot and dialogue. Moreover, there is no doubt that the greatest films will be not simply auteur films but marvellous expressively and stylistically as well: *Lola Montès*, *Shinheike Monogatari*, *La Règle du jeu*, *La signora di tutti*, *Sanshô dayû*, *Le Carrosse d'or*.

The auteur theory leaves us, as every theory does, with possibilities and questions. We need to develop much further a theory of performance, of the stylistic, of graded rather than coded modes of communication. We need to investigate and define, to construct critically the work of enormous numbers of directors who until now have only been incompletely comprehended. We need to begin the task of comparing author with author. There are any number of specific problems which stand out: Donen's relationship to Kelly and Arthur Freed, Boetticher's films outside the Ranown cycle, Welles's relationship to Toland (and – perhaps more important – Wyler's), Sirk's films outside the Ross Hunter cycle, the exact identity of Walsh or Wellman, the decipherment of Anthony Mann. Moreover, there is no reason why the auteur

Laurence Olivier's *Henry V*

theory should not be applied to the English cinema, which is still utterly amorphous, unclassified, unperceived. We need not two or three books on Hitchcock and Ford, but many, many more. We need comparisons with authors in the other arts: Ford with Fenimore Cooper, for example, or Hawks with Faulkner. The task which the critics of *Cahiers du cinéma* embarked on is still far from completed.

Busby Berkeley sequence in *Gold Diggers of 1933*

3: The Semiology of the Cinema

In recent years a considerable degree of interest has developed in the semiology of the cinema, in the question of whether it is possible to dissolve cinema criticism and cinema aesthetics into a special province of the general science of signs. It has become increasingly clear that traditional heroes of film language and film grammar, which grew up spontaneously over the years, need to be re-examined and related to the established discipline of linguistics. If the concept of 'language' is to be used it must be used scientifically and not simply as a loose, though suggestive, metaphor. The debate which has arisen in France and Italy, round the work of Roland Barthes, Christian Metz, Pier Paolo Pasolini and Umberto Eco, points in this direction.

The main impulse behind the work of these critics and semiologists springs from Ferdinand de Saussure's *Course in General Linguistics*. After Saussure's death in 1913 his former pupils at the University of Geneva collected and collated his lecture outlines and their own notes and synthesised these into a systematic presentation, which was published in Geneva in 1915. In the *Course* Saussure predicted a new science, the science of semiology.

A science that studies the life of signs within society is conceivable; it would be part of social psychology and consequently of general psychology; I shall call it semiology (from Greek *semeion*, 'sign'). Semiology would show what constitutes signs, what laws govern them. Since the science does not yet exist, no one can say what it would be; but it has a right to existence, a place staked out in advance. Linguistics is only a part of the general science of semiology; the laws discovered by semiology will be applicable to linguistics,

and the latter will circumscribe a well-defined area within the mass of anthropological facts.

Saussure, who was impressed by the work of Emile Durkheim (1858–1917) in sociology, emphasised that signs must be studied from a social viewpoint, that language was a social institution which eluded the individual will. The linguistic system – what might nowadays be called the 'code' – pre-existed the individual act of speech, the 'message'. Study of the system therefore had logical priority.

Saussure stressed, as his first principle, the arbitrary nature of the sign. The signifier (the sound-image *o-k-s* or *b-ö-f*, for example) has no natural connection with the signified (the concept 'ox'). To use Saussure's term, the sign is 'unmotivated'. Saussure was not certain what the full implications of the arbitrary nature of the linguistic sign were for semiology:

When semiology becomes organised as a science, the question will arise whether or not it properly includes modes of expression based on complete natural signs, such as pantomime. Supposing the new science welcomes them, its main concern will still be the whole group of systems grounded on the arbitrariness of the sign. In fact, every means of expression used in society is based, in principle, on collective behaviour or – what amounts to the same thing – on convention. Polite formulas, for instance, although often imbued with a certain natural expressiveness (as in the case of a Chinese who greets his emperor by bowing down to the ground nine times), are none the less fixed by rule; it is this rule and not the intrinsic value of the gestures that obliges one to use them. Signs that are wholly arbitrary realise better than the others the ideal of the semiological process; that is why language, the most complex and universal of all systems of expression, is also the most characteristic; in this sense linguistics can become the master-pattern for all branches of semiology although language is only one particular semiological system.

Linguistics was to be both a special province of semiology and, at the same time, the master-pattern ('le patron général') for the various other provinces. All the provinces, however – or, at least, the central ones – were to have as their object systems 'grounded on the arbitrariness of the sign'. These systems, in the event, proved hard to find. Would-be semiologists found themselves limited to such micro-languages as the language of traffic-signs,

the language of fans, ships' signalling systems, the language of gesture among Trappist monks, various kinds of semaphore and so on. These micro-languages proved extremely restricted cases, capable of articulating a very sparse semantic range. Many of them were parasitic on verbal language proper. Roland Barthes, as a result of his researches into the language of costume, concluded that it was impossible to escape the pervasive presence of verbal language. Words enter into discourse of another order either to fix an ambiguous meaning, like a label or a title, or to contribute to the meaning that cannot otherwise be communicated, like the words in the bubbles in a strip-cartoon. Words either anchor meaning or convey it.

It is only in very rare cases that non-verbal systems can exist without auxiliary support from the verbal code. Even highly developed and intellectualised systems like painting and music constantly have recourse to words, particularly at a popular level: songs, cartoons, posters. Indeed, it would be possible to write the history of painting as a function of the shifting

Hogarth's *Industry and Idleness*: words in the visual arts

relation between words and images. One of the main achievements of the Renaissance was to banish words from the picture space. Yet words repeatedly forced themselves back; they reappear in the paintings of El Greco, for instance, in Dürer, in Hogarth: one could give countless examples. In the twentieth century words have returned with a vengeance. In music, words were not banished until the beginning of the seventeenth century; they have asserted themselves in opera, in oratorio, in *Lieder*. The cinema is another obvious case in point. Few silent films were made without intertitles. Erwin Panofsky has recollected his cinemagoing days in Berlin around 1910:

The producers employed means of clarification similar to those we find in medieval art. One of these was printed titles or letters, striking equivalents of the medieval *tituli* and scrolls (at a still earlier date there even used to be explainers who would say, *viva voce*, 'Now he thinks his wife is dead but she isn't' or 'I don't wish to offend the ladies in the audience but I doubt that any of them would have done that much for her child').

In Japan, 'explainers' of this kind formed themselves into a guild, which proved strong enough to delay the advent of the talkie.

In the end Barthes reached the conclusion that semiology might be better seen as a branch of linguistics, rather than the other way round. This seems a desperate conclusion. The province turns out to be so much 'the most complex and universal' that it engulfs the whole. Yet our experience of cinema suggests that great complexity of meaning can be expressed through images. Thus, to take an obvious example, the most trivial and banal book can be made into an extremely interesting and, to all appearances, significant film; reading a screenplay is usually a barren and arid experience, intellectually as well as emotionally. The implication of this is that it is not only systems exclusively 'grounded on the arbitrariness of the sign' which are expressive and meaningful. 'Natural signs' cannot be as readily dismissed as Saussure imagined. It is this demand for the reintegration of the natural sign into semiology which led Christian Metz, a disciple of Barthes, to declare that cinema is indeed a language, but language without a code (without a *langue*, to use Saussure's term). It is a language because it has texts; there is a meaningful discourse. But, unlike verbal language, it cannot be referred back to a pre-

existent code. Metz's position involves him in a considerable number of problems which he never satisfactorily surmounts; he is forced back to the concept of 'a "logic of implication" by which the image becomes language'; he quotes with approval Béla Balázs's contention that it is through a 'current of induction' that we make sense of a film. It is not made clear whether we have to learn this logic or whether it is natural. And it is difficult to see how concepts like 'logic of implication' and 'current of induction' can be integrated into the theory of semiology.

What is needed is a more precise discussion of what we mean by a 'natural sign' and by the series of words such as 'analogous', 'continuous', 'motivated', which are used to describe such signs, by Barthes, Metz and others. Fortunately the groundwork necessary for further precision has already been accomplished by Charles Sanders Peirce, the American logician. Peirce was a contemporary of Saussure; like Saussure his papers were collected and published posthumously, between 1931 and 1935, twenty years

The poster: words in painting.
Toulouse Lautrec's *Jane Avril*

after his death in 1914. Peirce was the most original American thinker there has been, so original, as Roman Jakobson has pointed out, that for a great part of his working life he was unable to obtain a university post. His reputation now rests principally on his more accessible work, mainly his teachings on pragmatism. His work on semiology (or 'semiotic' as he himself called it) has been sadly neglected. Unfortunately, his most influential disciple, Charles Morris, travestied his position by coupling it with a virulent form of Behaviourism. Severe criticisms of Behaviourism in relation to linguistics and aesthetics, from writers such as E. H. Gombrich and Noam Chomsky, have naturally tended to damage Peirce by association with Morris. However, in recent years, Roman Jakobson has done a great deal to reawaken interest in Peirce's semiology, a revival of enthusiasm long overdue.

The main texts which concern us here are his *Speculative Grammar*, the letters to Lady Welby and *Existential Graphs* (subtitled 'my *chef d'œuvre*' by Peirce). These books contain Peirce's taxonomy of different classes of sign, which he regarded as the essential semiological foundation for a subsequent logic and rhetoric. The classification which is important to the present argument is that which Peirce called 'the second trichotomy of signs', their division into icons, indices and symbols. 'A sign is either an *icon*, an *index* or a *symbol*.'

An icon, according to Peirce, is a sign which represents its object mainly by its similarity to it; the relationship between signifier and signified is not arbitrary but is one of resemblances or likeness. Thus, for instance, the portrait of a man resembles him. Icons can, however, be divided into two sub-classes: images and diagrams. In the case of images 'simple qualities' are alike; in the case of diagrams the 'relations between the parts'. Many diagrams, of course, contain symboloid features; Peirce readily admitted this, for it was the dominant aspect or dimension of the sign which concerned him.

An index is a sign by virtue of an existential bond between itself and its object. Peirce gave several examples.

I see a man with a rolling gait. This is a probable indication that he is a sailor. I see a bowlegged man in corduroys, gaiters and a jacket. These are probable indications that he is a jockey or something of the sort. A sundial or clock indicates the time of day.

Other examples cited by Peirce are the weathercock, a sign of the direction of the wind which physically moves it, the barometer, the spirit-level. Roman Jakobson cites Man Friday's footprint in the sand and medical symptoms, such as pulse rates, rashes and so on. Symptomatology is a branch of the study of the indexical sign.

The third category of sign, the symbol, corresponds to Saussure's arbitrary sign. Like Saussure, Peirce speaks of a 'contract' by virtue of which the symbol is a sign. The symbolic sign eludes the individual will. 'You can write down the word "star", but that does not make you the creator of the word, nor if you erase it have you destroyed the word. The word lives in the minds of those who use it.' A symbolic sign demands neither resemblance to its object nor an existential bond with it. It is conventional and has the force of a law. Peirce was concerned about the appropriateness of calling this kind of sign a 'symbol', a possibility which Saussure also considered but rejected because of the danger of confusion. However, it seems certain that Saussure over-restricted the notion of sign by limiting it to Peirce's 'symbolic'; moreover, Peirce's trichotomy is elegant and exhaustive. The principal remaining problem, the categorisation of such so-called 'symbols' as the scales of justice or the Christian cross, is one that is soluble within Peirce's system, as I shall show later.

Peirce's categories are the foundation for any advance in semiology. It is important to note, however, that Peirce did not consider them to be mutually exclusive. On the contrary, all three aspects frequently – or, he sometimes suggests, invariably – overlap and are co-present. It is this awareness of overlapping which enabled Peirce to make some particularly relevant remarks about photography.

Photographs, especially instantaneous photographs, are very instructive, because we know that in certain respects they are exactly like the objects they represent. But this resemblance is due to the photographs having been produced under such circumstances that they were physically forced to correspond point by point to nature. In that aspect, then, they belong to the second class of signs, those by physical connection.

That is, to the indexical class. Elsewhere he describes a photographic print as a 'quasi-predicate', of which the light rays are the 'quasi-subject'.

Among European writers on semiology Roland Barthes reaches somewhat similar conclusions, though he does not use the category 'indexical', but sees the photographic print simply as 'iconic'. However, he describes how the photographic icon represents 'a kind of natural *being-there* of the object'. There is no human intervention, no transformation, no code, between the object and the sign; hence the paradox that a photograph is a message without a code. Christian Metz makes the transition from photography to cinema. Indeed, Metz verges upon using Peirce's concepts, mediated to him through the work of André Martinet.

A close-up of a revolver does not signify 'revolver' (a purely potential lexical unit) – but signifies *as a minimum*, leaving aside its connotations, 'Here is a revolver.' It carries with it its own actualisation, a kind of 'Here is' ('*Voici*': the very word which André Martinet considers to be a pure index of actualisation).

It is curious that Metz, in his voluminous writings, does not lay much greater stress on the analysis of this aspect of the cinema, since he is extremely hostile to any attempt to see the cinema as a symbolic process which refers back to a code. In fact, obscured beneath his semiological analysis is a very definite and frequently overt aesthetic *parti pris*. For, like Barthes and Saussure, he perceives only two modes of existence for the sign, natural and cultural. Moreover, he is inclined to see these as mutually exclusive, so that a language must be either natural or cultural, uncoded or coded. It cannot be both. Hence Metz's view of the cinema turns out like a curious inverted mirror image of Noam Chomsky's view of verbal language; whereas Chomsky banishes the ungrammatical into outer darkness, Metz banishes the grammatical. The work of Roman Jakobson, influenced by Peirce, is, as we shall see, a corrective to both these views. The cinema contains all three modes of the sign: indexical, iconic and symbolic. What has always happened is that theorists of the cinema have seized on one or other of these dimensions and used it as the ground for an aesthetic firman. Metz is no exception.

In his aesthetic preferences, Metz is quite clearly indebted to André Bazin, the most forceful and intelligent protagonist of 'realism' in the cinema. Bazin was one of the founders of *Cahiers du cinéma* and wrote frequently in

Esprit, the review founded by Emmanuel Mounier, the Catholic philosopher, originator of Personalism and the most important intellectual influence on Bazin. Many people have commented on the way in which Bazin modelled his style, somewhat abstruse, unafraid of plunging into the problems and terminology of philosophy, on that of Mounier. Bazin became interested in the cinema during his military service at Bordeaux in 1939. After his return to Paris he organised, in collaboration with friends from *Esprit*, clandestine film shows; during the German Occupation he showed films such as Fritz Lang's *Metropolis* and the banned works of Chaplin. Then, after the Liberation, he became one of the dominant figures in orienting the fantastic efflorescence of cinema culture which grew up in the clubs, in Henri Langlois's magnificent Cinémathèque, in the commercial cinemas, where American films once again reappeared. During this time, perhaps most important of all, Bazin developed his aesthetics of the cinema, an aesthetics antithetical to the 'pure cinema' of Delluc and the 'montage' theory of Malraux's celebrated article in *Verve*. A new direction was taken.

Bazin's starting point is an ontology of the photographic image. His conclusions are remarkably close to those of Peirce. Time and again Bazin speaks of photography in terms of a mould, a death-mask, a Veronica, the Holy Shroud of Turin, a relic, an imprint. Thus Bazin speaks of 'the lesser plastic arts, the moulding of death-masks for example, which likewise involves a certain automatic process. One might consider photography in this sense as a moulding, the taking of an impression, by the manipulation of light.' Thus Bazin repeatedly stresses the existential bond between sign and object which, for Peirce, was the determining characteristic of the indexical sign. But whereas Peirce made his observation in order to found a logic, Bazin wished to found an aesthetic. 'Photography affects us like a phenomenon in nature, like a flower or a snowflake whose vegetable or earthly origins are an inseparable part of their beauty.' Bazin's aesthetic asserted the primacy of the object over the image, the primacy of the natural world over the world of signs. 'Nature is always photogenic': this was Bazin's watchword.

Bazin developed a bipolar view of the cinema. On the one hand was Realism ('The good, the true, the just', as Godard was later to say of the work of Rossellini); on the other hand was Expressionism, the deforming

intervention of human agency. Fidelity to nature was the necessary touchstone of judgment. Those who transgressed, Bazin denounced: Fritz Lang's *Die Nibelungen*, *The Cabinet of Dr Caligari*. He recognised the Wagnerian ambitions of Eisenstein's *Ivan the Terrible* and wrote: 'One can detest opera, believe it to be a doomed musical genre, while still recognising the value of Wagner's music.' Similarly, we may admire Eisenstein, while still condemning his project as 'an aggressive return of a dangerous aestheticism'. Bazin found the constant falsification in *The Third Man* exasperating. In a brilliant article he compared Hollywood to the court at Versailles and asked where was its *Phèdre?* He found the answer, justly, in Charles Vidor's *Gilda*. Yet even this masterpiece was stripped of all 'natural accident'; an aesthetic cannot be founded on an 'existential void'.

In counterposition to these recurrent regressions into Expressionism, Bazin postulated a triumphal tradition of Realism. This tradition began with Feuillade, spontaneously, naïvely, and then developed in the 1920s in the films of Flaherty, Stroheim and Murnau, whom Bazin contrasted with Eisenstein,

Fritz Lang's *Die Nibelungen*; *The Cabinet of Dr Caligari*

Kuleshov and Gance. In the 1930s the tradition was kept alive principally by Jean Renoir. Bazin saw Renoir stemming from the tradition of his father, that of French Impressionism. Just as the French Impressionists – Manet, Degas, Bonnard – had reformulated the place of the picture frame in pictorial composition, under the influence of the snapshot, so Renoir *fils* had reformulated the place of the frame in cinematic composition. In contrast to Eisenstein's principle of montage, based on the sacrosanct close-up, the significant image centred in the frame, he had developed what Bazin called *re-cadrage* ('re-framing'): lateral camera movements deserted and recaptured a continuous reality. The blackness surrounding the screen masked off the world rather than framed the image. In the 1930s Jean Renoir alone

> forced himself to look back beyond the resources provided by montage and so uncover the secret of a film form that would permit everything to be said without chopping the world up into little fragments, that would reveal the hidden meanings in people and things without disturbing the unity natural to them.

In the 1940s the Realist tradition reasserted itself, though divided between two different currents. The first of these was inaugurated by *Citizen Kane* and continued in the later films of Welles and Wyler. Its characteristic feature was the use of deep focus. By this means, the spatial unity of scenes could be maintained, episodes could be presented in their physical entirety. The second current was that of Italian Neo-realism, whose cause Bazin espoused with especial fervour. Above all, he admired Rossellini. In Neo-realism Bazin recognised fidelity to nature, to things as they were. Fiction was reduced to a minimum. Acting, location, incident: all were as natural as possible. Of *Bicycle Thieves* Bazin wrote that it was the first example of pure cinema. No more actors, no more plot, no more *mise en scène*: the perfect aesthetic illusion of reality. In fact, no more cinema. Thus the film could obtain radical purity only through its own annihilation. The mystical tone of this kind of argument reflects, of course, the curious admixture of Catholicism and Existentialism which had formed Bazin. Yet it also develops logically from an aesthetic which stresses the passivity of the natural world rather than the agency of the human mind.

Pre-war realism: (top) Von Stroheim's *Greed*; Murnau's *City Girl*

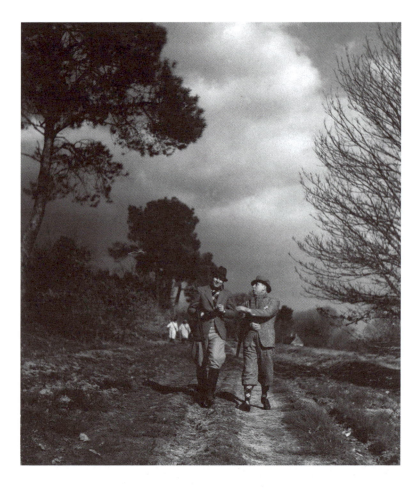

Bazin hoped that the two currents of the Realist tradition – Welles and Rossellini – would one day reconverge. He felt that their separation was due only to technical limitations: deep focus required more powerful lighting than could be used on natural locations. But when Visconti's *La terra trema* appeared, a film whose style was for the first time the same 'both *intra* and *extra muros*', the most Wellesian of Neo-realist films, nevertheless Bazin was

Renoir's *La Règle du jeu*

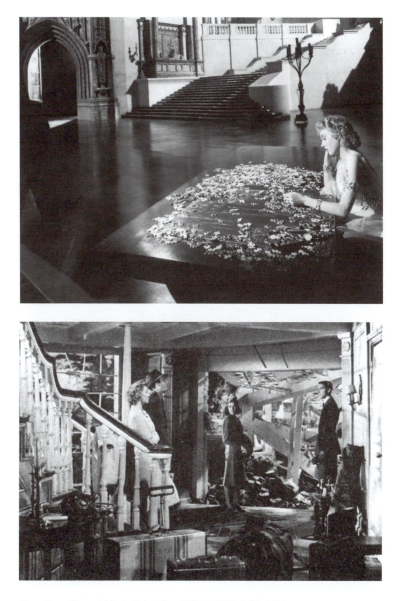

Deep focus: Orson Welles's *Citizen Kane*; William Wyler's *Mrs Miniver*

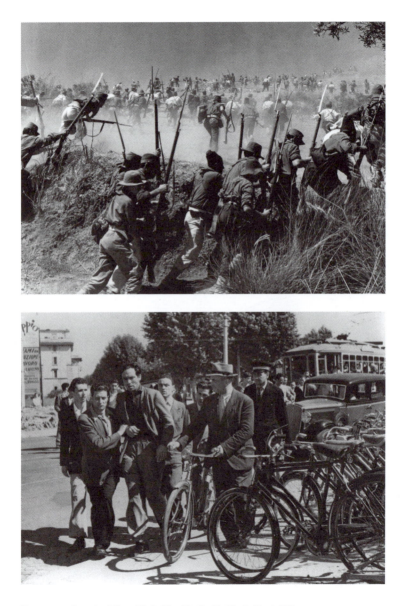

Post-war realism: (top) Rossellini's *Viva L'Italia*; De Sica's *Bicycle Thieves*

disappointed. The synthesis, though achieved, lacked fire and 'affective eloquence'. Probably Visconti was too close to the opera, to Expressionism, to be able to satisfy Bazin. But in the late 1940s and 50s his concept of Realism did develop a step further, towards what, in a review of *La strada*, he was to call 'realism of the person' ('de la personne'). The echo of Mounier was not by chance. Bazin was deeply influenced by Mounier's insistence that the interior and the exterior, the spiritual and the physical, the ideal and the material, were indissolubly linked. He reoriented the philosophical and socio-political ideas of Mounier and applied them to the cinema. Bazin broke with many of the Italian protagonists of Neo-realism when he asserted that 'Visconti is Neo-realist in *La terra trema* when he calls for social revolt and Rossellini is Neo-realist in the *Fioretti*, which illustrates a purely spiritual reality'. In Bresson's films Bazin saw 'the outward revelation of an interior density', in those of Rossellini 'the presence of the spiritual' is expressed with 'breath-taking obviousness'. The exterior, through the transparence of images stripped of all inessentials, reveals the interior. Bazin emphasised the importance of physiognomy, upon which – as in the films of Dreyer – the interior spiritual life was etched and printed.

Bazin believed that films should be made, not according to some *a priori* method or plan, but, like those of Rossellini, from 'fragments of raw reality, multiple and equivocal in themselves, whose meaning can only emerge *a posteriori* thanks to other facts, between which the mind is able to see relations'. Realism was the vocation of the cinema, not to signify but to reveal. Realism, for Bazin, had little to do with mimesis. He felt that cinema was closer to the art of the Egyptians which existed, in Panofsky's words, 'in a sphere of magical reality' than to that of the Greeks 'in a sphere of aesthetic ideality'. It was the existential bond between fact and image, world and film, which counted for most in Bazin's aesthetic, rather than any quality of similitude or resemblance. Hence the possibility – even the necessity – of an art which could reveal spiritual states. There was for Bazin a double movement of impression, of moulding and imprinting: first, the interior spiritual suffering was stamped upon the exterior physiognomy; then the exterior physiognomy was stamped and printed upon the sensitive film.

It would be difficult to overestimate the impact of Bazin's aesthetic. His influence can be seen in the critical writing of Andrew Sarris in the United

States, in the theories of Pier Paolo Pasolini in Italy, in Charles Barr's lucid article on CinemaScope (published in *Film Quarterly*, Summer 1963, but written in England), in Christian Metz's articles in *Communications* and *Cahiers du cinéma*. That is to say, all the most important writing on cinema in the last ten or twenty years has, by and large, charted out the course first set by Bazin. For all these writers Rossellini occupies a central place in film history. 'Things are there. Why manipulate them?' For Metz, Rossellini's question serves as a kind of motto; Rossellini, through his experience as a film-maker, had struck upon the same truth that the semiologist achieved by dint of scholarship. Both Metz and Barr contrast Rossellini with Eisenstein, the villain of the piece. They even fall into the same metaphors. Thus Barr, writing of Pudovkin, who is used interchangeably with Eisenstein, describes how he

reminds one of the bakers who first extract the nourishing parts of the flour, process it, and then put back some as 'extra goodness': the result may be eatable, but it is hardly the

Rossellini's *The Flowers of St Francis*

only way to make bread, and one can criticise it for being unnecessary and 'synthetic'. Indeed, one could extend the culinary analogy and say that the experience put over by the traditional aesthetic is essentially a *predigested* one.

And Metz: 'Prosthesis is to the leg as the cybernetic message is to the human phrase. And why not also mention – to introduce a lighter note and a change from Meccano – powdered milk and Nescafé? And all the various kinds of robot?' Thus Rossellini becomes a natural wholemeal director while Eisenstein is an *ersatz*, artificial, predigested. Behind these judgments stands the whole force of Romantic aesthetics: natural versus artificial, organic versus mechanical, imagination versus fancy.

But the Rossellini versus Eisenstein antinomy is not so clear-cut as might appear. First, we should remember that for Bazin it was Expressionism that was the mortal foe: *The Cabinet of Dr Caligari* rather than *Battleship Potemkin* or *October*. And, then, what of a director like Sternberg, clearly in the

Falconetti in Dreyer's *La Passion de Jeanne d'Arc*

Expressionist tradition? 'It is remarkable that Sternberg managed to stylise performances as late into the talkies as he did.' Andrew Sarris's observation immediately suggests that Sternberg must be arrayed against Rossellini. Yet, in the same paragraph, Sarris comments upon Sternberg's eschewal of 'pointless cutting within scenes', his achievements as a 'non-montage director'. This is the same kind of problem that Bazin met with Dreyer, whose work he much admired, including its studio sequences. 'The case of Dreyer's *Jeanne d'Arc* is a little more subtle since at first sight nature plays a nonexistent role.' Bazin found a way out of the dilemma through the absence of make-up. 'It is a documentary of faces. ... The whole of nature palpitates beneath every pore.' But his dyadic model had been dangerously shaken.

The truth is that a triadic model is necessary, following Peirce's trichotomy of the sign. Bazin, as we have seen, developed an aesthetic which was founded upon the indexical character of the photographic image. Metz contrasts this with an aesthetic which assumes that cinema, to be meaningful, must refer back to a code, to a grammar of some kind, that the language of

The Saga of Anatahan: fronds and creepers

cinema must be primarily symbolic. But there is a third alternative. Sternberg was virulently opposed to any kind of Realism. He sought, as far as possible, to disown and destroy the existential bond between the natural world and the film image. But this did not mean that he turned to the symbolic. Instead, he stressed the pictorial character of the cinema; he saw cinema in the light, not of the natural world or of verbal language, but of painting. 'The white canvas on to which the images are thrown is a two-dimensional flat surface. It is not startlingly new, the painter has used it for centuries.' The film director must create his own images, not by slavishly following nature, by bowing to 'the fetish of authenticity', but by imposing his own style, his own interpretation. 'The painter's power over his subject is unlimited, his control over the human form and face despotic.' But 'the director is at the mercy of his camera'; the dilemma of the film director is there, in the mechanical contraption he is compelled to use. Unless he controls it, he abdicates. For 'verisimilitude,

Max Ophuls's *Lola Montès*

whatever its virtue, is in opposition to every approach to art'. Sternberg created a completely artificial realm, from which nature was rigorously excluded (the main thing wrong with *The Saga of Anatahan*, he once said, is that it contained shots of the real sea, whereas everything else was false) but which depended, not on any common code, but on the individual imagination of the artist. It was the iconic aspect of the sign which Sternberg stressed, detached from the indexical in order to conjure up a world, comprehensible by virtue of resemblances to the natural world, yet other than it, a kind of dream world, a heterocosm.

The contrast with Rossellini is striking. Rossellini preferred to shoot on location; Sternberg always used a set. Rossellini avered that he never used a shooting script and never knew how a film would end when he began it; Sternberg cut every sequence in his head before shooting it and never hesitated while editing. Rossellini's films have a rough-and-ready, sketch-like look; Sternberg evidently paid meticulous attention to every detail. Rossellini used amateur actors, without make-up; Sternberg took the star system to its ultimate limit with Marlene Dietrich and revelled in hieratic masks and costumes. Rossellini spoke of the director being patient, waiting humbly and following the actors until they revealed themselves; Sternberg, rather than wishing humbly to reveal the essence, sought to exert autocratic control: he festooned the set with nets, veils, fronds, creepers, lattices, streamers, gauze, in order, as he himself put it, 'to conceal the actors', to mask their very existence.

Yet even Sternberg is not the extreme: this lies in animated film, usually left to one side by theorists of the cinema. But the separation is not clear-cut. Sternberg has recounted how the aircraft in *The Saga of Anatahan* was drawn with pen and ink. He also sprayed trees and sets with aluminium paint, a kind of extension of make-up to cover the whole of nature, rather than the human face alone. In the same way, Max Ophuls painted trees gold and the road red in his masterpiece *Lola Montès*. Alain Jessua, who worked with Ophuls, has described how he took the logical next step forward and, in *Comic Strip Hero*, tinted the film. John Huston made similar experiments. And Jessua also introduced the comic strip into the cinema. There is no reason at all why the photographic image should not be combined with the artificial image, tinted or drawn. This is common practice outside the cinema, in advertising and in

the work of artists such as El Lissitsky, George Grosz and Robert Rauschenberg.

Semiologists have been surprisingly silent on the subject of iconic signs. They suffer from two prejudices: firstly, in favour of the arbitrary and the symbolic, secondly in favour of the spoken and the acoustic. Both these prejudices are to be found in the work of Saussure, for whom language was a symbolic system which operated in one privileged sensory band. Even writing has persistently been assigned an inferior place by linguists who have seen in the alphabet and in the written letter only 'the sign of a sign', a secondary, artificial, exterior sub-system. These prejudices must be broken down. What

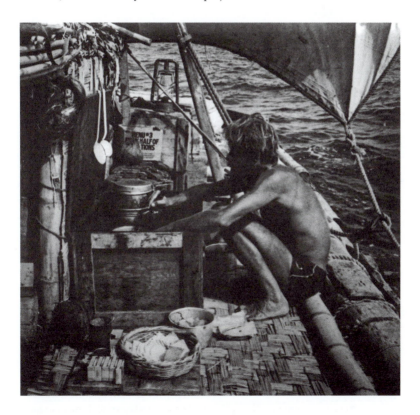

Kon-Tiki

is needed is a revival of the seventeenth-century science of characters, comprising the study of the whole range of communication within the visual sensory band, from writing, numbers and algebra through to the images of photography and the cinema. Within this band it will be found that signs range from those in which the symbolic aspect is clearly dominant, such as letters and numbers, arbitrary and discrete, through to signs in which the indexical aspect is dominant, such as the documentary photograph. Between these extremes, in the centre of the range, there is a considerable degree of overlap, of the coexistence of different aspects without any evident predominance of any one of them.

In the cinema, it is quite clear, indexical and iconic aspects are by far the most powerful. The symbolic is limited and secondary. But from the early days of film there has been a persistent, though understandable, tendency to exaggerate the importance of analogies with verbal language. The main reason for this, there seems little doubt, has been the desire to validate cinema as an art.

Clearly, a great deal of the influence which Bazin has exerted has been due to his ability to see the indexical aspect of the cinema as its essence – in the same way as its detractors – yet, at the same time, celebrate its artistic status. In fact, Bazin never argued the distinction between art and non-art within the cinema; his inclination was to be able to accept anything as art: thus, for example, his praise of documentary films such as *Kon-Tiki* and *Annapurna* which struck him forcefully. Christian Metz has attempted to fill this gap in Bazin's argument, but by no means with striking success. 'In the final analysis, it is on account of its wealth of connotations that a novel of Proust can be distinguished from a cookbook or a film of Visconti from a medical documentary.' Connotations, however, are uncoded, imprecise and nebulous: he does not believe that it would be possible to dissolve them into a rhetoric. In the last resort, the problem of art is the problem of style, of the author, of an idiolect. For Metz aesthetic value is purely a matter of 'expressiveness'; it has nothing to do with conceptual thought. Here again Metz reveals the basic Romanticism of his outlook. In fact, the aesthetic richness of the cinema springs from the fact that it comprises all three dimensions of the sign: indexical, iconic and symbolic. The great weakness of almost all those who have

written about the cinema is that they have taken one of these dimensions, made it the ground of their aesthetic, the 'essential' dimension of the cinematic sign, and discarded the rest. This is to impoverish the cinema. Moreover, none of these dimensions can be discounted: they are co-present. The great merit of Peirce's analysis of signs is that he did not see the different aspects as mutually exclusive. Unlike Saussure he did not show any particular prejudice in favour of one or the other. Indeed, he wanted a logic and a rhetoric which would be based on all three aspects. It is only by considering the interaction of the three different dimensions of the cinema that we can understand its aesthetic effect.

Exactly the same is true of verbal language which is, of course, predominantly a symbolic system. This is the dimension which Saussure illuminated so brilliantly, but to the exclusion of every other. He gave short shrift, for instance, to onomatopoeia. 'Onomatopoeia might be used to prove

Good and bad cowboys: Randolph Scott and Jack La Rue in Henry Hathaway's *To the Last Man*

that the choice of signifier is not always arbitrary. But onomatopoeic formations are never organic elements of a linguistic system. Besides, their number is much smaller than is generally supposed.' In recent years, the balance has been somewhat redressed by Roman Jakobson, who has made persistent efforts to focus attention once again on the work of Peirce. Jakobson has pointed out that, whereas Saussure held that 'signs that are wholly arbitrary realise better than the others the ideal of the semiological process', Peirce believed that in the most perfect of signs the iconic, the indexical and the symbolic would be amalgamated as nearly as possible in equal proportions.

Jakobson has written on several occasions about the iconic and indexical aspects of verbal language. The iconic, for instance, is manifest not only in onomatopoeia, but also in the syntactic structure of language. Thus a sentence like 'Veni, vidi, vici' reflects in its own temporal sequence that of the events which it describes. There is a resemblance, a similitude, between the syntactic order of the sentence and the historic order of the world. Again, Jakobson points out that there is no known language in which the plural is represented by the subtraction of a morpheme whereas, of course, in very many a morpheme is added. He also investigates the role of synaesthesia in language. In a brilliant article, 'Shifters, Verbal Categories, and the Russian Verb', Jakobson discusses the indexical dimensions of language. He focuses particular attention on pronouns, whose meaning – at one level – varies from message to message. This is because it is determined by the particular existential context. Thus when I say 'I', there is an existential bond between this utterance and myself, of which the hearer must be aware to grasp the significance of what is being said. Pronouns also have a symbolic aspect – they denote the 'source' of an utterance, in general terms – which makes them comprehensible on one level, at least, even when the actual identity of the source is unknown. The indexical aspect also comes to the fore in words such as 'here', 'there', 'this', 'that', and so on. Tenses are also indexical; they depend for full intelligibility on knowledge of the point in time at which a message was uttered.

Jakobson has also pointed out how these submerged dimensions of language become particularly important in literature and in poetry. He quotes

The Vamp, Theda Bara

with approval Pope's 'alliterative precept' to poets that 'the sound must seem an Echo of the sense' and stresses that poetry 'is a province where the internal nexus between sound and meaning changes from latent into patent and manifests itself most intensely and palpably'. The same is surely true, *mutatis mutandis*, of the cinema. Unlike verbal language, primarily symbolic, the cinema is, as we have seen, primarily indexical and iconic. It is the symbolic which is the submerged dimension. We should therefore expect that in the 'poetry' of the cinema, this aspect will be manifested more palpably.

In this respect, the iconography of the cinema (which, in Peirce's terms, is not the same as the iconic) is particularly interesting. Metz has minimised the importance of iconography. He discusses the epoch in which good cowboys wore whites shirts and bad cowboys black shirts, only in order to dismiss this incursion of the symbolic as unstable and fragile. Panofsky has also doubted the importance of iconography in the cinema.

Sam Taylor's *My Best Girl*, with Mary Pickford and Buddy Rogers: chequered tablecloth and breakfast coffee

There arose, identifiable by standardised appearance, behaviour and attributes, the well-remembered types of the Vamp and the Straight Girl (perhaps the most convincing modern equivalents of the medieval personifications of the Vices and Virtues), the Family Man and the Villain, the latter marked by a black moustache and walking-stick. Nocturnal scenes were printed on blue or green film. A checkered tablecloth meant, once for all, a 'poor but honest' milieu, a happy marriage, soon to be endangered by the shadows from the past, was symbolised by the young wife's pouring the breakfast coffee for her husband; the first kiss was invariably announced by the lady's gently playing with her partner's necktie and was invariably accompanied by her kicking out her left foot.

But as audiences grew more sophisticated, and particularly after the invention of the talking film, these devices 'became gradually less necessary'. Nevertheless, 'primitive symbolism' does survive, to Panofsky's pleasure, 'in such amusing details as the last sequence of *Casablanca* where the delightfully crooked and right-minded *préfet de police* casts an empty bottle of Vichy water into the waste-paper basket'.

The straight girl, Mary Pickford

In fact, I think, both Metz and Panofsky vastly underestimate the extent to which 'primitive symbolism' does survive, if indeed that is the right word at all, with its hardly muffled condemnation to death. Counter to the old post-Eisenstein overvaluation of the symbolic there has developed an equally strong prejudice *against* symbols. Barthes, for example, has commented on the 'peripheral zone' in which a kernel of rhetoric persists. He cites, as an instance, calendar pages torn away to show the passage of time. But recourse to rhetoric, he feels, means to welcome mediocrity. It is possible to convey 'Pigalle-ness' or 'Paris-ness' with shots of neon, cigarette-girls and so on, or with boulevard cafés and the Eiffel Tower, but for us rhetoric of this kind is discredited. It may still hold good in the Chinese theatre where a complicated code is used to express, say, weeping, but in Europe 'to show one is weeping, one must weep'. And, of course, 'the rejection of convention entails a no less draconian respect for nature'. We are back in familiar territory: cinema is *pseudo-physis*, not *techne*.

New York-ness: Stanley Donen's *On the Town*

Thus Roland Barthes sweeps away the American musical, *It's Always Fair Weather* and *On the Town* condemned to mediocrity by their recourse to rhetoric to convey 'New York-ness'. And what about Hitchcock: *The Birds* or *Vertigo*? The symbolic structure of the ascent and fall in *Lola Montès* or *La Ronde*? Welles? The sharks, the wheelchair, the hall of mirrors in *Lady from Shanghai*? Buñuel? *The Man Who Shot Liberty Valance*? The extraordinary symbolic scenes in the films of Douglas Sirk, *Imitation of Life* or *Written on the Wind*? Eisenstein's peacock is by no means the length and breadth of symbolism in the cinema. It is impossible to neglect this whole rich domain of meaning. Finally, Rossellini: what are we to say of the Vesuvian lovers in *Voyage to Italy*, the record of Hitler's voice playing among the ruins in *Germany Year Zero*, the man-eating tiger in *India*?

At this point, however, we must go forward with caution. Words such as *symbol* carry with them the risk of confusion. We have seen how Saussure's usage is not compatible with Peirce's. For Peirce the linguistic sign is a symbol, in a narrow and scientific sense. For Saussure, the linguistic sign is arbitrary, whereas

Hall of mirrors in Orson Welles's *Lady from Shanghai*

one characteristic of the symbol is that it is never wholly arbitrary; it is not empty, for there is the rudiment of a natural bond between the signifier and the signified. The symbol of justice, a pair of scales, could not be replaced by just any other symbol, such as a chariot.

The confusion has been increased still further by Hjelmslev and the Copenhagen school:

From the linguistic side there have been some misgivings about applying the term *symbol* to entities that stand in a purely arbitrary relationship to their interpretation. From this point of view, *symbol* should be used only of entities that are isomorphic with their interpretation, entities that are depictions or emblems, like Thorwaldsen's *Christ* as a symbol for compassion, the hammer and sickle as a symbol for Communism, scales as a symbol for justice, or the onomatopoetica in the sphere of language.

Hjelmslev, however, chose to use the term in a far broader application; as he put it, games such as chess, and perhaps music and mathematics, are symbolic systems, as opposed to semiotics. He suggested that there was an affinity between isomorphic symbols, such as the hammer and sickle, and the pieces in a game, pawns or bishops. Barthes complicated the issue still more by stressing that symbols had no adequate or exact meaning: 'Christianity "outruns" the cross.'

What should we say about the hammer and sickle, the Christian cross, the scales of justice? First, unlike Hjelmslev, we must distinguish clearly between a depiction or image, as Peirce would say, and an emblem. An image is predominantly iconic. An emblem, however, is a mixed sign, partially iconic, partially symbolic. Moreover, this dual character of the emblematic or allegorical sign can be overtly exploited: Panofsky cites the examples of Dürer's portrait of Lucas Paumgartner as St George, Bronzino's Andrea Doria as Neptune, Reynolds's Lady Stanhope as Contemplation. Emblems are unstable, labile: they may develop into predominantly symbolic signs or fall back into the iconic. Lessing, in the *Laocoön*, saw the problem with great clarity. The symbolic or allegorical, he held, are necessary to painters but redundant to poets, for verbal language, which has priority, is symbolic in itself.

Urania is for the poets the Muse of Astronomy; from her name, from her functions, we recognise her office. The artist in order to make it distinguishable must exhibit her with a pointer and celestial globe, this attitude of hers provides his alphabet from which he helps us to put together the name Urania. But when the poet would say that Urania has long ago foretold his death by the stars – 'Ipsa diu positis letum praedixerat astris Urania' – why should he, thinking of the painter, add thereto, Urania, the pointer in her hand, the celestial globe before her? Would it not be as if a man who can and may speak aloud should at the same time still make use of the signs which the mutes in the Turk's seraglio have invented for lack of utterance?

Lessing described a scale of representations between the purely iconic and the purely symbolic. The bridle in the hand of Temperance and the pillar on which Steadfastness leans are clearly allegorical.

The scales in the hand of Justice are certainly less purely allegorical, because the right use of the scales is really a part of justice. But the lyre or flute in the hand of a Muse, the spear in the hand of Mars, the hammer and tongs in the hand of Vulcan, are not symbols at all, but mere instruments.

Painters should minimise the symbolic – the extreme case, 'the inscribed labels which issue from the mouths of the persons in ancient Gothic pictures', Lessing disapproved of entirely. He looked forward to an art which would be more purely iconic, much more than he ever anticipated: Courbet, the *plein air* painters, the Impressionists. In fact, what happened is that, as the symbolic was ousted, the indexical began to make itself felt. Painters began to be interested in optics and the psychology of perception. Indeed, Courbet sounds strangely like Bazin:

I maintain, in addition, that painting is an essentially concrete art and can only consist of the representation of real and existing things. It is a completely physical language, the words of which consist of all visible objects; an object which is abstract, not visible, non-existent, is not within the realm of painting. ... The beautiful exists in nature and may be encountered in the midst of reality under the most diverse aspects. As soon as it is found there, it belongs to art, or rather, to the artist who knows how to see it there. As soon as

beauty is real and visible, it has its artistic expression from these very qualities. Artifice has no right to amplify this expression; by meddling with it, one only runs the risk of perverting and, consequently, of weakening it. The beauty provided by nature is superior to all the conventions of the artist.

One current in the history of art has been the abandonment of the lexicon of emblems and the turn to nature itself, to the existential contiguity of painter and object which Courbet demanded. At the end of this road lay photography; under its impact painting began to oscillate violently.

The iconic sign is the most labile; it observes neither the norms of convention nor the physical laws which govern the index, neither *thesis* nor *nomos*. Depiction is pulled towards the antinomic poles of photography and emblematics. Both these undercurrents are co-present in the iconic sign; neither can be conclusively suppressed. Nor is it true, as Barthes avers, that the symbolic dimension of the iconic sign is not adequate, not conceptually fixed. To say that 'Christianity "outruns" the cross' is no different in order from saying that Christianity outruns the word Christianity or divinity outruns the mere name of *God*. To see transcendent meaning is the task of the mystic, not the scientist. Barthes is dangerously close to Barth, with his 'impenetrable incognito' of Jesus Christ. There is no doubt that the cross can serve as a phatic signal and as a degenerate index, triggering off an effusive and devout meditation, but this should be radically distinguished from the conceptual content articulated by the symbolic sign.

It is particularly important to admit the presence of the symbolic – hence conceptual – dimension of the cinema because this is a necessary guarantee of objective criticism. The iconic is shifting and elusive; it defies capture by the critic. We can see the problem very clearly if we consider a concrete example: Christian Metz's interpretation of a famous shot from Eisenstein's *Que Viva Mexico!* Metz describes the heads of three peasants who have been buried in the sand, their tormented yet peaceful faces, after they have been trampled upon by the hooves of their oppressors' horses. At the denotative level the image means that they have suffered, they are dead. But there is also a connotative level: the nobility of the landscape, the beautiful, typically Eisensteinian, triangular composition of the shot. At this second level the

image expressed 'the grandeur of the Mexican people, the certainty of final victory, a kind of passionate love which the northerner feels for the sun-drenched splendour of the scene'. The Italian writer on aesthetics, Galvano della Volpe, has argued that this kind of interpretation has no objective validity, that it could never be established and argued like the paraphrasable meaning of a verbal text. There is no objective code; therefore there can only be subjective impressions. Cinema criticism, della Volpe concludes, may exist *de facto*, but it cannot exist *de jure*.

There is no way of telling what an image *connotes* in the sense in which Metz uses the word, even less accurate than its sense in what Peirce called 'J. S. Mills' objectionable terminology.' Della Volpe is right about this. But, like Metz, he too underestimates the possibility of a symbolic dimension in the cinematic message, the possibility, if not of arriving at a *de jure* criticism, at least of approaching it, maximising lucidity, minimising ambiguity. For the cinematic sign, the language or semiotic of cinema, like the verbal language,

Jean-Luc Godard: *Made in U.S.A.*

comprises not only the indexical and the iconic, but also the symbolic. Indeed, if we consider the origins of the cinema, strikingly mixed and impure, it would be astonishing if it were otherwise. Cinema did not only develop technically out of the magic lantern, the daguerreotype, the phenakistoscope and similar devices – its history of Realism – but also out of strip-cartoons, Wild West shows, automata, pulp novels, barnstorming melodramas, magic – its history of the narrative and the marvellous. Lumière and Méliès are not like Cain and Abel; there is no need for one to eliminate the other. It is quite misleading to validate one dimension of the cinema unilaterally at the expense of all the others. There is no pure cinema, grounded on a single essence, hermetically sealed from contamination.

This explains the value of a director like Jean-Luc Godard, who is unafraid to mix Hollywood with Kant and Hegel, Eisensteinian montage with Rossellinian Realism, words with images, professional actors with historical people, Lumière with Méliès, the documentary with the iconographic. More than anybody else Godard has realised the fantastic possibilities of the cinema as a medium of communication and expression. In his hands, as in Peirce's perfect sign, the cinema has become an almost equal amalgam of the symbolic, the iconic and the indexical. His films have conceptual meaning, pictorial beauty and documentary truth. It is no surprise that his influence should proliferate among directors throughout the world. The film-maker is fortunate to be working in the most semiologically complex of all media, the most aesthetically rich. We can repeat today Abel Gance's words four decades ago: 'The time of the image has come.'

Conclusion (1972)

Looking back over this book, even after a short distance of time, it strikes me that it was written at the beginning of a transitional period which is not yet over. What marks this period, I think, is the delayed encounter of the cinema with the 'modern movement' in the arts. The great breakthroughs in literature, painting and music, the hammer-blows which smashed (or should have smashed) traditional aesthetics, took place in the years before the First World War, at a time when the cinema was in its infancy, a novelty in the world of vaudeville, peepshows and nickelodeons. This was the period of the first abstract paintings, the first sound poems, the first noise bands. It was also the period when the idea of semiology was launched by Saussure in his Geneva Course and when Freud was making the most important of his discoveries. Precisely because the cinema was a new art, it took time for any of this to have an effect on it.

The first impact of the 'modern movement' on the cinema took place in the 1920s. The clearest example of this, of course, is Eisenstein. At the same time there was the work of the Parisian avant-garde – Léger, Man Ray, Buñuel – and of abstract film-makers like Eggeling and Richter. In Germany Expressionism fed into the cinema in the form of 'Caligarism', mainly under Eric Pommer's patronage. But looking back on it, we can see how superficial this first contact was and how it was completely obliterated during the 1930s. In Russia, socialist realism was launched and the avant-garde cinema of the 1920s cut short. In Germany, Pommer lost control of UFA after the financial disaster of *Metropolis* and soon, in any case, the Nazi regime was in power. The early experiments of

Léger or Richter petered out. Buñuel went his own way. Fischinger was working for Disney in the 1930s; Moholy-Nagy for Korda. If there was any kind of avant-garde in this period, it was to be found in the documentary movement, certainly the most conservative avant-garde imaginable.

The rise of the sound film and the rapid expansion of American economic and political power after the war led to the domination of Hollywood throughout most of the world. It is in this context that a director like Orson Welles could appear as an innovator, a dangerous experimentalist, Rossellini as a revolutionary, Humphrey Jennings a poet. Today these estimations seem absurd. There has been a complete change, a revaluation, a shift of focus which had made cinema history into something different. Eisenstein or Vertov look contemporary instead of antique. Welles or Jennings look hopelessly old-fashioned and dated. Yet this change has been very recent and its full effects are still to be felt. All the old landmarks are disappearing in the mists of time.

What has happened? Really, two things. First, the rise of the underground, particularly in America. This was a product of three factors: poets and painters taking up film-making, the arrival of European avant-garde artists like Richter as refugees, the peeling off of mavericks from Hollywood. There was also a crucial economic precondition: the availability of equipment and money to buy it. In the context of the underground, film-making was seen as an extension of the other arts. There was no attempt to compete with Hollywood by making feature films (except, as with Curtis Harrington, by becoming a Hollywood director). It took some time before the underground began to get into the cinemas, in fact only in the last few years when Warhol films began to bite into the sexploitation field. But it was more and more obvious that it was there to stay.

The second key development was the way that the French New Wave evolved, pushing back the conventional frontiers of the 'art' cinema. Godard has had an incalculable effect, and it was only right that this book should have built up towards a paean of praise for his films and an eager anticipation of what was to come. At the time I was writing, *Weekend* was the last Godard movie I had seen. It is now much clearer what the effect of May 1968 was on Godard. His films have increasingly been, so to speak, both politicised and

semiologised. It is difficult not to think of directors like Makavejev, Skolimowski, Bertolucci, Kluge, Glauber Rocha and so on, simply as post-Godard directors. Yet none of them have gone the whole way with him, and some have tended to retreat from the adventurousness of their own early 'Godardian' work.

It seems to me now that I was wrong in what I expected of Godard. 'More than anybody else Godard has realised the fantastic possibilities of the cinema as a medium of communication and expression. In his hands, as in Peirce's perfect sign, the cinema has become an almost equal amalgam of the symbolic, the iconic and the indexical. His films have conceptual meaning, pictorial beauty and documentary truth.' In a sense, the programme I was outlining has been fulfilled, but more by others than by Godard. A film like Makavejev's *WR – Mysteries of the Organism* exploits the full semiological possibilities of film in its blend of documentary, *vérité*, library clips, Hollywood, montage, etc. But thinking back on it, credit for this should go to Kenneth Anger's *Scorpio Rising*, rather than to Godard. Anger was the first film-magician in this sense (*WR* can almost be read out of *Scorpio Rising* by substituting Crowley for Reich and Jesus Christ for Stalin). It is obvious now that what concerned Godard was an interrogation of the cinema rather than a fulfilment of its potential.

It is necessary at this point to make a digression, to sketch in the background against which Godard is working and against which the 'modern movement' in the other arts also emerged. The twentieth century witnessed an assault on traditional art and aesthetics which laid the foundations for a revolutionary art which has not yet been consolidated. It is possible that this consolidation cannot take place independently, apart from the movement of society and of politics. The heroic first phase of the avant-garde in the arts coincided, after all, with the political phase which led from 1905 to the October Revolution; Godard's films are clearly linked with the political upheavals which reached a climax in Europe in May 1968. But it is nevertheless possible, on a theoretical level, to try to explain what this potential break with the past involved, would involve if it were to be carried through. This raises problems about the nature of art, its place in intellectual production, the ideology and philosophy which underpin it.

Signs and meanings: contemporary western thought, like its forerunners, sees the problem predominantly one way. Signs are used to communicate meanings between individuals. An individual constructs a message in his mind, a complex of meaning, an idea or thought process, which he wishes to convey to someone else. Both individuals possess a common code or grammar which they have learned. Through the agency of this code, the first individual, the source, maps his message on to, for instance, its verbal representation, a sequence. He then re-maps this sentence on to a signal, a sequence of sounds which give it a physical form, and transmits this signal through a channel. It is picked up by the second individual, the receiver, who then decodes the signal and thus obtains the original message. An idea has been transferred from one mind to another. There is some disagreement among scholars about whether the original message is articulated in words or in some kind of non-articulated thought process (the problem of semantics) but, given this reservation, the model outlined above holds good for most contemporary linguistics and semiotics: Weaver and Shannon, Jakobson, Chomsky, Prieto and their followers.

The common assumption of all these various views is that language, or any other system of transmitted signals, is an instrument, a tool. This assumption is quite explicit in Jakobson, for instance: 'These efforts [of the Prague School) proceed from a universally recognised view of language as a tool of communication.' Or the British linguist, Halliday: 'Language serves for the expression of "content": that is, of the speaker's expression of the real world, including the inner world of his own consciousness. We may call this the ideational function.' And Prieto: 'the instruments which are called signals and whose function consists of the transmission of messages. ... These instruments permit man to exercise an influence on his environment: in this case, this involves the transmission of messages to other members of the social group.' Or, to strike out in a different direction, Stalin:

Language is a medium, an instrument with the help of which people communicate with one another, exchange thoughts and understand each other. Being directly connected with thought, language registers and fixes in words, and in words combined into sentences, the result of thought and man's successes in his quest for knowledge, and thus makes possible the exchange of ideas in human society.

Both Jakobson and Halliday note additional functions of language, but both regard themselves primarily as 'functionalist' in approach. Prieto uses the term 'utilitarian' rather than 'functional' but the drift is the same.

Clearly this model of language rests on the notion of the thinking mind or consciousness which controls the material world. Matter belongs to the realm of instrumentality; thus, the consciousness makes use of the material signal as a tool. Behind every material signal is an ideal message, a kind of archi-signal. In essence, this view is a humanised version of the old theological belief that the material world as a whole comprised a signal which, when decoded, would reveal the message of the divine Logos. Like verbal language the material world was inadequate to express the Logos fully (it remained ineffable) but it could give a partial idea of the deity, who was, so to speak, pure Message. At the time of the Enlightenment, God was no longer envisaged as the author of the great book of the world, but the same semiotic model was transferred to human communication. Artists, in particular, were seen as quasi-divine authors who created a world in their imagination which they then expressed externally. Within a Romantic aesthetic, the signals were taken as symbols, to be decoded not by applying a common code but by intuition and empathy, projection into the artist's inner world. Porphyry's 'wise Theology wherein man indicated God and Divine Powers by images akin to sense and sketched invisible things in visible forms' was echoed in Coleridge's description of a symbol as characterised 'above all, by the translucence of the eternal through and in the temporal'. Within Classical aesthetics signals remained made up of conventional counters or tokens, as the Romantics contemptuously dubbed them.

In criticism, it was the Classical view which prevailed, not surprisingly, since Romanticism saw no need for critics. The function of criticism was seen as clarifying the decoding of signals in order to restore the original message as fully as possible. This was necessary because artistic messages were usually very complex, the signals were often ambiguous and a knowledge of the situation of the source, culturally and socially, could be helpful towards deciding on the most satisfactory decoding. Criticism thus comes to posit a 'content' of works of art, not immediately obvious from a rapid perusal of the work itself. Much might be missed by the casual or unsophisticated reader,

which the critic could point out. Basically, there was one correct decoding, as though the work of art was the Rosetta Stone. Within a Romantic or symbolic aesthetic, on the other hand, decoded intuitively, there could be no 'right answer'; it was all a matter of sensitivity, of spiritual attunement, so that criticism ended up with Walter Pater's mood-recreations. Within the Classical model, as Positivism gained strength, the 'content' of the work was interpreted not as a body of ideas or experiences, but as the expression of the artist's racial or geographical or social situation. Thus Taine's 'milieu' or the 'class background' of Positivist Marxists. Another tradition saw content in terms of moral stance. Of course, a number of critics have always confused the different positions, switching from technical expertise to mystical intuition at will.

One of the main effects of the 'modern movement' was to discredit the ideas of 'intention' and of 'content'. An artist like Duchamp for example stressed the impersonality of the work, the role of chance and parody, and even left works deliberately unfinished. The Surrealists produced automatic writing; any number of modern artists stressed the importance of 'form'. The really important breakthrough, however, came in the rejection of the traditional idea of a work as primarily a representation of something else, whether an idea or the real world, and the concentration of attention on the text of the work itself and on the signs from which it was constructed. This was not exactly the same thing as 'abstraction' or 'formalism' though it was easily confused with it. An 'abstract' artist like Kandinsky for example saw himself as expressing spiritual realities, which could be grasped only through pure form. Kandinsky was really the end-product of Symbolism. The same kind of aesthetic was developed by Hulme in England, who saw abstract art as representing timeless, supra-historical values, in contrast with the history-bound, man-centred figurative art of the Renaissance and Romanticism.

The 'modern movement' made it possible for the artist to interrogate his own work for the first time, to see it as problematic; to put in the forefront the material character of the work. Again, this could easily slide into a kind of mystical naturalism, in which an artefact was equated with a natural object like a tree, thus seeking to eradicate its status as a sign entirely. Or, on the other hand, it could lead towards technicians, concentrating on the material aspects

of art simply to perfect the work as an instrument. In a sense, modern art was searching for a semiology which would enable it to break with the Renaissance tradition, but which had still to be elaborated, and perhaps could not be elaborated until the need for it was felt. The aesthetic and 'philosophical' background to most of the works of the avant-garde was a dismal mixture of theosophy, Worringer, Frazer, bits of Bergson, even Bradley, and so on. The only exception to this is to be found in the early collaboration between the Russian linguists and Futurist poets. And later, of course, the Surrealists made an effort to understand Freud.

What was (and still is) needed was a semiology which reversed and transformed the usual terms of its problematic, which stopped seeing the signal, the text, as a means, a medium existing between human beings and the truth or meaning, whether the idealist transcendent truth of the Romantics or the immanent intentional meaning of the Classical aesthetic. Thus a text is a material object whose significance is determined not by a code external to it, mechanically, nor organically as a symbolic whole, but through its own interrogation of its own code. It is only through such an interrogation, through such an interior dialogue between signal and code, that a text can produce spaces within meaning, within the otherwise rigid straitjacket of the message, to produce a meaning of a new kind, generated within the text itself. To point out a parallel: this would be as if the dialogue of Freudian psychoanalysis, segregated as it is between the space of the signal (analysand) and that of the code (analyst), were to be compressed and condensed within one single space, that of the text.

The ideological effects of such a recasting of the semiological foundations of art would be of the utmost importance. It would situate the consciousness of the reader or spectator no longer outside the work as receiver, consumer and judge, but force him to put his consciousness at risk within the text itself, so that he is forced to interrogate his own codes, his own method of interpretation, in the course of reading, and thus to produce fissures and gaps in the space of his own consciousness (fissures and gaps which exist in reality but which are repressed by an ideology, characteristic of bourgeois society, which insists on the 'wholeness' and integrity of each individual consciousness). All previous aesthetics have accepted the

universality of art founded either in the universality of 'truth' or of 'reality' or of 'God'. The modern movement for the first time broke this universality into pieces and insisted on the singularity of every act of reading a text, a process of multiple decodings, in which a shift of code meant going back over signals previously 'deciphered' and vice versa, so that each reading was an open process, existing in a topological rather than a flat space, controlled yet inconclusive.

Classical aesthetics always posited an essential unity and coherence to every work, which permitted a uniform and exhaustive decoding. Modernism disrupts this unity; it opens the work up, both internally and externally, outwards. Thus there are no longer separate works, monads, each enclosed in its own individuality, a perfect globe, a whole. It produces works which are no longer centripetal, held together by their own centres, but centrifugal, throwing the reader out of the work to other works.

Thus, in the past, the difficulty of reading was simply to find the correct code, to clear up ambiguities or areas of ignorance. Once the code was known reading became automatic, the simultaneous access to the mind of signal and 'content', that magical process whereby ideas shone through marks on paper to enter the skull through the windows of the eyes. But Modernism makes reading difficult in another sense, not to find the code or to grasp the ideas, the 'content', but to make the process of decoding itself difficult, so that to read is to work. Reading becomes problematic; the 'content' is not attached to the signal (so closely attached as to be inseparable from it) by any bond; it is deliberately, so to speak, detached, held in suspension, so that the reader has to play his own part in its production. And, at the same time, the text, through imposing this practice of reading, disrupts the myth of the reader's own receptive consciousness. No longer an empty treasure house waiting to receive its treasure, the mind becomes productive. It works. Just as the author no longer 'finds' the words, but must 'produce' a text, so the reader too must work within the text. The old image of the reader as consumer is broken.

The text is thus no longer a transparent medium; it is a material object which provides the conditions for the production of meaning, within constraints which it sets itself. It is open rather than closed; multiple rather than single; productive rather than exhaustive. Although it is produced by an

individual, the author, it does not simply represent or express the author's ideas, but exists in its own right. It is not an instrument of communication but a challenge to the mystification that communication can exist. For inter-personal communication, it substitutes the idea of collective production; writer and reader are indifferently critics of the text and it is through their collaboration that meanings are collectively produced. At the same time, these 'meanings' have effects; just as the text, by introducing its own decoding procedures, interrogates itself, so the reader too must interrogate himself, puncture the bubble of his consciousness and introduce into it the rifts, contradictions and questions which are the problematic of the text.

The text then becomes the location of thought, rather than the mind. The text is the factory where thought is at work, rather than the transport system which conveys the finished product. Hence the danger of the myths of clarity and transparency and of the receptive mind; they present thought as a pre-packaged, available, given, from the point of view of the consumer. Whereas the producer of thought is then envisaged as the traditional philosopher, whose thought is the function of a pure consciousness, pure mental activity, externalised for others only when completed. It is to preserve this myth that notebooks and drafts are so rigidly separated from final versions, so that the process of thought as a dialectic of writing and reading (in the case even of 'individual' thought, as a dialogue with oneself) is obscured and is presented as an internal affair made public only when finished. In addition, drafts and notes, when they are made public, are seen as the raw material, itself still partly inchoate and incoherent, out of which the final, coherent version is fashioned. Thus incompatible elements have to be made compatible, and it is this general compatibility and consequentiality which marks the completion of a work. Within a Modernist view, however, all work is work in progress, the circle is never closed. Incompatible elements in a text should not be ironed out but confronted.

This is the context in which Godard's films should be seen. Godard's work represents a continual examination and re-examination of the premises of film-making accepted by film-maker and by spectator. It is not simply a question of the juxtaposition of different styles or of different 'points of view', but of the systematic challenging of the assumptions underlying the

adoption of a style or a point of view. In Godard's earliest films the narrative and dramatic structure are taken for granted, but the characters in the films question each other about the codes they use, about the sources of misunderstanding and incomprehension. Then, as his career continued, he began more and more to question, not the interpersonal communication of the characters, but the communication represented by the film itself. Finally, he began to conceive of making a film, not as communicating at all, but as producing a text in which the problems of film-making were themselves raised. This is as political an aspect of Godard's cinema as the overtly political debate and quotation which also take place in it. For it is precisely by making things 'difficult' for the spectator in this way, by breaking up the flow of his films, that Godard compels the spectator to question himself about how he looks at films, whether as a passive consumer and judge outside the work, accepting the code chosen by the director, or whether within the work as a participant in a dialogue.

Godard's work is particularly important for the cinema because there, more perhaps than in any other art form, semiological mystification is possible. This is because of the predominantly indexical-iconic character of most films and the 'illusion of reality' which the cinema provides. The cinema seems to fulfil the age-old dream of providing a means of communication in which the signals employed are themselves identical or near-identical with the world which is the object of thought. Reality is, so to speak, filtered and abstracted in the mind, conceptualised, and then this conceptualisation of reality is mapped on to signals which reflect the original reality itself, in a way which words, for instance, can never hope to match. Thus the cinema is seen to give world-views in the literal sense of the term, world-conceptions which are literally word-pictures. The dross filtered out of the sensuous world by the process of abstraction and thought is restored in the process of communication. Hence the immense attraction of Realist aesthetics for theorists of the cinema.

For Realist aesthetics, the cinema is the privileged form which is able to provide both appearance and essence, both the actual look of the real world and its truth. The real world is returned to the spectator purified by its traverse through the mind of the artist, the visionary who both sees and shows. Non-

Realist aesthetics, as is pointed out elsewhere in this book, are accused of reducing or dehydrating the richness of reality; by seeking to make the cinema into a conventional medium they are robbing it of its potential as an alternative world, better, purer, truer, and so on. In fact, this aesthetic rests on a monstrous delusion: the idea that truth resides in the real world and can be picked out by a camera. Obviously, if this were the case, everybody would have access to the truth, since everybody lives all their life in the real world. The Realism claim rests on a sleight of hand: the identification of authentic experience with truth. Truth has no meaning unless it has explanatory force, unless it is knowledge, a product of thought. Different people may experience the fact of poverty, but can attribute it to all kinds of different causes: the will of God, bad luck, natural dearth, capitalism. They all have a genuine experience of poverty, but what they know about it is completely different. It is the same with sunshine: everybody has experienced it but very few know anything scientifically about the sun. Realism is in fact, as it was historically, an outgrowth of Romanticism, typically Romantic in its distrust of or lack of interest in scientific knowledge.

Besides Realism, the other main current in film theory has been the attempt to import into the cinema a traditional Romantic concept of the artist, the privileged individual with the faculty of imagination. Basically, the concept of imagination was the short cut by which Romantic writers on aesthetics crammed the classical duality of thought plus expression, reason plus rhetoric, into one copious portmanteau. The imagination produced not concepts plus similes, but metaphors which fused concept and simile into a whole. Thus the artist in the cinema is able to produce visual metaphors, in which the act of thought and the act of filming are simultaneous and inseparable. This idea of the imaginative artist makes it possible to go beyond the old distinction of scriptwriter and director which divorced composition from execution. One of the problems that had always faced film aesthetics was how to get round this awkward division, which made it impossible to see a film as the creation of a single subjectivity. Gradually, in the acknowledged 'art' cinema first of all, the gap was bridged and the director was acknowledged to be the imaginative artist. A few critics, attached to the idea of the priority of the scriptwriter and of composition before execution, have held out against

this trend, but not with much success. While it is possible to argue that the composer of a musical score envisages every note auditorily or that the writer of a play has an idea of how it should be performed inherent in the text, because of the primacy of words in the bourgeois theatre, it is difficult to argue along similar lines about the scriptwriter.

At this point, it is necessary to say something about the auteur theory since this has often been seen as a way of introducing the idea of the creative personality into the Hollywood cinema. Indeed, it is true that many protagonists of the auteur theory do argue in this way. However, I do not hold this view and I think it is important to detach the auteur theory from any suspicion that it simply represents a 'cult of personality' or apotheosis of the director. To my mind, the auteur theory actually represents a radical break with the idea of an 'art' cinema, not the transplant of traditional ideas about 'art' into Hollywood. The 'art' cinema is rooted in the idea of creativity and the film as the expression of an individual vision. What the auteur theory argues is that any film, certainly a Hollywood film, is a network of different statements, crossing and contradicting each other, elaborated into a final 'coherent' version. Like a dream, the film the spectator sees is, so to speak, the 'film façade', the end-product of 'secondary revision', which hides and masks the process which remains latent in the film 'unconscious'. Sometimes the 'façade' is so worked over, so smoothed out, or else so clotted with disparate elements, that it is impossible to see beyond it, or rather to see anything in it except the characters, the dialogue, the plot, and so on. But in other cases, by a process of comparison with other films, it is possible to decipher, not a coherent message or world-view, but a structure which underlies the film and shapes it, gives it a certain pattern of energy cathexis. It is this structure which auteur analysis disengages from the film.

The structure is associated with a single director, an individual, not because he has played the role of artist, expressing himself or his own vision in the film, but because it is through the force of his preoccupations that an unconscious, unintended meaning can be decoded in the film, usually to the surprise of the individual involved. The film is not a communication, but an artefact which is unconsciously structured in a certain way. Auteur analysis does not consist of retracing a film to its origins, to its creative source. It

consists of tracing a structure (not a message) within the work, which can then *post factum* be assigned to an individual, the director, on empirical grounds. It is wrong, in the name of a denial of the traditional idea of creative subjectivity, to deny any status to individuals at all. But Fuller or Hawks or Hitchcock, the directors, are quite separate from 'Fuller' or 'Hawks' or 'Hitchcock', the structures named after them, and should not be methodologically confused. There can be no doubt that the presence of a structure in the text can often be connected with the presence of a director on the set, but the situation in the cinema, where the director's primary task is often one of co-ordination and rationalisation, is very different from that in the other arts, where there is a much more direct relationship between artist and work. It is in this sense that it is possible to speak of a film auteur as an un-conscious catalyst.

However, the structures discerned in the text are often attacked in another way. Robin Wood, for example, has argued that the 'auteur' film is something like a Platonic Idea. It posits a 'real' film, of which the actual film is only a flawed transcript, while the archi-film itself exists only in the mind of the critic. This attack rests on a misunderstanding. The main point about the Platonic Idea is that it predates the empirical reality, as archetype. But the 'auteur' film (or structure) is not an archi-film at all in this sense. It is an explanatory device which specifies partially how any individual film works. Some films it can say nothing or next to nothing about at all. Auteur theory cannot simply be applied indiscriminately. Nor does an auteur analysis exhaust what can be said about any single film. It does no more than provide one way of decoding a film, by specifying what its mechanics are at one level. There are other kinds of code which could be proposed, and whether they are of any value or not will have to be settled by reference to the text, to the films in question.

Underlying the anti-Platonic argument, however, there is often a hostility towards any kind of explanation which involves a degree of distancing from the 'lived experience' of watching the film itself. Yet clearly any kind of serious critical work – I would say scientific, though I know this drives some people into transports of rage – must involve a distance, a gap between the film and the criticism, the text and the meta-text. It is as though

meteorologists were reproached for getting away from the 'lived experience' of walking in the rain or sunbathing. Once again, we are back with the myth of transparency, the idea that the mark of a good film is that it conveys a rich meaning, an important truth, in a way which can be grasped immediately. If this is the case, then clearly all the critic has to do is to describe the experience of watching the film, reception of a signal, in such a way as to clear up any little confusions or enigmas which still remain. The most that the critic can do is to put the spectator on the right wavelength so that he can see for himself as clearly as the critic, who is already tuned in.

The auteur theory, as I conceive it, insists that the spectator has to work at reading the text. With some films this work is wasted, unproductive. But with others it is not. In these cases, in a certain sense, the film changes, it becomes another film – as far as experience of it is concerned, it is no longer possible to look at it 'with the same eyes'. There is no integral, genuine experience which the critic enjoys and which he tries to guide others towards. Above all, the critic's experience is not essentially grounded in or guaranteed by the essence of the film itself. The critic is not at the heart of the matter. The critic is someone who persists in learning to see the film differently and is able to specify the mechanisms which make this possible. This is not a question of 'reading in' or projecting the critic's own concerns into the film; any reading of a film has to be justified by an explanation of how the film itself works to make this reading possible. Nor is it the single reading, the one which gives us the true meaning of the film; it is simply a reading which produces more meaning.

Again, it is necessary to insist that since there is no true, essential meaning there can therefore be no exhaustive criticism, which settles the interpretation of a film once and for all. Moreover, since the meaning is not contained integrally in any film, any decoding may not apply over the whole area of it. Traditional criticism is always seeking for the comprehensive code which will give the complete interpretation, covering every detail. This is a wild-goose chase, in the cinema, above all, which is a collective form. Both Classical and Romantic aesthetics hold to the belief that every detail should have a meaning – Classical aesthetics because of its belief in a common, universal code; Romantic aesthetics because of its belief in an organic unity in

which every detail reflects the essence of the whole. The auteur theory argues that any single decoding has to compete, certainly in the cinema, with noise from signals coded differently. Beyond that, it is an illusion to think of any work as complete in itself, an isolated unity whose intercourse with other films, other texts, is carefully controlled to avoid contamination. Different codes may run across the frontiers of texts at liberty, meet and conflict within them. This is how language itself is structured, and the failure of linguistics, for instance, to deal with the problem of semantics is exemplified in the idea that to the unitary code of grammar (the syntactic component of language) there must correspond a unitary semantic code, which would give a correct semantic interpretation of any sentence. Thus the idea of 'grammaticality' is wrongly extended to include a quite false notion of 'semanticity'. In fact, no headway can be made in semantics until this myth is dispelled.

The auteur theory has important implications for the problem of evaluation. Orthodox aesthetics sees the problem in predictable terms. The 'good' work is one which has both a rich meaning and a correspondingly complex form, wedded together in a unity (Romantic) or isomorphic with each other (Classical). Thus the critic, to demonstrate the value of a work, must be able to identify the 'content', establish its truth, profundity, and so forth, and then demonstrate how it is expressed with minimum loss or leakage in the signals of the text itself, which are patterned in a way which gives coherence to the work as a whole. 'Truth' of content is not envisaged as being like scientific truth, but more like 'human' truth, a distillation of the world of human experience, particularly interpersonal experience. The world itself is an untidy place, full of loose ends, but the artefact can tie all these loose ends together and thus convey to us a meaningful truth, an insight, which enables us to go back to the real world with a reordered and recycled experience which will enable us to cope better, live more fully and so on. In this way art is given a humanistic function, which guarantees its value.

All this is overthrown when we begin to see loose ends in works of art, to refuse to acknowledge organic unity or integral content. Moreover, we have to revise our whole idea of criteria, of judgment. The notion behind criteria is that they are timeless and universal. They are then applied to a particular work and it is judged accordingly. This rigid view is varied to the extent that

different criteria may apply to different kinds of works or that slightly different criteria may reflect different points of view or kinds of experience, though all are rooted in a common humanity. But almost all current theories of evaluation depend on identifying the work first and then confronting it with criteria. The work is then criticised for falling short on one score or another. It is blemished in some way. Evidently, if we reject the idea of an exhaustive interpretation, we have to reject this kind of evaluation. Instead, we should concentrate on the *productivity* of the work. This is what the 'modern movement' is about. The text, in Octavio Paz's words, is something like a machine for producing meaning. Moreover, its meaning is not neutral, something to be simply absorbed by the consumer.

The meaning of texts can be destructive – of the codes used in other texts, which may be the codes used by the spectator or the reader, who thus finds his own habitual codes threatened, the battle opening up in his own reading. In one sense, everybody knows this. We know that *Don Quixote* was destructive of the chivalric romance. We know that *Ulysses* or *Finnegans Wake* are destructive of the nineteenth-century novel. But it seems difficult to admit this destructiveness into court when judgments are to be made. We have to. To go to the cinema, to read books or to listen to music is to be a partisan. Evaluation cannot be impartial. We cannot divorce the problem of codes from the problem of criteria. We cannot be passive consumers of films who then stand back to make judgments from above the fray. Judgments are made in the process of looking or reading. There is a sense in which to reject something as unintelligible is to make a judgment. It is to refuse to use a code. This may be right or wrong, but it is not the same thing as decoding a work before applying criteria. A valuable work, a powerful work at least, is one which challenges codes, overthrows established ways of reading or looking, not simply to establish new ones, but to compel an unending dialogue, not at random but productively.

This brings us back to Godard. The hostility felt towards Godard expresses precisely a reluctance to embark on this dialogue, a satisfaction with the cinema as it is. When, in *East Wind*, Godard criticises not only the work of other film-makers, but his own practice in the first part of the same film, he is at the same time asking us to criticise our own practice of watching his film.

At the same time as he interrogates himself, we are interrogating ourselves. The place of his interrogation is the film, the text. This is not simply a question of self-consciousness. It is consciousness, first and foremost, of a text, and the effect of this text is like the effect of an active intruder. It is this intrusion which sets up conflicts which cannot be settled by one (rational) part of consciousness surveying another part of its own past and then bringing it back into line. It is only natural that people should want to drive the intruder out, though it is difficult to see how a critic could justify this.

Godard represents the second wave of impact of the 'modern movement' of the cinema – the movement represented elsewhere by Duchamp, Joyce, and so on. During the 1920s, Russian film-makers like Eisenstein and Vertov make up the first wave. It remains to be seen whether Godard will have any greater short-term effect than they had. But it is necessary to take a stand on this question and to take most seriously directors like Godard himself, Makavejev, Straub, Marker, Rocha, some underground directors. As I have suggested, they are not all doing the same thing, and it may be that a director like Makavejev is not really in the same camp as Godard at all. This remains to be seen. For this reason, I do not believe that development of auteur analyses of Hollywood films is any longer a first priority. This does not mean that the real advances of auteur criticism should not be defended and safeguarded. Nor does it mean that Hollywood should be dismissed out of hand as unwatchable. Any theory of the cinema, any film-making, must take Hollywood into account. It provides the dominant codes with which films are read and will continue to do so for the foreseeable future. No theorist, no avant-garde director can simply turn their back on Hollywood. It is only in confrontation with Hollywood that anything new can be produced. Moreover, while Hollywood is an implacable foe, it is not monolithic. It contains contradictions within itself, different kinds of conflicts and fissures. Hollywood cannot be smashed semiologically in a day, any more than it can economically. In this sense, there may be an aspect of 'adventurism' or Utopianism in Godard. There certainly is in a number of underground film-makers.

So, looking back over this book, I feel that its most valuable sections are those on Eisenstein and on semiology, even though I have now changed my

views on the latter. I no longer think that the future of cinema simply lies in a full use of all available codes. I think codes should be confronted with each other, that films are texts which should be structured around contradictions of codes. The cinema had its origins in popular entertainment and this gave it great strength. It was able to resist the blandishments of traditional 'art' – novel, play, painting and so on. Nevertheless, the period of the rise of Hollywood coincided in many respects with a move in Hollywood towards artistic respectability, personified for example by Irving Thalberg. This movement never really got beyond kitsch – Welles, who should have been its culmination, proved too much for it. At the same time, the popular side of Hollywood was never completely smothered by the cult of the Oscar and of fine film-making either. Now, for the second time – the first wave proved premature – the avant-garde has made itself felt in the cinema. Perhaps the fact that it is fighting mainly against Hollywood rather than against traditional 'art' will give it an advantage over the avant-garde in the other arts. It is possible that the transitional period we have now entered into could end with victories for the avant-garde that has emerged.

The Writings of Lee Russell: *New Left Review* (1964–7)

Samuel Fuller
[First published in *NLR* no. 23, January/February 1964, pp. 86–9]

Samuel Fuller was one year old when Walsh made his first film, three years old when Chaplin made his first, four years old when Griffith made *Birth of a Nation*, six years old when Ford made his first. Many veterans of the silent film are still alive, working or looking for work: Swan, Lang, Hitchcock, Hawks, Renoir, Vidor. Fuller made his first film, *I Shot Jesse James*, after two decades of sound, in 1949. He is a post-Welles director, a little older than Welles, whose films appear along with films made by directors whose cinema careers began before Welles was born. The fantastically foreshortened time-scale of the cinema has meant that few American directors are seen in their proper perspective, Fuller perhaps least of all. Even an informed critic like Andrew Sarris, writing in *Film Culture*, has described Fuller as a 'primitive'; his failure to treat 'contemporary', 'real-life' subjects and situations has led most critics to lose sight of his distinctiveness and to relegate him into the ranks of the 'action directors' who are thought of as making up the solid, traditional rearguard of American cinema rather than its brilliant, exceptional vanguard. Ritt, Cassavetes and Sanders excite critical attention, while Fuller is neglected.

Fuller has worked consistently within the American cinema genres: Western, gangster, Pacific war. These genres, I would argue, are the great

strength of the American cinema. America is a comparatively young nation which has grown very rapidly into a leading global power. It is no accident that the epochs of the cinema genres are also the epochs of crisis in America's consciousness of itself, its national identity and its role in history. The American cinema helped to develop the national consciousness while it developed its own genres, through its mutually responsive relationship with its mass public. American cinema has developed artistically out of the romantic movement and of national consciousness. This trend was strengthened by the emergence of the genres, in which themes and attitudes could be systematically developed. The work of Fuller in these genres represents a far point of bourgeois romantic–nationalist consciousness, in which its contradictions are clearly exposed.

Fuller's world is a violent world, a world of conflict: Red Indian *v.* white man, gangster *v.* police, American *v.* Communist. (Fuller has updated the Pacific war movie to deal with both Korea and Vietnam.) But neither the fronts nor the occasions for conflict are clearly delimited. Battles take place in utter confusion: in thick fog, in snowstorms, in mazes. All Fuller's war films are about encounters behind the enemy lines. Nor do the protagonists even know why or for what they are fighting. 'How do you tell a North Korean from a South Korean?' asks a puzzled GI in *Steel Helmet*. His stogie-chewing sergeant replies: 'If he's running with you, he's a South Korean. If he's running after you he's a North Korean.' In *China Gate* we see the defence of the American alliance in Vietnam by a commando patrol: one is a German veteran of the Hermann Goering Brigade, one an American negro, both enlisted in the Foreign Legion. The only reason they give for being there is that the Korean War is over so they looked for another trouble-spot. They are, in fact, the dregs of society, psychopathic killers with no purpose in life. Fuller often points out how such people take the burden of defending the society which has rejected them.

The typical Fuller hero is poised ambiguously in the conflict. Often he is a double agent. In *Verboten* the neo-Nazi, Bruno, infiltrates the American Occupation HQ; in *House of Bamboo*, a military policeman infiltrates a gang entirely made up of men discharged with ignominy from the US army. In *Pick-up on South Street* and *China Gate* the central characters try to play both ends at once, America and Communism, to their personal advantage. 'Don't

wave the flag at me,' says the pickpocket hero of *Pick-up* who has inadvertently lifted a microfilm from a Russian spy, and proceeds to auction it to the highest bidder. Lucky Legs, in *China Gate*, makes possible the success of a French mission by her friendship with the Vietminh lookouts and camps, whom she leads in singing the 'Marseillaise' while the legionaries sneak by. In the end they both choose America. Why? Irrational personal loyalties.

Ambiguity in its most extreme form is represented in Fuller's films by the Nisei, the Japanese American, and the Chinese American. In *Hell and High Water* a captured Chinese Communist appeals to an American Chinese, who is a stool-pigeon to get information from him. Despite the Communist's evident humanity and amiability the American Chinese betrays him. He is, as he sees it, a loyal American. Fuller takes the matter further. He asks how the white American sees the Chinese American. One of the major themes of his films is anti-racism, subordinated to the theme of nationalism. In *The Crimson Kimono*, set in Los Angeles, a white girl leaves her white boyfriend for his best friend, a Nisei. This film was made in the same year, 1959, as *Hiroshima, mon amour*. Fuller deals with the race problem much more radically than Resnais. The Nisei marries the white girl; the animosity of his friend when he realises what is happening is clearly shown, culminating in a bout of *kendo*-fighting, when he goes out of his mind and tries to kill the Nisei.

To Fuller, however, it is America that is always paramount. There is a clear contradiction between his attitude to the Nisei and the negro, whom Fuller sees as being necessarily integrated into American society, and the attitude he takes to the white 'renegade' O'Meara in *Run of the Arrow*, a Western. O'Meara, a Southerner, cannot tolerate the idea of living under the Union flag and the Union constitution, after Lee's surrender. 'They chased us when we had no legs; they crammed our bread into their mouths when we had no food.' He goes west and joins the Sioux nation. When the Yankees come and make a treaty with the Sioux chief Red Cloud, Red Cloud insists that they employ a Sioux scout, not a Cherokee. The Sioux scout chosen by the chief is O'Meara. Fuller is scrupulously fair to the Indians: he permits O'Meara to criticise the treaty terms and sympathises when the Indians wipe out a US cavalry detachment after the terms are broken. But he insists that O'Meara cannot fully integrate himself into the Sioux nation. He returns with his Indian

wife and child to the Union, recognising that he is an American. Yet he insists that the Nisei is not a 'renegade' and that he can be integrated into America. Fuller's anti-racism is limited by his nationalism and his nationalism is finally determined by his own nationality. Fuller is an American and in the end all his heroes choose America.

But Fuller does not evade the problems; he evades the answers. Although he is committed to America, he is well aware of the contradictions in American society and does not hesitate to confront them. His America is a violent, divided America; his saviours of America are delinquents and misfits. His Americans rampage through South-East Asia – through Burma, Vietnam, Korea, Japan – and huge statues of the Buddha smile sardonically down on them. In *Steel Helmet* US troops crouched on the Buddha's lap fire over the Buddha's shoulder. Fuller's romantic nationalism is quite incapable of seeing any positive way forward, any real future. The America he celebrates is teetering into lunacy. This is further demonstrated by the plot-synopsis of the film he is now working on, *Shock Corridor*.

A journalist (Fuller himself was a journalist before he went into cinema, a formation he is proud of and which he has explicitly used in his film about journalism, *Park Row*) wants to win the Pulitzer Prize. He hears of an unsolved murder in a lunatic asylum and arranges to be drafted into the asylum – a double agent between sanity and lunacy – and write up the story. There are three key witnesses. First, the single negro student in a Southern university, who has gone mad and thinks himself the head of the Ku Klux Klan. Second, a GI who went over to the Communists after being captured in Korea. Third, an atomic scientist who has regressed to the mental age of six. The journalist solves the murder, writes the story and wins the Pulitzer Prize. But he is so disturbed by his experience that he too goes insane and is put in an asylum. His choice has been made.

Finally, a few comments on Fuller's style. Fuller has an extraordinary command over tempo. He is celebrated both for his quick jump-cutting – a decisive influence on Godard's *Breathless* – and for the length of individual takes. (A take in *Verboten* of 5m. 29s.; a take in *Run of the Arrow* of 4m. 11s.) His films contain unusually striking images: a view of Fujiyama between the shoes

The Crimson Kimono

of a corpse (*House of Bamboo*); a battle in a maze of polygonal man-height tank-traps (*Merrill's Marauders*); a dumb child being sucked into quicksand and blowing on a harmonica for help (*Run of the Arrow*). Finally, despite all the speculation about Lang and Losey, it seems to me that Fuller is the film director whose methodology closest approaches Brecht's theatre. Compare, for instance, his use of characters both as actors in a drama and spokesmen of their consciousness of the drama, his use of song and of exotic, distant settings, and even his use of posters and slogans: at the end of *Run of the Arrow* a rubric flashes on to the screen, 'The end of this story will be written by you'.

Fuller is an example of a distinctive creative personality (he has written, produced and directed the majority of his films) working within a traditional genre to extend and explore both its traditional themes and his own attitudes to them. The genres he has used are the genres which deal with the key areas of American history, and Fuller has used them to confront the problems which are raised by the contradictions of American history. He has not shirked those contradictions but has sought to dissolve them in an extreme statement of romantic nationalism. He has pushed romantic nationalism as far as it will go. His future films will show how far he can push his own energy and integrity.

Jean Renoir
[First published in *NLR* no. 25, May/June 1964, pp. 57–60]

In 1936, it is often forgotten, Jean Renoir made a propaganda film, *La Vie est à nous*, for the French Communist Party, starring Maurice Thorez, Jacques Duclos, etc.; in 1937, he made *La Marseillaise* for the Trade Union movement (CGT). Then the war and exile in Hollywood. The heady days of the Popular Front never returned. In 1950, he made *The River* in India (his last American film), explaining that, whereas before the war he had tried to raise 'a protesting voice', he now thought that both the times and he himself had changed: his new mood was one of 'love', of the 'indulgent smile'. Following films seemed to confirm the trend: *French Cancan, Elena et les hommes*. Betrayal? Or maturity? The critics split. One camp praised the pre-war Renoir, the Renoir 'of the left'; the other praised the post-war Renoir, the Renoir of 'pure cinema'. One school, leaning on the authority of André Bazin,

remembered 'French' Renoir; another, headed by the emerging critics of *Cahiers du cinéma*, heralded 'American' Renoir. As Renoir grew older, the *Cahiers* critics argued, he grew more personal, hence more of an author, a greater director. Debate turned acrimonious. Renoir, one anti-*Cahiers* critic wrote, 'deified by imbeciles, has lost all sense of values'. And so on.

The truth is that Renoir's work is a coherent whole. The mainspring of his thought has always been the question of the natural man: nature and artifice, Pan and Faust, natural harmony. His differing attitudes to society have been the result of the 'natural' *naïveté* he has cherished. The Popular Front appealed to him, he has confessed, partly because it seemed to presage an era of harmony between classes, a national idyll; after the war the forces which had made up the Front showed discord rather than concord and Renoir retreated from political life, away from camps and blocs into the countryside, his father's estate, nostalgia and a kind of pantheism. Yet Renoir the pantheist is none other than Renoir the Communist, Renoir the 'red' propagandist. His first allegiance has always been to the ordinary man, asking nothing more than to eat, drink, sleep, make love and live in harmony with all the other millions of ordinary men throughout the world. He dislikes regimentation, systematisation – anything which threatens the natural, human qualities to which he is attached. He detests the conditions imposed on man by capital – at its furthest limit his detestation has led him to anarchism and pacifism – but he cannot accept the conflict or the discipline necessary for the overthrow of the capitalist system. His great philosophical ancestor is Rousseau; at one time his preoccupation has been the General Will, at another the Noble Savage.

Renoir recognises the existence of social classes and nationalities – he is fascinated by them, as phenomena – but he insists that these differences need not divide men in their human essence. Thus masters and servants – their lives and escapades – have always humanly interacted and interlocked in Renoir's world, though the two orders remain distinct. (Renoir has always preferred to depict master–servant relations than employer-worker: he is repelled by the anonymity of the factory.) Witness, for instance, the conversation about harems between the marquis and the servant in *La Règle du jeu*. The divisions which count are 'spiritual', not social, divisions. 'My world is divided into miser and spendthrift, careless and cautious, master and slave, sly and sincere,

creator and copyist.' (Master and slave, to Renoir, are spiritual categories – he uses 'aristocrat' in the same way.) Renoir is the spokesman for human values which capitalist society will destroy as far as it can – the values which Rousseau thought of as pre-social. He is confident that these values cannot be destroyed entirely, that there are spiritual recesses into which capitalism cannot reach, that human beings cannot be entirely dehumanised. Renoir believes that most people want no more than a simple, uncomplicated life; anything further is vanity, false pomp. This involves a renunciation of public life and a retreat into privacy, a flight from the central realities of an inhuman society to its human margins. It explains Renoir's fascination with women, wandering players, gypsies, vagabonds, poachers and so on – all those who live in this human margin. Yet Renoir's bonhomie – his open optimism – easily slips into buffoonery – a kind of hidden pessimism.

The purest expression of Renoir's attachment to the natural man is his film *Boudu sauvé des eaux*, made in 1932. Ever since he made it, he has said, he has been looking in vain for another such story. A Parisian bookseller rescues a tramp, Boudu, who has thrown himself into the Seine. He takes him home and starts trying to civilise him, to educate him in the desiderata of bourgeois life. But Boudu is intractable – a natural man, impervious to restraint or nicety – he climbs on to the dinner table, sleeps curled up on the floor, ruins rare books, tears down the curtains, assaults his benefactor's wife, etc. Eventually, a kind of settlement is reached and it is decided that Boudu is to marry the maid. (Marrying the maid is a recurrent feature of Renoir's films.) During the wedding party, Boudu upsets a boat on the Seine, swims ashore, lies down beneath a hedge and returns happily to a life of vagrancy. Boudu's incursion into society is destructive, anarchic: the same bourgeoisie which, in Renoir's words, produced Proust and the railway, cannot cope with Boudu. It is clear which way of life Renoir regards as more authentic. But Boudu is an extreme case: on the whole, Renoir tempers nature with prudence.

For me the red traffic-light symbolises exactly that side of our modern civilisation which I do not like. A red light comes on and everyone stops: exactly as though they had been ordered to. Everyone becomes like soldiers marching in step. The sergeant-major shouts 'Halt!' and everyone halts. There is a red light and everyone stops. To me, that is

insulting. All the same you have to accept it, because if you carried on, despite the red light, you would probably get killed.

Renoir's masterpiece, *La Règle du jeu*, explores the same theme on a different level; it is more complex and more nuanced. André Jurieux, a popular hero (an ace pilot who is clumsy on the ground: the symbol is familiar), disturbs the aristocratic house party to which he is invited by his passion for his host's wife. The code of rules by which life is ordered breaks down and guests and host begin to fight 'like Polish navvies'. Jurieux, the disturbing force, must be expelled; he is shot and a speech of great delicacy by De la Chesnaye – the host, a marquis who adores mechanical music-boxes – restores order and the conventional code. The shooting of Jurieux echoes the shooting of birds and rabbits at the butts – the senseless destruction of natural beings in order to conform with a style of life. Such a schema does not suggest the full scope of the film: the surface is continually fluctuating and it is this fluctuating interaction of the characters, rather than the intrigue (a kind of

La Règle du jeu

Beaumarchais plot), which sets the pace and holds the eye. Renoir gives his actors a great deal of room and time – by the use of deep focus and long takes – and encourages them to move about. The film is awash with movement and gesture, so that the first impression is of a continual to and fro, combined with sharp psychological accuracy. The camera, in André Bazin's phrase, is 'the invisible guest, with no privilege but invisibility'. The construction of the film reveals itself little by little to the attentive spectator: Renoir does not belabour his points. Indeed, in *La Règle du jeu* tragedy emerges imperceptibly from breakneck farce; the aristocracy are most doomed – an aristocracy who are never cartoons, as they are in Eisenstein – when they are at their best.

After the war, Renoir returned again to the themes of *La Règle du jeu*, most obviously in *Elena et les hommes*, but also in *Le Carrosse d'or*, made in Italy in 1952. There is space here only to make some suggestive remarks about this film. First, it takes up again the same triad of characters who appeared in *La Règle du jeu*: Viceroy = Marquis, Bullfighter = Pilot (the popular hero), Felipe = Octave. But here is a difference: it is the woman, Camilla, who is the disruptive, natural force; the bullfighter is merely the suitor who is clumsy, even ridiculous, when outside the arena. Second, the golden coach itself is used as a symbol of human vanity, of the wish for public acclaim and pomp. It is the coach of Faust (mastery over nature): the viceroy must choose between the coach and Camilla (submission to nature). But third, Renoir introduces an idea which radically modifies his attitude to nature: that, in some circumstances, it is most natural to play artificial roles. Thus, Camilla, the natural force, is only really her natural self when playing on the stage in the *commedia dell'arte*. Real life and theatre becoming inextricably confused: it would be, in a sense, unnatural for the viceroy to choose Camilla; he cannot. Yet finally, Felipe, who goes to live with the Indians (Rousseau's savages), can be natural, because he opts out of society altogether. He is, like Octave in *La Règle du jeu*, a failure, unable to choose at first between acceptance and refusal of society – between two sets of values – but finally constrained to leave.

Renoir has always been a pioneer. His film *Toni* (1934) is widely considered to be a main source of Italian Neo-Realism: there is a direct link through Visconti, who was Renoir's assistant. *La Règle du jeu* used deep focus before Welles. Renoir wanted to be more free to place his actors and let them

move. The same kind of consideration led him to TV techniques for *Le Déjeuner sur l'herbe* and *Dr Cordelier*, shot with several cameras simultaneously and hidden microphones: this gave much more fluidity and also meant that the actors could not play to the camera. Renoir has never liked quick cutting: an extravagant camera movement, like the 360-degree pan so admired by Bazin in *Le Crime de Monsieur Lange*, is often preferred to a cut. His films use less and less *champs-contre-champs*, fewer and fewer close-ups. The tempo of his films comes from the actors, not from the montage. When he uses close-ups, for instance, it is not to stress a dramatic climax, but to punctuate with images from outside the main action. Often they are of nature ('quasi-animist' is Jacques Rivette's phrase): the frogs and twitching rabbits in *La Règle du jeu*, the squirrel Kleber in *Diary of a Chambermaid*, the insects in *Le Déjeuner sur l'herbe*.

Undoubtedly Renoir is one of the great masters of the cinema. His work stretches from Gorky's *Lower Depths* to *commedia dell'arte*; it embraces Indian snake-charmers, nymphs and satyrs, Jekyll and Hyde, General Boulanger, test-tube babies, cancan dancers and the Communist Party. Some critics have seen no more in Renoir than the retreat into a pastoral idyll, a reminiscence of his father's painting. The enormous diversity of Renoir's material gainsays them. For, while he does insist on the values of the idyll – values uncorrupted by capitalism – he has never made the limits of the idyll his own horizon. On the contrary, he has insisted on applying these values to every kind of circumstance. Perhaps he has been over-optimistic. But it would be wrong to reproach him for the over-optimism of, say, *Elena et les hommes* – its pervasive atmosphere of benevolence and sympathy for everyone – and not for the over-optimism which marked his support of the Popular Front. Moreover, it is his optimism which enables him to reduce the values of bourgeois society to farce; it is not the hypocritical optimism of bourgeois sentimentality. It is a firm confidence in man and his attachment of authentic values. Apropos of *La Marseillaise*, Renoir commented on the men who stormed the Tuileries: 'Of course, first and foremost, they were revolutionaries, but that did not stop them eating, drinking, feeling too hot or feeling too cold. ... They were in the midst of events, which transformed the destinies of the world, like straws in a storm. But we must not forget that the storm which swept them along was their own work.'

Stanley Kubrick

[First published in *NLR* no. 26, Summer 1964, pp. 71–4]

Stanley Kubrick, by his meteoric rise to the top of the industry, has so far managed to outpace critical appraisal. At first he was greeted as the regenerator of the thriller; suddenly he turned to good causes and social content. And then no sooner had he won new friends with *Paths of Glory* than he strained their allegiance to the limit by choosing to make a blockbuster, *Spartacus*. Next, *Lolita* confirmed Andrew Sarris in the dark view he had taken of Kubrick, but was welcomed by Jean-Luc Godard in the pages of *Cahiers du cinéma* as 'simple and lucid', a 'surprise'. Finally, *Dr Strangelove* split the more orthodox critics as unexpectedly as *Lolita* has split Sarris and Godard. To some it seemed a deeply serious film, courageous and progressive; to others, sick and nihilistic. By and large, two broad currents of opinion seem to have formed. On the one hand, Kubrick can be seen as trying bravely – and more or less successfully – to make 'serious', nonconformist films which, at the same time, reach a mass audience and benefit from all the resources usually available only to the mere 'spectacular'. Or, on the other hand, Kubrick can be seen as stretching his powers too far, as dissipating his talent in grandiose projects and 'big ideas', attractive for their scope, but which he can mark with his own personality only in quirks and fragments. But either way, uneasy doubts remain.

One crucial ambiguity in Kubrick's work lies in the relationship between his *bien-pensant* liberalism and his obsession with disaster. Kubrick has mentioned that Max Ophuls is his favourite director: most critics have thought this a stylistic preference and noted it alongside his addiction to tracking shots. But here is another, more profound, common quality: Kubrick's films are pervaded with the Ophulsian bitter-sweet. *Lolita*, of course, is bitter-sweet through and through. In *Killer's Kiss*, the two lovers, Gloria and Davy, are both failures – a failed dancer, overshadowed by her ballerina sister, and a failed boxer, whom Gloria watches on the TV pummelled ignominiously on to the canvas. Two of Kubrick's films, *Paths of Glory* and *Dr Strangelove*, end with sentimental songs, used to counterpoint total defeat. In *Paths of Glory* the song mocks the order for battle-weary troops to return to the front after the

Dr Strangelove

execution of three among them for cowardice – three who were, in fact, innocent, who were arbitrarily chosen as scapegoats to cover up the blunders and savagery of a high officer. In *Dr Strangelove*, the irony is even more fierce: a Vera Lynn song accompanies a long sequence of atomic explosions and mushroom clouds. Yet there is a vital distinction to be made between Ophuls's pessimism and Kubrick's. Ophuls was a romantic – indeed, an arch-romantic. In *Lola Montès*, his greatest and most pessimistic film, the myth of Lola is that of Icarus: Lola's aspiration to an ideal, individual freedom is shattered by the reality of human history, a reality which, since her own vision remains pure, she cannot grasp even after her fall. She ends up in a cage in a circus menagerie, imprisoned, degraded, fallen – but still attached to her broken dream, which she re-enacts each night. The re-enactment – fictive and theatrical – is a heroic reassertion of the value of the aspirations of her wrecked life: the triumph of myth over reality through art. But for Kubrick, there are no myths, no freedom, no hope: only their absence. The counterpart of Kubrick's jejune liberalism is a jejune nihilism. Kubrick's *Lolita* is dominated not by the quest for an impossible passion (impossible because Lolita must live in time) but by the search for Quilty, tracking him down and killing him. Kubrick's world is dehumanised; human passions are fatuous. His pessimism is cold and obsessive.

For Kubrick, the bitter-sweet easily spills over into the grotesque and into black farce. This streak showed itself very early and it has gradually grown dominant: the fight with fire-axe and fire-pole between Davy and Rapalo in *Killer's Kiss*, in which a roomful of tailor's dummies are hacked to pieces by huge swipes, limbs and heads flying everywhere; Nikki's conversation with the negro car-park attendant in *The Killing*; the ping-pong before Quilty's murder in *Lolita*, the grotesque Pentagon war-room sequences in *Dr Strangelove*. Expressionism is pushed toward Surrealism – bizarre juxtaposition, macabre undertones, the triumph of the irrational. But Kubrick goes much further than Welles, particularly in his choice of actors. It is entirely logical that Kubrick should have fixed on Peter Sellers for his two latest films: an actor with almost no human essence, an impersonator and a caricaturist. And whereas in Welles caricature-actors are used as foils for the massive, perverted, but very human quality of Welles himself, in Kubrick there is nothing but caricature. The real logic of *Dr Strangelove* is that Sellers

should play, not just three, but all the parts. For Welles, the world is a nightmare which perverts man's Faustian aspirations into Mephisophelean evil: the only authentic response is stoicism and scepticism – Welles's favourite writer is Montaigne. For Kubrick, everything is diseased, all human qualities are caricatures, there is no authenticity. (Even his apparently positive characters – Dax and Spartacus – experience nothing authentically but defeat: hope, for them, is just ignorance.)

Before he went into movies, Kubrick worked as a still photographer for *Look*. His first films were praised by critics for their 'visual flair': *Killer's Kiss* is full of carefully composed shots – reflections, shadows, silhouettes, etc. The general effect is rather fussy and over-ornamental. *The Killing* is a much cleaner film. It tells the story of a racetrack heist; the tasks of each member of the gang are slotted into a precise schedule. The cutting is brilliant; the plan of the film reflects the plan of the robbery in its precision. Some sequences are repeated twice, from different viewpoints, as the different roles of different actors in each operation are followed. The camera is very mobile. This mobility becomes over-obvious in *Paths of Glory*: the camera tracks endlessly down trenches full of exhausted soldiers – the trench walls circumscribe the camera's range too blatantly. In another scene the camera tracks back and forth across the end of a large hall as Colonel Dax, defender in a court martial, paces back and forth with it. All Kubrick's films tend to be over-directed. In his later films, the construction becomes much looser, the camerawork more expressionistic still. The retreat from naturalism is very obvious in *Lolita*, which was made in England: the paean of praise to the American landscape – motels, tollgates, clover-leafs, neon, etc. – which might have been expected from Nabokov's book, was completely foregone by Kubrick. In *Dr Strangelove* the plot develops very loosely and schematically – it does not seem to matter how much time there is left; the point is that there is not enough.

Kubrick is an ambitious director. But his more grandiose projects do not seem to have forced him to deepen his thought: fundamentally, *Dr Strangelove* is an advance over *Killer's Kiss* only in so far as its pessimism is spread much wider, more universalised and more cosmic. Certainly this makes a more sensational effect: the end of the world is necessarily sensational. But, at the same time, it is not the end of the real world; it is the end of a monstrous

caricature. For, the more universalised the pessimism becomes, the more it is necessary to dehumanise the world and to caricature mankind. Thus *Dr Strangelove* has no real bite. On the other hand, Kubrick is certainly not a Preminger. The claim of 'daring', of 'confronting problems', is obviously hollow with Preminger; even though he has made films about drug addiction, rape, Israel, homosexuality in the United States senate, the Ku Klux Klan and so on, he has never been more than a parasite on controversy. Indeed, his two latest films have been apologias for the American constitution and the college of cardinals. Compared with Preminger, Kubrick is a genuine nonconformist. Indeed, he seems increasingly anti-American: he has even gone into voluntary exile. But the more Kubrick retreats into expressionism and caricature, the more his pessimism becomes merely a question of mood, rather than the outcome of a confrontation of real problems.

In the last resort, perhaps, Kubrick shows no more than the easy way out of the liberal impasse. He sees the inadequacy of liberalism, its impotence when it comes to a crisis, but he cannot abandon it. He goes on repeating its platitudes. Each time they taste sourer in the mouth. Dalton Trumbo gives way as scriptwriter to Terry Southern. And as the platitudes become more and more bitter, more and more farcical, so does the world. Everybody becomes Peter Sellers. Humanity becomes the most grotesque platitude of all. Meanwhile, his best film remains *The Killing*, where the human quality of the characters (Sterling Hayden, Kola Kwarian, Tim Carey, Ted de Corsia, Jay C. Flippen), seen in relation to each other and to their work, is as yet unmatched. Yet, despite the facility of Kubrick's development, it would be wrong to discount him altogether. Somewhere inside him is lurking a Nathanael West struggling to emerge. If he does not succeed in releasing him, Kubrick will end up as fatuous as the world he depicts.

Louis Malle
[First published in *NLR* no. 30, March/April 1965, pp. 73–6]

The *nouvelle vague* is now at least six years old and the time has come to take stock. Perhaps the best way to do this is to consider the work of Louis Malle, never at the heart of the group who took the headlines, yet in a way the *nou-*

velle vague's arch-exponent, and certainly its most consistently successful in terms of both box office and prizes. In his latest film, *Le Feu follet*, Malle showed himself perhaps closer to the original spirit of the movement than others who have sheered off in their own personal or hyper-personal directions. Malle, the most eclectic, is also the most typical. The paradox need not surprise: unable to develop a style with its own dynamic, the eclectic devises a composite, whose surface shimmers with unresolved tensions, but which is easily assimilable. In the wrong circumstances, the eclectic becomes either an academic or a grotesque. Malle, an intelligent director, has been saved from these extremes both by the progressive atmosphere surrounding him and by his own good judgment. But, whereas Godard is Godard and Truffaut is Truffaut, Malle is the *nouvelle vague*.

It is worth recapitulating why it was that the first films of the movement created such a vivid impression of novelty. Partly it was a question of *mise en scène*: semi-newsreel, often handheld camerawork; a carelessness about framing and a much greater insistence on texture; a belief that the camera should follow actors encouraged to act naturally rather than perform in front of the autocratic camera; a new willingness to use unorthodox effects more or less casually rather than as set pieces. Partly it was a new approach to content and a new kind of content: episodic construction, often with many parentheses; a fearlessness about introducing 'intellectual' material, conversation and allusions; a phenomenological approach to domestic psychological problems; a more candid treatment of sexuality; a preference for natural, 'spontaneous', rather than instrumental, plot-forwarding dialogue, often improvised on the spot. Other features were more superficial: in-jokes, tributes to the American gangster movie, visual puns. Also there was a clear insistence, often to the point of flagrancy, on having a developed cinematic culture, leading to an insistence on clear-cut directional control.

Almost all these qualities and characteristics are to be found in Malle's films. His first film, *Ascenseur pour l'échafaud*, did not fully satisfy him – unlike other *nouvelle vague* directors, who managed to make their own projects as first films, Malle had the screenplay forced on him. It was a film which was given *nouvelle vague* treatment (the Miles Davis soundtrack, for instance), it established Malle's talent, but did not give him the chance to make his *own*

film. *Les Amants*, his next film and his own project, was clearly too concerned with the kind of preoccupations a *nouvelle vague* film ought to have. Its central feature, a long erotic sequence of love-making, signalled a new liberty without making any real new advance. The plot, despite its modern trappings – the 2CV and the bathroom – was essentially ultra-romantic and anachronistic. As so often with Malle, the most distinctive feature of the film was its ornament: the polo, the bathroom, etc.

Zazie dans le métro was a more important work, not exactly because of its merits, but because it was an unashamed attempt to make a split-level film, which would appeal to *cinéphiles* and the general public, but for different reasons. On the one hand, it was an anthology of allusions and quotes from numerous historic movies; on the other, it was a zany crackpot comedy, with lots of chases and slapstick. The film also showed Malle's mounting interest in camerawork; plot and character hardly exist and the film is kept from sagging almost entirely by stimulating the eye and not allowing it to settle. *Zazie* showed how it was possible to use typical *nouvelle vague* devices in order to enliven an action of little interest to the director in itself and turn it into a virtuoso stylistic exercise. (This, of course, is what Richardson tried to do with *Tom Jones*.) It should be said that since Queneau's original book was little more than a virtuoso semantic exercise itself, it is arguable that Malle was translating it faithfully into cinematic terms. But this merely underlines the point that Malle has been unable to find his own dynamic.

The *nouvelle vague* was always careful not to seem afraid of commercialism; its admiration for American cinema implied a belief that good cinema might well also be good box office. Yet it soon became quite clear that the leading *nouvelle vague* directors, far from being shadowy figures in the Hollywood jungle, were going to be enthroned as the idols of the intelligentsia, in the full glare of the limelight and applauded by the very critics who spurned the American cinema. Besides, they were nearly all intellectuals themselves and, though it is one thing to insist that the cinema – for all the merits of American directors – still lacked a certain intellectual dimension, it is quite another to litter Faulkner's *Wild Palms* or Goethe's *Elective Affinities* around on the screen and comment on them in long passages of screenplay. Consequently, there was always a fundamental tension in

nouvelle vague cinema, sometimes expressing itself in surprising ways, apparently perverse: thus Godard makes films with Brigitte Bardot and Eddie Constantine.

Malle too made a film with Brigitte Bardot, *Vie privée*. Godard's *Le Mépris* was utterly paradoxical, to the point of self-destruction; it was an attempt to make 'a film of Antonioni in the style of Hitchcock and Hawks', a bizarre juxtaposition of *Playboy*-type close-ups of Brigitte with a recondite allegory based on *The Odyssey*. But Malle's film was, as one might expect, a more or less straight commercial property, similar in its key idea to Clouzot's *La Vérité*, but given a new kind of stylistic gloss. Its two most striking features – Decae's experimental *pointilliste* photography and a long sequence of Brigitte Bardot falling through space, based on the parachute jump in Sirk's *Tarnished Angels* – had no relevance to the plot of the film, which seemed to

Vie privée

demand either newsreel treatment or else out-and-out Ophulsian theatricality. Once more, however, Malle lapsed at crucial moments into a weak romanticism which belied his quirks of experimentation. The film seemed subservient to conservative box-office opinion and not committed to the belief that advanced cinema could pay well. Moreover, he seemed quite incapable of dealing seriously with any of the themes – such as the nature of stardom, the private and the public face, etc. – which the film might have suggested.

It seemed, after *Vie privée* had been shown, that little more could be expected from Malle. However, he proved resilient enough to make a comeback and his most recent film, *Le Feu follet*, was well received almost everywhere. It was not an outstandingly good film, but it was a film which perhaps more than any other was calculated to catch the attention of the intellectual. The screenplay was based on an adaptation of a novel by Drieu La Rochelle, with the hero changed from a drug addict to an alcoholic. This shift brought the film into line with its prevailing mood, which was clearly signalled by a number of allusions to Scott Fitzgerald. Although the film, like the book, ends with the hero's suicide, it was not so much a suicide of an oppressed or broken man as of a privileged yet doomed man, a man who obscurely feels that he has no further time to live and that to continue living, perversely, would be to live in such a condition of radical separation from others as hardly to be living at all. The film does not consider the origins of this feeling of fatality and of separation, but chronicles a series of episodes in which it becomes manifest. The camera, therefore, is the typical *nouvelle vague* following camera, but it is also endowed, for quite long periods, with the hero's own subjectivity.

The principal episodes are in the form of vignettes of the hero's friends: an earnest adept of the kabbala, a beatnik girl and a Maecenas who likes to entertain the wealthy and the witty. Like the hero, they are all intellectuals. During the day, the hero, who has just undergone an alcoholic's cure, gets incapably drunk. However, this is not the centre of the film; alcoholism, it is evident, is a symptom and not a disease. What is really at stake is the essential character of the intellectual, his obsession with the problematic, his fear that the problem is a false problem. The film owes its success to the fact that its audience – an audience of intellectuals – through the obsessive camera, is

made to share the activities of other intellectuals and see them as unintelligible, phantom-like. Thus Malle makes use of the process of audience identification with the camera and the radical separation between the audience and the shadows on the screen. Cinema, in this sense, becomes the central rite of a cult, by which a defined group makes its auto-critique, its confession of fear that life cannot be made intelligible, and enacts the suicide in shadows which it will not – need not – make in substance.

Evidently, underlying a cinema of this kind is a fundamental jadedness and lack of energy. It seeks to evoke a state of mind, a quality of feeling, which is saturated in intellectuality but does not give its material any intelligible structure. It is this basic lack of orientation which allows Malle to oscillate so violently between the hyper-intellectual and the vulgar. His next film, *Viva Maria*, starring Brigitte Bardot and Jeanne Moreau, promises to be yet another tightrope-walk. Doubtless, it will be both a commercial success and strong contender for a Golden Lion. But it will probably do little to solve the problems which beset Malle and the rapidly dissipating *nouvelle vague*. It is not only fresh ideas about cinema which are now needed, but fresh ideas about society, about people, about the world. A new cinema demands a new anthropology.

Budd Boetticher

[First published in *NLR* no. 32, July/August 1965, pp. 78–84]

Budd Boetticher is not a well-known director; indeed, even such a knowledgeable critic as Andrew Sarris ranks him among 'esoterica'. Most critics would be inclined to dismiss him as responsible for no more than a few run-of-the-mill Westerns, hardly distinguishable from his equally anonymous fellows – a typical Hollywood technician, a name which flashes past on the credits and is soon forgotten. This would be to misjudge Boetticher. His works are, in fact, distinctive, homogeneous in theme and treatment, and of more than usual interest. He is an author and well aware of it himself; he is lucid about his own films. It is high time critics were equally lucid.

Budd Boetticher's first contact with the movies was in 1941, when Mamoulian went to Mexico to make *Blood and Sand*. Boetticher had already

been in Mexico some years – he went there to recuperate after an American football season – and while there had taken up bullfighting, eventually becoming a professional. Mamoulian hired him, as an American and a torero, as the technical adviser on bullfighting for his film. Boetticher became as enthusiastic about movies as he had about bullfighting and, after three years as messenger boy and assistant director, made his first film, *One Mysterious Night*, in 1944. For a number of years he made ephemeral quickies; his *prise de conscience* as an author in his own right did not come till 1951, when he made *The Bullfighter and the Lady*. For this film, he changed his signature from Oscar Boetticher Jr to Budd Boetticher; he himself has recognised it as the turning point in his career. Even then, it was another five years before Boetticher found the conditions which really suited him. The breakthrough came in 1956 with *Seven Men from Now*; his first film for Ranown Productions, *The Tall T*, came the next year. During these two films the team was assembled with which Boetticher was to make his most characteristic work: Randolph Scott as star, Harry Joe Brown as producer, Burt Kennedy as scriptwriter. *Seven Men from Now* was also Boetticher's first film to get critical acknowledgment: André Bazin reviewed it in *Cahiers du cinéma* under the head, 'An Exemplary Western'. Boetticher made five Westerns with Ranown; they are the core of his achievement. Finally, in 1960, he made his most celebrated work, *The Rise and Fall of Legs Diamond*, for Warner. To make this film, he had to tear up a Philip Yordan script in front of Yordan's face and shoot in such a way that the producer could not puzzle out how to do the montage. Exasperated, he left Hollywood and America, determined, in future, to work under conditions of his own choice. Since then he has made only the unreleased *Arruza* in Mexico, after considerable difficulties. He now has numerous projects but uncertain prospects.

The typical Boetticher–Ranown Western may seem very unsophisticated. It begins with the hero (Randolph Scott) riding leisurely through a labyrinth of huge rounded rocks, classic badlands terrain, and emerging to approach an isolated swing-station. Then, gradually, further characters are made known; usually, the hero proves to be on a mission of vengeance, to kill those who killed his wife. He and his small group of travelling companions, thrown together by accident, have to contend with

various hazards: bandits, Indians, etc. The films develop, in Andrew Sarris's words, into 'floating poker games, where every character takes turns at bluffing about his hand until the final showdown'. The hero expresses a 'weary serenity', has a constant patient grin and willingness to brew up a pot of coffee, which disarms each adversary in turn as he is prised away from the others. Finally, after the showdown, the hero rides off again through the same rounded rocks, still alone, certainly with no exultation after his victory.

At first sight, these Westerns are no more than extremely conservative exercises in a kind of Western which has been outdated. This impression is strengthened by Randolph Scott's resemblance to William Hart, noted immediately by Bazin. The Westerns of Ince and Hart were simple moral confrontations, in which good vanquished evil; since then, the Western has been enriched by more complex sociological and psychological themes. John Ford's *The Iron Horse* (1924) already presaged new developments, which he himself was to carry through as the Western became the key genre for the creation of a popular myth of American society and history. Today, Westerns as diverse as Penn's *The Left-Handed Gun*, almost a psychological study of delinquency, or Fuller's *Run of the Arrow* have completely transformed the genre. Bazin saw, in Boetticher and Anthony Mann, a parallel tendency towards the increasingly subtle refinement of the pristine form of the genre; it cannot be denied that there was a strain of nostalgia for innocence in his attitude. In fact, Boetticher's works are something more than Bazin's expressions of 'classicism', the 'essence' of a tradition, undistracted by intellectualism, symbolism, baroque formalism, etc. The classical form which he chooses is the form which best fits his themes: it presents an ahistorical world in which each man is master of his own individual destiny. And it is the historic crisis of individualism which is crucial to Boetticher's preoccupations and his vision of the world.

'I am not interested in making films about mass feelings. I am for the individual.' The central problem in Boetticher's films is the problem of the individual in an age – increasingly collectivised – in which individualism is no longer at all self-evident, in which individual action is increasingly problematic and the individual no longer conceived as a value per se. This problem is also central, as has often been pointed out, to the work of such

writers as Hemingway and Malraux (Boetticher has himself expressed his sympathy for aspects of Hemingway). This crisis in individualism has led, as Lucien Goldmann has shown, to two principal problems: the problem of death and the problem of action. For individualism, death is an absolute limit which cannot be transcended; it renders the life which precedes it absurd. How then can there be any meaningful individual action during life? How can individual action have any value, if it cannot have transcendent value, because of the absolutely devaluing limit of death? These problems are to be found in Boetticher's films. Indeed, Boetticher insists on putting them very starkly; he permits no compromise with any kind of collectivism, any kind of transcendence of the individual. Two examples will show this.

Boetticher has made only one war film, *Red Ball Express*, with which he was extremely dissatisfied. He later contrasted the Western 'in which individuals (the story must be kept very personal) accept to face dangers in which they risk death, in order to achieve a definite goal' with the war film 'in which armies are flung into danger and destruction by destiny at the command of the countries involved in the war'.

'In other words, I prefer my films to be based on heroes who want to do what they are doing, despite the danger and the risk of death. ... In war, nobody wants to die and I hate making films about people who are forced to do such and such a thing.' Courage in war is not authentic courage, because it is not authentically chosen; it is a desperate reaction. The same point comes out in *The Man from the Alamo*, about a Texan who leaves the Alamo just before the famous battle; he is branded a coward and a deserter. But for Boetticher he shows more courage than those who stayed; he made an individual choice to leave, to try to save his family in their border farmstead. He risked his life – and his reputation – for a precise, personal goal rather than stay, under the pressure of mass feeling, to fight for a collective cause. He is a typical Boetticher hero. 'He did his duty, which was as difficult and dangerous for him as for those who stayed.' (In the same vein, Boetticher speaks of Shakespeare's *Henry V* and of the scene in which the king goes round the camp the night before the battle, when Shakespeare raises the whole issue of the personal involvement of the soldiers in the king's war.)

The risk of death is essential to any action in Boetticher's films. It is both

the guarantee of the seriousness of the hero's action and the final mockery which makes that action absurd. Meaningful action is both dependent on the risk of death and made meaningless by it. Goldmann has described how, in the early novels of Malraux, a solution to this paradox is found by the total immersion of the hero in historical, collective action (the Chinese revolution of 1927) until the moment of death, not for the values of the revolution itself, quite foreign to a hero who is neither Chinese nor revolutionary by conviction, but for the opportunity it offers of authentically meaningful action. Boetticher, as we have seen, rejects this solution; he cannot identify himself, in any circumstances, with a historic cause or a collective action. He takes refuge, therefore, in an ahistorical world, in which individuals can still act authentically as individuals, can still be masters of their own destiny.

The goal of vengeance for a murdered wife which Boetticher's heroes have so often set themselves offers, in a society in which justice is not collectivised, the opportunity of meaningful personal action. Of course, this significance is still retroactively destroyed at the moment of death. The full absurdity of death is quite ruthlessly shown in *The Tall T* in which bodies are thrown down a well – 'Pretty soon, that well's going to be chock-a-block' – and in which the killer (Henry Silva) invites a victim to run for the well and see if he can get there before he is shot, 'to kind of make it more interesting'. The removal of an individual exactly amounts to the removal of all meaning from his life.

Of course, it is quite clear that the moral structure of Boetticher's world is utterly different from the simple moralism of Ince and Hart. There is no clear dividing line between bad and good in Boetticher's films. 'All my films with Randy Scott have pretty much the same story, with variants. A man whose wife has been killed is searching out her murderer. In this way I can show quite subtle relations between a hero, wrongly bent on vengeance, and outlaws who, in contrast, want to break with their past.' And, about the 'bad men' in his Westerns: 'They've made mistakes like everybody; but they are human beings, sometimes more human than Scott.'

The question of good and evil is not for Boetticher a question of abstract and eternal moral principles; it is a question of individual choice in a given situation. The important thing, moreover, is the value which resides in action

of a certain kind; not action to values of a certain kind. Evidently, this is a kind of existentialist ethic, which by its nature is impure and imperfect, but which recognises this. Hence the irony which marks Boetticher's films and particularly his attitude to his heroes. The characters played by Randolph Scott are always fallible and vulnerable; they make their way inch by inch, not at all with the sublime confidence of crusaders. Yet it is possible for Andrew Sarris to talk of the 'moral certitude' of Boetticher's heroes; in fact, he is confusing the philosophical integrity which structures the films with what he takes to be the absolute moral endorsement of the hero. Boetticher sympathises with almost all of his characters; they are all in the same predicament in which the prime faults are inauthenticity and self-deception, rather than infringement of any collectively recognised code. The fact that some end up dead and some alive does not necessarily indicate any moral judgment, but an underlying tragedy which Boetticher prefers to treat with irony.

Something ought to be said about the heroes' style of action; this is not emphasised for its style in itself but as the most effective way of carrying out the action needed to achieve the goal chosen. Boetticher's heroes act by dissolving groups and collectivities of any kind into their constituent individuals. Thus in *Seven Men from Now* and *The Tall T*, the hero picks off the outlaws one by one, separating off each member of the band in turn. And in *Buchanan Rides Alone* the same method is applied to the three Agry brothers who run Agry Town, who, at first grouped together against Buchanan (Randolph Scott), end up, after his prodding and prising, in conflict with each other. Similarly, in the same film, when Buchanan is about to be shot he manages to ally himself with one of the gunmen against the other, by confiding to Lafe from east Texas that all he wants is to head out and get himself a spread by the Pecos River. Buchanan's technique is, by his personal approach to Lafe, to reveal his own individuality to him so that he is no longer willing to act as an agent for somebody else or for the collectivity at large, enforced and enforcing.

Evidently the themes and problems which I have discussed have a close connection to the ethos of bullfighting, about which Boetticher has made three films, and which is personally of great importance to him. The ethos of bullfighting also contains obvious traps and pitfalls; around it has crystallised

The Tall T

an extremely repugnant élitism, quick to degenerate into a cult of violence, tradition and super-humanity. Boetticher does not escape these traps. It is impossible to separate the personal encounter between the bullfighter and the bull, the individual drama of action and death, from the society and social context which surrounds and exploits it. Thus, in *The Bullfighter and the Lady*, the role of the crowd, incapable itself of action, is to provoke the bullfighter into action, even when he is wounded. In this respect, the crowd in Boetticher's bullfighting movies is similar to the women in his Westerns – phantoms, with no authentic significance. 'What counts is what the heroine provokes, or rather what she represents. She is the one, or rather the love or fear she inspires in the hero, or else the concern he feels for her, who makes him act the way he does. In herself, the woman has not the slightest importance.' The crowd, like the heroine, represents passivity in contrast with the hero, the bullfighter, who is the man of action. The danger is clear; it is not so unlikely that Boetticher could follow Malraux into an élitism, in which men of action are thought of as creating values. It is a pity that *Arruza*, the latest and most personal bullfighting film, has not yet been released; it would help clarify this point.

Finally, there is *The Rise and Fall of Legs Diamond*. Legs Diamond (Ray Danton) is the last individualist, the last single king of crime; in the end he is replaced by the syndicate, by the confederation of crime bosses seated around a round table, at which there is no chair for Legs. At which, indeed, he wants no chair. Legs Diamond, moreover, believes himself to be invulnerable, bullet-proof, immortal; he believes in fact that it is impossible that death should deprive his life of all significance. For him his own individuality is an absolute; hence his ruthlessness – afraid that his brother, stricken with TB, will be used as a pawn against him, he abandons him, refuses to pay the clinic bills and shrugs when he is shot dead in his wheelchair. Instead, he boasts that nobody can hurt him, because he has no ties with anybody. And this, in the end, is his downfall. 'You were invulnerable as long as somebody loved you,' and 'He didn't love anybody; that's why he's dead.' Boetticher seems to condemn Legs Diamond because he is incapable of any interpersonal relationships, and to hold that individualism only has any meaning in so far as it recognises the individuality and personality of others and hence its own relativity. 'In the last shot, you are left with just the slush and sleet. That is all that remains of

Diamond. But it is Alice who has to face it. Diamond will never be worried by the cold of the night again.' His life, in fact, was a tragi-farce – and this is how the movie is conceived, not as a didactic story like most gangster movies. In *Legs Diamond*, unlike the Westerns, the heroine, Alice (Karen Steele), is more authentic than the hero, in that she is willing to risk her life acting to save him, but he is unwilling to do the same for her. He has no goal except his own absolute aggrandisement; he dupes himself that there is no further problem.

Legs Diamond is technically and stylistically Boetticher's most remarkable film. It is shot entirely with the techniques actually available and in use in the 1920s; deep focus, uniform lighting, no tracking shots, no dolly, etc. This also enables him to integrate stock shots and newsreel sequences into the movie much more successfully than is usually the case. It is constructed with great dramatic skill, economy and flair with gags. Boetticher has said that he would not want there to be any 'Boetticher touch' like the 'Lubitsch touch'. He distrusts the elegant compositions and 'Frankenheimer effects' and puts the narrative as his first priority; he is not interested in style as such. Nevertheless, *Legs Diamond* is stylistically extremely original. Boetticher's other great asset is his handling of actors: Ray Danton had such a success in *Legs Diamond* that he was even given a cameo appearance in the same role in Pevney's *Portrait of a Mobster*, about Dutch Schultz. Boetticher has given breaks to a great number of good actors: Lee Marvin, Richard Boone, Henry Silva, Skip Homeier, etc. With women he is much less sure – for Boetticher, acting and action as he understands it go together. He is always keenly interested in what actors can do well in real life and tries to fit it into the film (Robert Stack and shooting in *The Bullfighter and the Lady*); he complains about having to use stand-ins for actors who cannot ride, fight bulls, etc. (he himself stood in for Stack in *The Bullfighter and the Lady*). Finally, Boetticher has always insisted that cinema is a visual art; he has more than once expressed his admiration for Cézanne, Van Gogh, Gauguin etc., and regretted that they were never able to make a film.

There is much else which could be said – about Boetticher's attitude to his favourite country Mexico, for instance. But the important thing is to recognise the nature of Boetticher's achievement up till now. In many ways, he is a miniaturist – he does not have great imaginative vigour or panoramic sweep or painful self-consciousness, but works on a much smaller scale and in

a much lower key. In many ways, his concern with individualism is anachronistic, though less so, perhaps, in America, where old myths die hard. But it would be quite wrong to assume that, because his movies are not about the sociological and psychological problems to which we are more attuned, they are without theme or content. I realise that in this review I have committed the cardinal sin of talking about Westerns and philosophy in the same breath; I am quite unrepentant. André Bazin described *Seven Men from Now* as 'one of the most intelligent Westerns I know, but also one of the least intellectual'. Boetticher, himself always a man of action (bullfighter, horseman, etc.) does not give his movies an openly intellectual dimension; nevertheless, he has always insisted that the Western is more than cowboys and Indians, it is an expression of moral attitudes. He has always, since at least *The Bullfighter and the Lady*, taken film-making seriously, to the point of jeopardising his career. And he has consistently made intelligent movies, treating – however intuitively – fundamental themes with great lucidity. He feels that he has not yet made a really successful movie; certainly, some of his films are failures, others – I have mentioned his bullfighting movies – contain dangerous flaws. It is to be hoped that he will be able to complete *The Long Hard Year of the White Rolls-Royce*, which he feels will be *the* film. We can then make a much more definite assessment of his place and of his whole work. He may well surprise many who have till now ignored him.

Alfred Hitchcock
[First published in *NLR* no. 35, January/February 1966, pp. 89–92]

Hitchcock, of course, is a household name. His first film was made in 1921, his first sound film (*Blackmail*) in 1929, his first American film (*Rebecca*) in 1940. He has come to dominate completely the suspense thriller genre; his silhouette on publicity posters is enough to chill spines in anticipation. But he is not only a household name; his films are also, arguably, the pinnacle of film art. At least three serious and extremely interesting book-length exegeses have been devoted to Hitchcock's work; Rohmer and Chabrol's classic *Hitchcock* (Paris, 1965), Jean Douchet's *Hitchcock* (Paris, 1965) and Robin Wood's *Hitchcock's Films* (London, 1965). All these books contain exhaustive accounts and

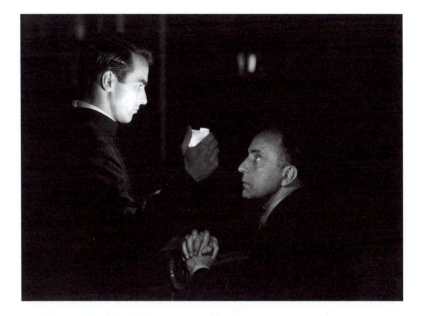

theories of Hitchcock's principal themes: Wood's book, though not the most brilliant, is perhaps the best. The critic, therefore, who now chooses to write about Hitchcock is not, as is usually the case with auteur criticism, starting *ex nihilo*; there is already an established area of critical agreement, and a number of embryonic critical debates are under way. On the other hand, there is still an important task of popularisation of this critical debate to be accomplished. Perhaps the next step should be, as far as space allows, to sketch out the main themes which have been discerned in Hitchcock's films – particularly his recent films – and then, in conclusion, to make some general and synthesising remarks about their implications, connections and importance.

First, there is the theme of guilt: of common guilt and exchanged guilt. A recurrent pattern in Hitchcock's films is that of the man wrongly accused of some crime he has not committed; the plainest example is *The Wrong Man*. This theme is typically developed by revealing how the wrongly accused man could very well have been guilty; he is compromised in all kinds of ways. And by

I Confess

identification with the hero, the audience is compromised as well; this is the theme of common guilt. A frequent dimension of this theme is the transition from play to reality; in both *Rope* and *Strangers on a Train* ordinary people at a party play with the idea of murder, revelling in the idea; in each case they are talking to a real murderer: words have become unpleasantly and ambivalently involved with deeds. *Strangers on a Train* takes the theme further with the notion of exchanged guilt: Guy and Bruno both have strong motives for committing murder, as they mutually – though tacitly – admit; when Bruno actually commits one murder, Guy is inevitably implicated in his guilt. Hitchcock's world is never one of a simple division between good and evil, purity and corruption; his heroes are always involved in the actions of the villains; they are separated from them only by a social and moral convention. During the film they become guilty, and this guilt can never entirely leave them. In *I Confess*, for instance, the priest hero is found legally guilty of murder – there was a clear motive – but the true murderer is later revealed and the priest freed; but, though the juridical guilt is thus annulled, the moral guilt remains.

Second, there is the theme of chaos narrowly underlying order. Hitchcock's films begin, typically, with some banal events from ordinary, normal life. The characters are firmly set in their habitual setting, a setting more or less the same as that in which the audience must pass their lives. Then by a trick of fate, a chance meeting or an arbitrary choice, they are plunged into an anti-world of chaos and disorder, a monstrous world in which normal categories shift abruptly and disconcertingly, in which the hero is cut off from all sustaining social relations and flung, unprepared and solitary, into a world of constant physical and psychological trauma. In contingent detail this anti-world is the same as the normal world, but its essence runs completely counter. It is a world of excitement as against banality, but it is also a world of evil, of unreason. Thus, in *The Birds* the quite ordinary small-town world of Bodega Bay is abruptly shattered by the meaningless attacks of the birds. Everything is turned upside down: instead of civilised man caging wild birds, wild birds encage civilised man, in telephone kiosks and in boarded-up houses. This is not just an image of doomsday or vengeance; it is also an image of the precariousness of the civilised, rational order. Even a film like *North by Northwest*, usually considered nothing more than a divertissement, exhibits the

same theme: Thornhill is kidnapped in a hotel lobby and is suddenly flung into a world of international political intrigue and calculated murder. The utterly public and commonplace Mount Rushmore monument is turned into the scene of an intense, private drama, quite surreal and incomprehensible to an out-sider, a normal onlooker. (Hitchcock frequently uses these public monuments for startling episodes in the intrigues of the chaos-world: the Albert Hall, the United Nations, etc.; their use universalises the chaos.)

Third, there is the theme of temptation, obsession, fascination and vertigo. Once the heroes have left the world of order and reality for the world of chaos and illusion, they are incapable of drawing back. They are enthralled, terrorised but excited; chaos and panic seem to meet some unexpressed inner need; there is a kind of obsessive release. In *North by Northwest* Thornhill insists on re-entering the chaos-world when, after his trial for drunkenness, he has a chance to fall back into normal life; it is as if he must find out the meaning of the absurd events which overtook him and somehow capture them for the world of reason. In fact, he enters more and more into the world of unreason, unintelligibility and the absurd. In *Rear Window* Jeffries obsessively involves himself in the unreason he observes in the block opposite until it bursts into his own private room. And in *Vertigo*, when Scottie is cheated of his dream he tries to rebuild it out of reality, almost demanding the disaster which eventually occurs. The film, as Rohmer has pointed out, is full of spiral images, images of instability and mesmerisation, images of spinning down into darkness. (These spiral images in Hitchcock's films are usually associated with the eye, spiralling out of the light into the dark pupil and again – with a special meaning in the context of the cinema – being mesmerised by the world of appearances.)

Fourth, there is the theme of uncertain, shifting identity and the search for secure identity. In the great majority of Hitchcock's films, there are repeated and complicated cases of mistaken or altering identity. Clearly, this links up with both the exchange of guilt theme and the chaos-world theme. One implication is that identity is a purely formal social attribute, rapidly destroyed by kaleidoscopic changes in social co-ordinates; only rarely can it be said to represent a relatively autonomous core of being. And, not only is it a formal attribute, but it is easily confused and merged with the identity of others. Mere

accidents of physiognomy, clothes, documents, etc., not only confer the formal identity of somebody else, but even their moral being, their history and their guilt. And, in the same way that identities merge, they also split up and disintegrate into separate, parallel identities: in *Marnie* for instance, the heroine changed her identity by changing her clothes and dyeing her hair. The same thing happens with the transformation of Madeleine into Judy in *Vertigo*.

Fifth, there is the theme of therapeutic experience, strongly insisted on by Robin Wood, but about which I am more dubious. Wood argues particularly from the case of *Marnie* instead of representing a development in Hitchcock's moral thought, a recognition that descent into the chaos-world is not irrevocable, that identity can be secured, that guilt can be purged, that it might turn out to be merely a more superficial film with rather a shallow confidence. Again, it seems to me rather doubtful to argue, as Wood does, that Jeffries goes through a therapeutic experience in *Rear Window*. Wood quotes Douchet's view that the block opposite is like a cinema screen on to which Jeffries projects his own subconscious desires in a kind of dream form – particularly his desire to get rid of Lisa, his future wife – and that these desires erupt destructively into his own life, punishing him. And, in particular, punishing him (and by implication the involved cinema audience) both for the sin of curiosity and for the urge to work out interior desires in externalised fantasy. Wood insists that a murder is actually detected and a marriage actually affirmed. But, on the other hand, he concedes that, in one sense, nothing has changed: Lisa, at the end, is looking at the same fashion photos, though this time inside a news magazine cover: her new understanding is hypocritical and illusory. And, though murderers are brought to justice in Hitchcock films, this does not simply mean a triumph of order and reason; more often than not, reason can only be reasserted through the violent and inextricable entry of unreason into its world: a dialectical paradox vividly expressed in the startling, mad denouements of so many Hitchcock films: the nun in *Vertigo*, the Mount Rushmore climax of *North by Northwest*.

Finally, there is the notorious mother theme, important in *Strangers on a Train* and reaching its final macabre conclusion in *Psycho*. Even in the family, what is presumed to be the most secure and loving of relationships is revealed, in the most grotesque and macabre way, to be potentially horrific and

destructive. The world of chaos inhabits the family itself. It is worth noting that the theme of the mother has really come into its own in American films: presumably, the legendary American mother made a strong impression on Hitchcock.

Indeed, Hitchcock's pessimism and emphasis on unreason and chaos has grown immeasurably stronger during his American period. His British films, by comparison, are light-hearted and amusing, without either the sinister undertones of the American films or, more importantly, the serious themes which shape them. Hitchcock seems to have been rather affectionate towards English hierarchised class society and rather admiring of its continuity and stability. It was not till he reached America that he began to see society as precarious and fragile, constantly threatened by unreason.

Something should also be said about two further dimensions of Hitchcock: his Catholic upbringing and his attitude towards psychology. Rohmer and Chabrol insisted that Hitchcock is still a Catholic director; I do not think this can be sustained, though clearly he has been very much influenced by Catholicism. This is readily confirmed by the overt evidence of *I Confess* or *The Wrong Man*; the theme of guilt is particularly pertinent. On the other hand there is no parallel theme of redemption, certainly not through the proper channels.

Many critics have attacked Hitchcock for his rather ham-handed attitude to Freudian psychological theory – his vulgarisations of dream experience and psychotherapy in *Spellbound* and *Vertigo*, his portrayal of trauma in, say, *Marnie* and the glib conclusion of *Psycho*. It must be admitted that there are few niceties in Hitchcock's psychology; he has adopted various key Freudian ideas which he uses quite unashamedly in whatever way he sees fit. But the point is that Hitchcock is not primarily interested in the medical diagnosis and therapy of psychosis; indeed, this is just the kind of ordered, rational triumph of reason over disorder which he rejects. He is concerned with showing the proximity of chaos to order and their recurrent, arbitrary (irrational) interpenetration, their mutual subordination to each other. He is interested in the moral reality of unreason and not the medical categories of madness. Freudian vocabulary and imagery is necessary to locate his themes in the modern world; but he is himself locating Freud in a different world of his own.

Hitchcock's films are primarily moral. They portray a dialectical world in which the unreason of nature narrowly underlies the order of civilisation, not only in the external but also in the internal world. This unreason is common to all men, erupts in all men. We are fascinated by it and need to involve ourselves in it in an attempt to make it intelligible. There can be no purity, no withdrawal. We must recognise the precariousness of our security. Hitchcock's vision is intensely pessimistic, in a sense almost nihilistic, but it is worked out on several levels and in several dimensions. He is a great film-maker.

Josef von Sternberg
[First published in *NLR* no. 36, March/April 1966, pp. 78–81]

Josef von Sternberg remains best known as the director of a sequence of films with Marlene Dietrich in the 1930s, starting with *The Blue Angel* in Germany and then continuing in Hollywood. Usually these are thought of as 'glamour' films, successful because they took people's minds off the miseries of the Depression era, but today dated, bizarre and basically contentless and empty. Josef von Sternberg is remembered as an eccentric and monomaniac director, creator of a shopgirl's dream world, unable to ride with the times into the post-war 1940s. Still he retains a certain legendary splendour, an aura of the days when Hollywood was really Hollywood.

In fact, Sternberg's career stretches both before and after the Dietrich period, starting with *Salvation Hunters*, shot in Hollywood in 1925, and concluding with *The Saga of Anatahan*, shot in Kyoto in 1953. Throughout this period Sternberg fought a continuous bitter battle for full control over the films he was directing, in order to put into effect the theories of cinema which he had developed. This struggle met with limited and uneven success. Indeed, it was not until his very last film, made not in Hollywood but in Japan, that Sternberg was allowed anything like the freedom he desired. As we see Sternberg's films, then, we are forced to decipher the true sense of his work through a structure which has been repeatedly distorted and betrayed.

Sternberg strongly believes – and his belief has been strengthened by his experience in the cinema – that art is the prerogative of a creative élite, appreciated only by a minority. He interprets interference by producers with

his work as an attempt to cater to the taste of the masses, necessarily a lowest common denominator. Cinema is always being degraded and debased, but its vocation is to be an art. His view of human history is fatalist and stoic. Little changes. There is no essential point of difference between Heraclitus and John Dewey, Praxiteles and Maillol, Aesop and Walt Disney. Perhaps there is progress in technique, but, on the other hand, perhaps taste actually deteriorates. Fundamentally, mankind is still in its infancy – uncontrollable and self-destructive, panic-struck and full of guilt – and shows scant sign of ever escaping it. Only the artist is able to create anything which escapes the depredations of his fellows and of time. His task is to grasp the myths which most highly express the human predicament and, by mastery of style and technique, reinterpret them to each age. To achieve this, he must understand both the character of the human condition and that of his chosen art.

Cinema, to Sternberg, is a new art with its own specific qualities. The secret of the cinema is light: image in motion encountering light and shadow. He puts great stress on this formal specificity of the cinema: he even envisages projecting his films upside-down so that the play of light and shadow in movement is undisturbed by the intrusion of extraneous elements.

Sternberg maintains a contemptuous attitude towards actors, whom he views as no more than the directors' instruments. 'Monstrously enlarged as it is on the screen, the human face should be treated like a landscape.' Fundamentally, its expressivity is due, not to the intelligence or skill of the actor, but to the way in which the director illuminates and obscures its features. (It is not surprising that the two actors about whom Sternberg is most scathing – Emil Jannings in *The Last Command* and Charles Laughton in the unfinished *I, Claudius* – are especially famous for their virtuosity as actors. Similarly, Marlene Dietrich, whom he launched from nowhere and whom he depicts as always unbelievably servile to his slightest whim, was his favourite actress. He was destined, in a society where women – and, by extension, actresses – are predisposed to be servile and passive, to be a 'woman's director'.)

It is clear that somebody who, like Sternberg, views human history as a goalless charade and art as a privileged activity, should stress not realism but artificiality. He has always prided himself on the artificiality of his sets and his plots. 'I was an unquestioned authority on Hollywood, and that made it difficult

to be unrealistic in picturing it. I felt more at home with the Russian Revolution, for there I was free to use my imagination.' On the other hand, Sternberg nurtures the fond hope that, in this way, he can go to the heart of a situation, undistracted by petty detail, by what he refers to as 'the fetish of authenticity'. In this sense, he sees his work paradoxically as realist rather than symbolic.

Sternberg's work, if anything, is baroque. Yet, at the same time, this is vitiated by a strong streak of nineteenth-century sentimentality. Perhaps it is rather facile to connect this with his early years in Vienna; Sternberg himself acknowledges the influence of Schnitzler, but hardly ever mentions the baroque which dominates the city. But all the marks of the baroque are in his work: the importance of movement, of light and shade, the multiplicity of ornament, the curious coexistence of abstraction and eroticism, extravagance and chimeras, the retreat from realism into imagination. Sternberg's vision of himself and his art is curiously akin to that of, say, Bernini, even down to the fascination with carnivals. The typical Sternberg film is festooned with streamers, ribbons, notes, fronds, tendrils, lattices, veils, gauze, interposed between the camera and the subject, bringing the background into the foreground, casting a web of light and shadow (as Sternberg put it, concealing the actors). All sharp edges and corners are veiled and obscured and everything, as far as possible, made awash with swirls of moving light.

Connected with this baroque sensibility is Sternberg's obsessive interest in the phantasmagoric quality of human life. His autobiography contains numerous long drawn-out evocations (echoed in *Shanghai Gesture*, *Macao*, etc.) of gambling dens in Shanghai, cock-fighting arenas in Java, striptease shows in Havana, pagan dances in India, camel markets in Egypt, etc. (Shanghai and Havana, of course, are now denied him: China has been 'shuffled', in Cuba Castro is 'drest in a little brief authority'). He seems to owe this fascination – or at least relate it – to his childhood fascination with the Prater Gardens in Vienna, a phantasmagoric memory of jugglers, tumblers, midgets, sword-swallowers, weightlifters, bearded women, Red Indians, elephants, two-headed calves, magicians, cannibals, mazes of mirrors, etc., all thrown together under the giant ferris wheel. (Sternberg directly celebrates the Prater in *The Case of Lena Smith* in 1929.) However, it presents some theoretical difficulties for him, since these entertainments are so unashamedly – even luridly – popular.

Whenever on occasion my work has found favour with the crowd, the sources within me which were tapped were never obvious to me. To make contact with the emotions of a crowd would not have been difficult for me had I accepted its criteria and used the formulas to please it, which never vary ... [and yet] ... nothing that has ever stirred a crowd has failed to find an echo in me. I plead guilty to more susceptibility than I was always able to cope with. Nor are my intentions, rarely successful, meant to camouflage my mistakes.

In fact, Sternberg's 'mistakes' are an integral part of his vision of the world: the counter of his aristocratic disdain and aloofness, of seeing in art the only stability, is to be obsessed with the grotesque, fantastic dream-like quality of popular life and its ceaseless carnival-like instability, as he would see it.

Something more, perhaps, should be said about the roles of Marlene Dietrich in Sternberg's films. Sternberg himself indignantly disavows every

The Scarlet Empress

accusation that he set out to exploit Marlene Dietrich's physical attraction; indeed, he is constantly very contemptuous about the 'attractiveness' of actors and actresses, contrasting them unfavourably with scarecrows, which are designed to repel. He refers to her always in the most abstract terms. He modelled her, he claims, on the paintings of Felicien Rops and Toulouse-Lautrec; what appealed to him was her disdain and coldness: in this, he was consciously distancing her from what he thought of as erotic. He deliberately encouraged a de-feminising image of her, by dressing her in men's clothes for her nightclub performances. In *The Scarlet Empress* she ends up playing an explicitly male role. Of course, this contrasts strangely with his autocratic manner towards her and his claim that she would obey anything he ordered, to the extent of laying an egg for him if he didn't like the one prepared for his breakfast. Once again he ended up producing in art the direct converse of what he thought true of life. He was fascinated by the shifting and ambiguous roles of dominance and servility: this is made clear by *The Blue Angel* and *The Last Command*, in which a despotic Russian general becomes – by a twist of fate – an abused film extra who is made to play the role of a despotic Russian general. In his attitude to Dietrich, strains show: for instance, the sentimentality of the child's bedtime story in *Blonde Venus* or the prayer and station reconciliation scenes in *Shanghai Express*. These are the occasions on which woman is – rather pathetically – put back in her place. But, as a general rule, woman is consciously de-feminised – yet she remains so radically 'other' that this only serves to accentuate her specificity and hence, by making her even more problematic, her mystery.

Finally, a word should be said about *The Saga of Anatahan*, Sternberg's most personal film, in which he recapitulates the whole of human history and his urge to destruction. Perhaps the most interesting aspect of this film is his attempt to overcome the problems brought by the introduction of sound film. For Sternberg, this was almost a disaster: it threatened to subordinate the tempo of cinema to that of speech, the camera to the microphone and the director to scriptwriter and actor. In *Morocco* he deliberately chose a fatuous story in order that the importance of words should be minimised. In *The Saga of Anatahan* he reaches a more satisfactory solution: the actors talk throughout in Japanese and a commentary by Sternberg himself is inserted

over the other sound. This gives him much greater freedom in choosing the right rhythm for the montage. It has been the most important attempt to solve the difficult problem of sound, which – as Eisenstein foresaw and feared – destroyed classical montage, perhaps until the work of Godard, who has, of course, found a much more complex and original solution, based partly on the use of visual written words, partly by sound mixing, partly by deliberate passages of silence and by special use of music and song.

By emphasising the role of the (autocratic) director and by fixing the specificity of the cinema to the problems of light and shade, Sternberg became a director of great originality. His work is unmistakable. On the other hand, these very characteristics, in his case, went hand in hand with other *parti pris* which tend to vitiate his achievement. His emphasis on the privileged role of the creative individual has led him to a retreat from realism which, on occasion, becomes blind and ludicrous. His distaste for words and for actors has led him to a dehumanisation which, at the same time, is infected with an unrejected Viennese sentimentalism. The whole trend of cinema has been away from the baroque sensibility which most obviously marks the work of Sternberg. But the obvious similarity between the predicament of the baroque artist and that of the cinema director means, almost certainly, that Sternberg will have and hold a (constantly disputed) place in the history of the cinema. Few, at any rate, will want to deny the originality of the director of *Underworld* (the seminal gangster film), *Dishonoured* and *The Saga of Anatahan*.

Jean-Luc Godard
[First published in *NLR* no. 39, September/October 1966, pp. 83–7]

I had intended to write about Godard before reading Robin Wood's article [also in *NLR* no. 39]; the first thing which struck me as I read it was that, though I agree that the issue which he raises is one of the key ones, the words which he uses and stresses are quite different from those I would choose. This springs, of course, from an underlying difference in critical method: his terminology, like his method, is largely derived from that of F. R. Leavis. There is no doubt about the provenance of words such as 'tradition',

'identity', 'wholeness', etc. In a sense, then, my own interpretation of Godard's films, juxtaposed with Robin Wood's, implies not only a clash of opinions but also a clash of method and, in the last analysis, a clash of world-views. But first Godard's films.

The cultural references in Godard's films are, as Robin Wood writes, 'not decorative but integral'. For Godard culture is hardly able to sustain itself; it is not intelligence, but violence, which makes the world go round. 'Il faut avoir la force quelquefois de frayer son chemin avec un poignard.' It is the world of *Les Carabiniers* of *Ubu Roi*, which Godard has said he would like to film. It is a world in which the newspapers, as in *Bande à part*, are full of almost surrealistic excesses of violence; it is a world of Algeria, of San Domingo, of Vietnam, to which Godard makes constant references and which give the larger context of his films. And this all-pervasive violence is also vandalism. It is the execution of the girl who recites Mayakovsky in *Les Carabiniers*, it is the destruction of books in *Alphaville*, it is the suicide of Drieu La Rochelle or Nicolas de Staël.

But we do not condone this world of violence and vandalism into which we are thrown. Where is the vein of optimism which prevents us from committing suicide? The answers which Godard explores are the romantic answers of beauty, action, contemplation. The antinomy between action and contemplation or reflection is recurrent in Godard's films. Action is the correlate of adventure; it is to leave behind the everyday norms of life, to leave for Rome, for Brazil (both *Le Petit soldat* and *Bande à part*), for the Outerlands: topographic symbols for a world in which all conduct is improvised, experimental – yet at the same time symbols also of withdrawal, of distancing and hence of contemplation, of repose (the Jules Verne paradise of *Pierrot le fou*). In *Le Petit soldat* reflection follows action ('Pour moi, le temps de l'action a passé! J'ai vielli. Celui de la reflexion commence'). In the story of Porthos told by Brice Parain in *Vivre sa vie* reflection prevents action, it is a form of suicide; in *Pierrot le fou* action, incarnated by Marianne, and contemplation, by Ferdinand, prove mutually destructive.

The problem is also that of time: above all, of the ambiguous nature of the present. For Godard, the present is both the moment in which one feels oneself alive, the existential moment of responsibility for lighting a cigarette,

and also the monstrous unstructured, dehistoricised desert of *Alphaville* or *Une Femme mariée*. Increasingly, in Godard's films, the present has become the realm of woman: he remains uncertain whether it is a realm of innocent hedonism or of mindless viciousness. Already – in Veronica, in *Le Petit soldat* – we see this dilemma: the beautiful cover girl who likes Paul Klee and Gauguin and who is at the same time a terrorist who dies under torture. In *Pierrot le fou* it is even more evident. (While on this point, it may be worth commenting on the resemblance between Alpha 60's interrogation of Lemmy Caution and Nana's of Brice Parain.)

Another recurrent feature of Godard's attitude to women is that they are traitors. Patricia betrays Michel in *À bout de souffle*; Marianne betrays Ferdinand in *Pierrot le fou*. Living in the present means to be unable to bear any fixity of relations with others, which would imply a past and a future. Yet set against this image of woman is one drawn from romanticism, from

Le Petit soldat

association with ideas of purity, beauty, etc. It is Godard's inability to resolve this contradiction which explains his continuous hostile fascination with women, reminiscent in a way of Hitchcock.

Hence, too, the instability of his portrayal of women: certain constant features remain, but with different degrees of emphasis and in a number of different combinations. Thus, for instance, there is a criss-crossing of roles between *À bout de souffle* and *Pierrot le fou*: the car-stealer, murderer, gangster is no longer Michel but Marianne; the companion is not Patricia but Pierrot. (The character of Patricia is further complicated by a reversal of roles between Europe and America – a kind of anti-Henry James – in which Michel is the B-feature Bogart hero, Patricia the intellectual reading *Wild Palms*.) Again, some of Patricia's innocence survives in Veronica and is then further refined into the girl who recites Mayakovsky in *Les Carabiniers*. And she, in turn, is the polar opposite of the protagonist of *La Femme mariée*, who herself inherits something of Patricia's shiftlessness and capacity for betrayal.

Next, there is Godard's attitude to freedom. For him, freedom is always personal freedom: he recognises no social ties. His heroes, like those of Samuel Fuller, operate in a perpetual no-man's-land, a labyrinth in the interstices of society. Freedom is, in very simple terms, doing what you want to when you want to. The sharpest test of freedom, for Godard, is torture. Bruno, in *Le Petit soldat*, does not want to give information: even if he did, he would not want the occasion forced on him. To do what one wants – to be silent – when under torture is the extreme of personal freedom. Yet at the same time freedom is interwoven with destiny: men choose their own fate, but it remains a fatality also in its impact on us. Thus Michel Poiccard chooses, by not escaping, to be shot by the police – but when he is shot, it takes on the form of destiny. And when Ferdinand dies at the end of *Pierrot le fou*, he has chosen to commit suicide while, at the same time, the image of the spark travelling along the fuse makes it a fatality.

These themes interconnect with Godard's attitude to the cinema itself. The cinema is both the double of life and, at the same time, an artifice. It is both instantaneity – action now – and permanence, a kind of memory. It is both America, innocent, without history, and Europe, part of a fragmented culture and itself the most eclectic of arts. It is both the freedom of the travelling shot and the necessity of the frame. Robin Wood comments on the

analogy between the improvised conduct of Godard's heroes and the improvised form of his films and on the use of allusions to strip cartoon to emphasise one aspect of cinema, just as documentary is used to emphasise another. Godard himself has commented on the paradoxical nature of the cinema, on its being a series of Chinese boxes of reality and illusion, as in Renoir's *The Golden Coach*. This reflects not only his attitude to the cinema, but also his attitude to life itself, in which war, for instance, as in the Mayakovsky fable in *Les Carabiniers* or the Vietnam charade in *Pierrot le fou*, is both an absurd pantomime and a horrible reality. But in the last resort the problem for Godard has always been to tell the truth – hence his admiration for Brecht and Rossellini.

In many ways, what I have said about Godard echoes what Robin Wood says, though with a different accent. But I feel there is also a radical difference between our points of view. The problem centres round his use of the word 'tradition', in a way which makes it almost synonymous with 'culture'. For Godard, I think, culture is not intimately part of society: it is what remains of the work of artists, many of whom were antagonistic to society, marginal to it, indifferent to it. If society has any meaning at all it is as an instrument of violence. It is defined by the soldier and the police.

The artist is something quite different; he is somebody who is pursuing a kind of personal adventure. There seems no reference in Godard to the possibility of a culture securely integrated into society, in the sense suggested by tradition. Thus there is not wholeness and fragmentation, but violence and beauty, vandalism and art, brute force and intelligence. The first are the main characteristics of the world into which we are thrown, the second are the values on which we may base a personal search.

'Godard rejects society because society has rejected tradition.' I think not: Godard's belief, as shown in the films, is that the exercise of freedom is incompatible with observance of prevalent social norms (whether these could be called traditional or not) and that art or culture has no social function but is all that remains of a disparate number of individual adventures, individual searches. In fact, in that society is fundamentally vandalistic, art is essentially dysfunctional: there is no possibility whatever of a cultural tradition in Robin Wood's sense, only a kind of cultural guerrilla war.

The void in Godard's view, evidently, is the absence of politics. In a sense, Godard himself acknowledges this: he talks, for instance, of the possibility of making political films in Italy, though not in France. Yet, in another sense, he is not deeply interested: he talks of politics as what you see the other side of the window and, citing Velázquez, speaks of portraiture as the highest form of art. Interestingly, whenever revolutionary politics enters his films, it is defeated: Veronica is killed in *Le Petit soldat*, the partisans are shot in *Les Carabiniers*, the Dominican student is exiled in *Pierrot le fou*. I think this helps Godard evade the issue; it is the romantic cult of defeat, of nostalgia for Spain, etc. Desperately, Godard falls back on individualism and attempts to reconstitute the legend of the American frontier in contemporary France: Jesse James reappears as Pierrot le Fou. Yet, as Robin Wood says, he adopts no easy or comforting solutions: there is a relentlessness about *Pierrot le fou* which is, not that of a lost traditionalist, but that of a lost revolutionary.

For if, as seems evident enough, Godard is radically dissatisfied with society, then it is the absence of politics which condemns him to rootlessness and despair. To be dissatisfied, after all, is to want change. Politics is the principle of change in history; when we abandon it nothing remains except the scattered, expendable efforts of artists and romantics. In this sense, as Godard has said, art is always left wing. Tradition is the enemy. The tradition of our society, it would be hard to deny, is violence, vandalism, oppression and its developing sanctions, the advertiser's copy and the carabinier's gun.

Roberto Rossellini
[First published in *NLR* no. 42, March/April 1967, pp. 69–71]

Rossellini's reputation has ebbed and flowed more perhaps than that of any other leading director. In part this has been because of the nexus between politics and film criticism in Italy, in part because of changes in fashion and taste, in part because of the personal scandals which have punctuated Rossellini's career. Nevertheless, looked back on now, from the near peak of his achievement, *The Seizure of Power by Louis XIV*, his work shows a remarkable consistency, thematically and stylistically. He has persevered on his own path; sporadically this has criss-crossed with the stampede of popular and critical taste.

Rossellini's themes are fundamentally Italian, indeed southern Italian. The humus from which his themes spring is that of traditional Catholic (superstitious and semi-pagan) southern Italy about to be sucked into the vortex of northern Europe, with its entirely different kind of civilisation, cultural and social. Thus we find at the centre of his work the antagonistic couplets north *v.* south, cynicism *v.* innocence, positivism *v.* spirituality, etc. His Bergman cycle, for instance, is dominated by the theme of the northern woman coming south and undergoing a spiritual crisis, from which she emerges with a kind of religious faith. It would be misleading to call this faith Catholic: in many ways, with its emphasis on acceptance, it is Oriental (Buddhist or Hindu) and, of course, this becomes explicitly apparent in his film *India*. In terms of Christianity, Rossellini's vision of sainthood is close to the Dostoyevskian holy fool, to Simone Weil (whose influence Rossellini acknowledges) or to a kind of legendary Franciscanism, alluded to in several films, including of course his version of *The Little Flowers*.

This emphasis on naïve faith and acceptance naturally goes hand in hand with an unabashed populism: in *The Miracle* or *The Machine for Exterminating the Wicked* this takes the form of an extreme indulgence in southern Italian superstition, to the point of centring films around 'miraculous', supernatural events, which Rossellini justifies as part and parcel of popular culture. In *Europa 51* there is a clear distinction drawn between the 'human' slum-dwellers and the 'inhuman' bourgeois and bureaucrats: priest and *Paese Sera* journalist occupy an uneasy middle position. Again, Rossellini's Resistance films are populist in tone, with the same curious tensions between priest and Communist. This populism has led to political difficulties for Rossellini: he has often succeeded in disgruntling both the Communist Party and the Catholic Church. (In *Vanina Vanini*, for instance, Rossellini actually used both Marxists and priests as scriptwriters, so that the tension between Catholic and *Carbonaro* in the film was actually thrown back into the scriptwriting, with predictable results.) In fact, Rossellini is scarcely interested in politics, but he has a troubled consciousness (which would now be called Johannine) of the overlap of Church and Party in much popular (peasant and *petit bourgeois*) culture, which is uneasily reflected in his films.

The counterpart of Rossellini's populism is an intense patriotism and also a concern with heroism: not as a psychological so much as a socio-

political category. His patriotism is the natural result of his confidence in Italy and expresses itself in his constant return to first the Resistance, then the *Risorgimento*. (Rossellini's retreat backwards into history, following that eastwards to India, springs from his disenchantment with the cynicism of modern Europe: a search for the pure well of life, in fact.) In *Viva l'Italia* it is clearly linked with the theme of heroism: Garibaldi is the popular hero (in the same way that St Francis is the popular saint). The two films have the same oleographic quality. Rossellini's approach is to bathe Garibaldi in a charismatic aura, while at the same time stressing his 'human' weaknesses and foibles, such as his gout. With this kind of concept of the hero, it is not hard to make the transition from Garibaldi to Louis XIV.

I have sketched Rossellini's themes first because it is important to point out that his work has this thematic consistency, in view of the rhetoric about 'realism' with which critics have always surrounded his films. It is easy to see what 'realism' means when applied to Rossellini: it means the absence, to an unusual degree, of professional actors, stage sets, make-up, a prearranged shooting script, etc. It means a grainy, rather rough-and-ready look, reminiscent of newsreels, far from Hollywood 'quality'. But this is a question of method and style: it in no way means any greater quotient of truth or reality as regards the thematic content of the film. This is not to say that form and content are unrelated: the ideology of 'acceptance' and 'patience' which relates to Rossellini's views of sainthood also relates to his methods of work, to the concept of the camera which records (accepts the given, eliminating directorial intervention) and follows (patiently waiting the moment of revelation). Similarly, his episodic method of construction (*Paisà*, *The Little Flowers*, *India* etc.) springs from a dislike of 'artificial' plots, which parallels his dislike of the 'artificiality' of modern European society.

In some ways, Rossellini's 'realism' is a correct, more honest concept than others: the natural concomitant of the non-intervention of the director is the non-intervention politically of man in the natural course of history (or, as in *India*, in the natural cycle of life and death). The left-wing ideology of 'realism' has great difficulty in overcoming the inconsistency of an approach that both stays at the level of the phenomenal forms and also demands the revelation of an esoteric (essential) meaning: the traditional Marxist attack

(derived from Taint and Blinks) adumbrates a theory of types, as distinct from contingent phenomena, but this has obvious drawbacks: it easily falls into schematism or even sentimental idealisation.

Rossellini's impact has been considerable; he has represented the opposite pole to, say, the American musical (the Lumière tradition as against Méliès). He has reminded directors that there is a scale of possibilities of *mise en scène*, at one end of which he stands. He has thus contributed enormously to the development of contemporary cinema: we can see his influence on Godard, for instance, in his use of episodic construction (*Vivre sa vie*), his deliberately non-quality photography (*Les Carabiniers*), his portrait of Karina (echoing Rossellini's portraiture of Bergman). In this sense, Rossellini is a historic director. He is also a consistent author, who has persevered in developing his personal themes and style in adverse circumstances. He also has obvious limitations, as this article will have suggested, if only cursorily: these are clearly related to the uncritical character of his realism. For, despite the vaunted objectivity of the lens, the world reveals itself to Rossellini much as he had subjectively envisaged it.

Roma città aperta (1945)

Conclusion (1969)

The only possible conclusion is that an enormous amount of work still remains to be done. We all believe that the mass media play a crucial role in our society. We all believe that it is important to understand the operation of visual images. All these things have been reiterated time and time again, each time more vociferously than the last. Yet, in reality, in Britain and America at least, almost nothing is actually achieved.

At the root of the trouble, I think, is the strange disproportion that there is between the arts throughout the educational system. Literature has an overwhelming preponderance. Painting is quite strong. Music is weak. Cinema is almost non-existent. Moreover, literary criticism, as well as being privileged, is also parochial. Very few literary critics see the problem of 'literariness' as part of the broader problem of 'art-ness' or conceive of novels and poems as being of the same order as sculptures or symphonies. Ideally, the theory and criticism of the various arts should interact to the mutual advantage of each. The problem of narrative, for instance, is common to cinema and music. The problem of allegory is common to painting and poetry. And, of course, the theory of each separate art should be grounded on a general theory of aesthetics as a province of semiology.

The much greater weight given to literary studies has damaging effects on the study of the other arts. It leads very often to an over-reaction against literature. We can see this, in a very virulent form, among disciples of Marshall McLuhan. Elsewhere, it leads to the simple adoption of literary critical methods where they are not necessarily altogether adequate; this often tends to happen in

film criticism. In fact, I think cinema is probably closer to literature than to any of the other arts. I do not believe that we should abandon print culture or anything of that kind. Nonetheless, I am more and more convinced that a large part of the resources and time now devoted to literary criticism and the study of literature should be shared out much more equitably among the other arts. I cannot see what marks out one art as more important for study than any other. At university level, faculties of film, of music, of design, of art history, should be as frequent as faculties of literature. In schools, instead of all teaching literature as a major subject, many should teach the other arts. In these schools, literature would occupy the subsidiary place now allotted to painting and music.

This kind of massive reform would also imply, of course, a reassessment of the role of aesthetics. As I have emphasised earlier, aesthetics is, by and large, a demoralised subsidiary of philosophy. This should be changed. Moreover, philosophy itself would benefit from the shock of its junior partner emancipating itself. Perhaps it would be no bad thing if large tracts of philosophy were similarly emancipated, so that they would bear the same relation to the teaching of history or political science, for example, as aesthetics would to art. Philosophy, in fact, would be dissolved into theory. Whatever proved indissoluble could be retained as philosophy: epistemology, logic and axiomatics, for example. In any case, there seems no good reason why the study of aesthetics should be divorced from the study of literature. And, by the same token, aesthetics should be studied along with music, film and the other individual arts.

Of course, the problems in the way of film study do not all spring from the recalcitrance of the academic and educational system. To begin with, there is the enormous problem of film availability. Very few governments have yet had the courage to bring in legislation on the statutory deposit of films; in Britain, the National Film Archive bears little comparison with the British Museum Library: it is forced to beg for films, to try and buy those it can afford and to ask for gifts when it has not got the resources to purchase. Some companies grudge giving films to the Archive, presumably because they are afraid that this would somehow eat into their profits. Other companies give old scratched copies. The whole situation is completely deplorable. There are countless films which are not available in Britain; those who want to see them, for purposes of research, have to travel abroad.

Moreover, the policy of the Archive is only to show films if they have had a second print made, so that one print at least remains undamaged by the wear and tear of projection. All Archives face the same dilemma: either they show the films they have, in the hope that they will thus create an informed and enthusiastic public of *cinéphiles*, a rich film culture, but at the cost of damaging the films in their collection, eventually perhaps beyond repair, or else they preserve the films, secure and safe in their vaults, at the cost of starving people in their appetite for films which they cannot see on the ordinary circuits. My own view is that, faced with this terrible dilemma, it would be wrong to condemn those who choose to plough back the films of the past in order to help produce the films and the film culture of the future. But perhaps this is only on the assumption that somebody, somewhere, is also preserving, to cover part of the risk. Of course, in the final analysis, the dilemma can only really be solved by a massive injection of money.

Even then, all that would be achieved, with statutory deposit and the funds to make show prints, is that many more films would be available for showing at, for instance, the National Film Theatre or for special projection at the Archive. It still would not be possible for people to borrow films for weeks at a time in order to project them over and over again and study them in depth. If somebody is writing literary criticism they can keep the most important books by them and refer to them when they please. The time will no doubt come in the future when films will be treated like books, when projectors and some new type of cassette, for example, will be generally obtainable. Although it is worth pointing pointing out that even when this becomes technically possible, there will still be all kinds of problems about rights and profits which cannot be solved till the whole structure of the film industry is reorganised. At any rate, for the time being, there seems no prospect of such a revolution, technical or economic. It is therefore all the more important that there should be statutory deposit. Then, at least, a few people could be confident of seeing the films which they want and need for their work. Unless this happens it is very difficult to see how there can possibly be any significant advance in the study of the cinema. The brutal absence of films will make a mockery of all the fine words about understanding our visual environment.

So far I have only dealt with the broader problems of the organisation of film study. I have conjured up an idyllic picture of departments of film studies at universities with untrammeled access to whatever films they want and of schools in which the teaching of film plays a major part. But, of course, even if this happy state of affairs was to come about, there would still be enormous theoretical problems to be solved. This is particularly true, of course, in the field of semiology, which is still at the pioneering stage. We do not yet have the kind of general agreement over basic principles which would permit convincing semiological studies of individual films. There have, in fact, been a few tentative moves in this direction. *Adieu Philippine*, by Jacques Rozier, was analysed by Michèle Lacoste in *Image et Son* 201, January 1967, using methods developed by Christian Metz. There are two contrasted analyses of Rossellini's *Voyage to Italy* in *Cinema e Film* 2, Spring 1967; the first, by Gianfranco Albano, Paquito Del Bosco and Luigi Faccini, is Pasolinian and the second, by Adriano Apra and Luigi Martelli, Metzian. I do not think that any of these attempts turned out completely successfully; they tell us as much about the methods used as they do about the films analysed. But this kind of disappointment is unavoidable at the start of any new scientific enterprise. As time goes on, and our methods are refined, we can hope for a much greater degree of success.

There is also great scope for studies of individual auteurs; the work of investigating and assessing the cinema, sifting and evaluating, has hardly begun. It is still regarded as rather curious that there are three books on Hitchcock in English and felt to be a triumph that there is one book on Hawks. Yet if we consider the situation in literature, once again we are immediately made aware of an enormous disproportion. There are countless books about William Faulkner, for instance, in contrast to the one about Hawks: two men who worked together over a period of two decades, whose worlds and preoccupations have an evident affinity. It seems plain to me that Hitchcock is at least as important an artist as, say, Scott Fitzgerald, much more important than many other modern American novelists who have found their way on to the university curriculum. I do not think that time is wasted writing about these novelists, all things being equal, and I do not think it would be wasted if hundreds of post-graduates were writing research theses on Jean Renoir, Max Ophuls or John Ford.

I hope that, by writing this book, I have done something to encourage further study of the cinema, at least by suggesting possible points of departure or stimulating disagreement. The three sections into which it is divided are more or less independent of each other, yet there are times at which exactly the same problems emerge. Implicit cross-references make themselves felt, which point towards new areas, new zones of study. The cinema is such a vast subject that it is only over long periods that the central problems will crystallise. Vast territories still need to be researched; the cinema grows and expands much faster than criticism. Today we are in danger of losing touch entirely with the silent epoch, for instance, which survives for most people only in a handful of films. For all this ground to be covered, much greater specialisation is going to be required. At the moment, there is a feeling that critics ought to see practically every film which comes out, which is evidently absurd. It is more important for a critic to see a good selection of films from the past than to see the whole spectrum of new releases week by week.

Over thirty years ago Roman Jakobson wrote, in an article published in the Czech review *Listy pro umeni a kritiku* I, 1933:

'We are lazy and lack curiosity.' This challenge from the poet is valid today. We have witnessed the lightning growth of a new art. We have watched it liberating itself from the influence of the older arts and in turn even starting to exert its own influence on them. We have seen it establish its own standards and its own laws, and then consciously turn these standards upside-down. And today the film is a powerful instrument of propaganda and education, an everyday fact of life for the masses, surpassing in this respect all the other arts.

To the art historian, however, all this is a matter of indifference. The collector of paintings and curios is exclusively interested in the old masters. Why concern oneself with the rise of the cinema and the ways in which it has achieved its independence when one can produce fantasies about the origin of the theatre, or the syncretic character of prehistoric art? The fewer early examples to have been preserved, the more exciting the reconstruction of the development of artistic forms becomes. To the researcher the history of the cinema is all too dull – mere vivisection, in fact. What interests him is the hunt for antiquities. In fact, today, the search for early examples of the cinema may soon become a fitting task for the archaeologist; already the early decades have become 'the fragmentary

period', and, according to the experts, virtually nothing has been preserved of pre-1907 French films beyond the first Lumière productions.

Roman Jakobson's challenge has not yet been answered. Documentary, animated cartoon, musical comedy, newsreels, horror movies, abstract films, westerns, Eisenstein, Walt Disney, Neorealism, Buster Keaton: the cinema has an extraordinary richness, an extraordinary range and vitality. We have just begun to study it.

Style and Stylistics (1969)

The concept of 'style' is part of the stock-in-trade of every critic; we use it repeatedly in common parlance. Yet it is one of those concepts which is rarely questioned or defined, but insinuates itself into our discourse without any prior examination of credentials. It is a resolutely ideological concept, with almost no theoretical standing whatever. In this respect it is like the concepts of 'love' or 'sanity'; it appears to meet a need, but when looked at closely it seems to evaporate, to have no real meaning at all. It is simply an operative concept, which we use without comprehending, as we need air to breathe, without any knowledge of what its gaseous composition may be.

As we look closer at the concept of style, we find a bewildering medley of different preconceptions and usages, springing from different academic disciplines – literary criticism, art history, psychology, linguistics, anthropology – and from different scientific or would-be scientific methods and ways of looking at the world. At one extreme, particularly among art historians, there is a tendency to see styles as moments in an independent life of forms, transcending individual differences – Wolfflin's art history without names – and part of a succession of different combinations of motifs, giving way to each other according to some overriding historical process. At the other extreme are those who concentrate on the individual aspects of style: on the way each individual eats a grapefruit, as one psychologist has put it. The emphasis is not on the norm, but on deviation from it. Individual personality is seen as a bundle of multiple deviations, an antinomy between the centrifugal and pathological and the centripetal and normal.

Yet, for both art historian and psychologist, the one looking at the vast movements of history, the other at the details of individual behaviour, style is something unconscious, inaccessible to choice and decision. It seems possible, however, in a limited area at least, to break away from these unconscious forces. Thus, to take a particular example, a successful forger can effectively suppress his personal style and choose that of somebody else. This 'conscious' act is quite different from the 'unconscious' act of the author who, in the Borges short story, is writing Cervantes's *Don Quixote* for a second time, without any foreknowledge of the original. Forgery, and its near-kin parody, express a conscious decision to break out of both the movement of history and the bounds of personality, to defy determinism. This is one pole of freedom. The second is that which can be seen in neologism. What we experience as the peculiar *freedom* of art, compared with other kinds of communication, is in fact an oscillation between these two poles of parody and neologism. This can be seen in a very clear-cut form in the work of James Joyce.

Continuing this line of argument, we can establish a very elementary typology of styles. There are those which are individual and those which are collective, on the one hand, and, on the other hand, those which are conscious and those which are unconscious. Of course, none of the four possible combinations can exist in a pure form; this typology is only designed to clarify somewhat the ways in which people talk about style. Thus the Baroque style of the art historians can be seen as collective and unconscious, a kind of language which every artist of the time was compelled to make use of, without fully understanding, if he wished to communicate. All changes in style which are due to underlying changes in the language are of this kind. Secondly, there are collective styles which are consciously willed. The style of *Time* magazine is an example of this or, in the cinema, the style of the Metro-Goldwyn-Mayer musical.

Thirdly, there are individual styles which are unconscious. This aspect of style can be approached in a number of different ways. There is the quasi-scientific approach used to establish authorship, by use of word-counts or the comparison of ear-lobes and fingernails in paintings. This is the approach which sees style as the 'fingerprint' of an individual (though, as has been pointed out, a fingerprint which changes with time). At another level, these

tics of the author can lead to a psychoanalytic interpretation of his work. Thus the twenty key-words of Mallarmé's poetry have been connected with experiences in his childhood; Diderot's nervous style has been linked with his nervous disposition; Bachelard, in his cycle of books on the psychoanalysis of the elements, considers the different images of fire, water, etc., used by different poets and categorises these psychologically, a method which is used by Roland Barthes in his book on Michelet, in which he largely ignores Michelet's views on history and concentrates on his imagery of blood, etc.

Finally, there is the conscious individual style, a kind of dandyism, generally looked at in two different ways: either as a concretisation of the will or as the assumption of a kind of rhetoric. Thus Charles F. Hockett's distinction between 'Sir, I have the honour to inform you' and 'Jeez, boss, get a load of dis' is one between two different manners of expression: the content, Hockett claims, is the same, but the forms chosen different. Susan Sontag, in *Against Interpretation*, writes 'what is inevitable in a work of art is the style': style, in fact, is the suppression of the appearance of arbitrariness. Both Hockett and Sontag put emphasis on choice, but the assumptions of the one lead towards stylistics as a kind of rhetoric, of the other as looking at style as a device for regularising the inchoate and the random, like an ultra-complicated gambling system. This approach leads to a discussion of information theory, though Sontag herself has not followed this very far, limiting herself to the observation that 'every style depends on, and can be analysed in terms of, some principle of repetition or redundancy'.

Pantheon Directors (1969)

In *Film Culture* 27, Winter 1962/63, Andrew Sarris wrote that

it can be argued that any exact ranking of artists is arbitrary and pointless. Arbitrary up to a point, perhaps, but pointless, no. Even Bazin concedes the polemical value of the *politique*. Many film critics would rather not commit themselves to specific rankings ostensibly because every film should be judged on its own merits. In many instances, this reticence masks the critic's condescension to the medium. Since it has not been firmly established that the cinema is an art at all, it requires cultural audacity to establish a pantheon for film directors. Without such audacity, I see little point in being a film critic.

I am in full agreement with Andrew Sarris about this; I believe the reader has a right to know how the critic assesses the value and importance of the artists – in this case, directors – of whom he speaks. Like Andrew Sarris, I would like to emphasise that any ranking must be provisional and that I would never endorse 'a Ptolemaic constellation of directors in a fixed orbit'. Nevertheless, I think it is only by the publication, comparison and discussion of rankings that individual, subjective taste can be transcended and some degree of general validity established. Sarris published his own listing of American directors in *Film Culture* 28, Spring 1963. I have followed the categories he used; like him, I have limited myself to the American cinema, but I have not ventured any judgment on directors from the silent epoch, out of sheer ignorance. Nor have I added, as Sarris did, summaries of the director's work.

Pantheon Directors

Charles Chaplin, John Ford, Samuel Fuller, Howard Hawks, Alfred Hitchcock, Fritz Lang, Ernst Lubitsch, Max Ophuls, Josef Von Sternberg, Orson Welles.

SECOND LINE

Budd Boetticher, Stanley Donen, Joseph Mankiewicz, Vincente Minnelli, Arthur Penn, Nicholas Ray, Douglas Sirk, Preston Sturges, Frank Tashlin, Raoul Walsh.

THIRD LINE

Frank Capra, George Cukor, Jules Dassin, Elia Kazan, Stanley Kubrick, Albert Lewin, Anthony Mann, Sam Peckinpah, King Vidor, Billy Wilder.

Probably this list favours older directors, rather than younger. Some directors I simply do not feel able to judge, either out of ignorance, like William Wellman or Cecil B. DeMille, or out of uncertainty.

I have not included any non-American directors. For the record, I think that the best work of Renoir, Rossellini and Mizoguchi is probably better than anything produced in America.

Afterword (1997): Lee Russell Interviews Peter Wollen

When did you write this book?
A long time ago! In fact, as it happens, I wrote *Signs and Meaning in the Cinema* in the month of May, 1968. As fortune decreed, this has become an emblematic date. May, 1968 – it seemed like the beginning of a new epoch. *Signs and Meaning* is full of the same sense of a beginning – a new approach to film studies, a new intellectual seriousness, new theoretical developments, the promise of a new cinema, even the foundation of a new academic discipline.

You were working at the British Film Institute?
Yes. In the BFI Education Department, under Paddy Whannel. We were intellectual activists. We organised a series of seminars. We taught an annual summer school. We started the *Cinema One* series of books. We re-founded *Screen* magazine as a theoretical journal. In retrospect, it all looks positively heroic in its optimism. Yet, in some ways, that optimism turned out to be quite justified. Cinema studies has become a recognised academic discipline and, as a discipline, it has developed its own distinctive style and tradition, its own theoretical foundation. In other ways, it has simply led to a typical process of academicisation.

When I wrote the book, I was not working in a university, as I am now. I saw myself as an intellectual rather than an academic and I was consciously not writing for a university readership, if only because none existed. I envisaged readers who were being swept along by the same artistic and intellectual tides as I was myself – readers who were excited by the films of

Jean-Luc Godard, the rediscovery of a hidden Hollywood, the structuralism of Claude Lévi-Strauss, the newly launched venture of semiology and the politics of the 'New Left', or perhaps I should say the 'New New Left'.

'The New New Left'? Perhaps you had better explain that. The way I remember it, the 'New Left' would have been the group which founded the journal New Left Review *at the end of the 1950s. Ex-Communists like Edward Thompson and Raymond Williams, who had left the Party in 1956, after Hungary, and were searching for a new politics.*

It was launched in 1959. There was a merger of ex-Communists from the *New Reasoner* with Stuart Hall's *University and Left Review*. But then in 1962 there was an internal *coup* and a new editorial group came into the *NLR* office, with Perry Anderson replacing Stuart Hall as the editor and E. P. Thompson ejected as the chair of the board.

And the new regime was what you mean by the 'New New Left'?
That's right. The new team wanted to develop the journal in a very different way. They weren't so directly concerned with English – or British – culture. They felt Britain was too insular. They wanted to import fresh ideas from Western Europe, from France and Italy especially – Sartre, Lévi-Strauss, Gramsci, and so on. Later they went on to introduce Althusser and Lacan to England. They were interested in psychoanalysis and they had a very different cultural policy.

They came from Oxford too, like you did.
Mostly – but not exclusively! Their intellectual agenda was formed at Oxford. I think that's fair to say.

What do you see as the underlying rationale for their new policy agenda?
Well, the way I see it, they wanted to provide a nucleus from which a new critical intelligentsia could develop, by combining 'western Marxism' with a broader cultural and artistic radicalism and a strong commitment to theory. It was never an academic journal. Actually, in 1968 two of the editors lost their teaching jobs for their role in the student uprisings – at Hornsey College of Art and the LSE.

What did you mean by saying just now that cinema studies has undergone 'a typical process of academicisation'? Can you expand on that?

It is a natural process, isn't it? The first generation were freelance intellectuals who were interested in laying the foundations of film study – the broad theoretical issues of film aesthetics, film semiotics and film historiography which would give the field credibility and a definite shape, which would enable it to stand on its own feet rather than be just an adjunct to literature or art or communications. When the field was successfully established as a discipline in its own right, then inevitably there came a loss of focus, with a growing range of different research agendas. It is probably a cyclical process. An interest in 'high theory', in the old Enlightenment sense, will roll back again in the future, I imagine, in an effort to redefine the discipline again.

But hasn't theory always persisted, even pervaded the discipline? In fact, you could easily argue that the humanities in general became completely dominated by theory. Overdominated, I would say. I must admit I was attracted by the element of cinephilia and that's precisely what got lost with the relentless expansion of theory over the face of academe. The auteur theory may have been called a theory, but really it was an expression of fanatical love for the cinema.

True enough, theory has expanded everywhere, but it has ceased to be film theory as such. Barthes or Foucault or Derrida were introduced into film studies from outside.

That's precisely my point. They weren't introduced to explain film better, but because academics became fascinated by theory in itself for itself. Theory for theory's sake.

But then there is someone like Deleuze, who does write specifically about film. There's a cinephile side to Deleuze.

But I still feel that his work on the cinema is basically a by-product of some much broader theoretical project.

I am not going to argue about Deleuze's concept of time or whatever! I never followed Deleuze closely. In fact, I never did theory in that sort of way at all. I was always interested in the ontology of film as such, just as the Russian

Formalists spoke about literature as such. That kind of theory has gone out of fashion. But it will come back. Mark my words!

In the book, you put aesthetics first, rather than semiotics. Why was that?
I wanted to establish, first and foremost, that film was an art and therefore it should be studied for its own sake in the same way as the other arts – literature, painting, music, etc. At that time, film was primarily seen in the context of the mass media, which led to a communications or sociological approach, rather than an aesthetic approach. Of course, viewing the mass media as art was polemical and provocative.

Do you think that particular battle was won?
Yes and no. Take Alfred Hitchcock, for example. I regard Hitchcock as one of the great artists of the twentieth century, genuinely on a par with Stravinsky or Kafka. I don't think that is generally accepted, even now. For the book, I

Alfred Hitchcock in the late 1950s

Wavelength (Michael Snow, 1967)

decided to write about Eisenstein rather than Hitchcock, partly because Eisenstein was already accepted as a great artist, even though he had worked with a large budget in an industrial context. He was a kind of wedge that I could use to break open the crust of prejudice and philistinism and hopefully smooth the path for others, like Hitchcock. And then Eisenstein also provided me with a way of linking the cinema to theory and semiotics through his own concerns with the nature of 'film language'. But later on in the book, in the section on auteurism, I chose Hawks rather than Hitchcock, which was a more polemical choice. All or nothing. It is difficult to imagine the battles that we fought in those comparatively recent years, not simply for auteurism or semiotics, but for cinema itself.

As an art form?
Yes, as an art form. In fact, as the art form of the twentieth century. Part of the problem facing the cinema, from an aesthetic point of view, was the total dominance of Modernism in the other arts. In literature or painting or music,

Modernism had become, so to speak, the guarantor of 'Art-ness' – as Roland Barthes might have said, Modernism connoted 'Art-ness'. But Modernism had made very little headway in Hollywood. Eisenstein, on the other hand, was clearly a Modernist, as I described, and that was part of the reason for focusing on him. Since then, I have become interested in Hawks's relationship to Modernism as well, in two rather different senses – both his sense that a film should work like a piece of precise engineering and his prolonged partnership with Faulkner. Hitchcock, too, had both explicit and implicit connections with Modernism. And Hitchcock's preoccupation with the look or the gaze – what William Rothman calls 'the "I" of the camera' – can perfectly well be seen in conjunction with Sartre's concerns. Sartre's analysis of the look in *Being and Nothingness* reads like a critical commentary on Hitch.

What about experimental and avant-garde film? They didn't figure so prominently until much later. How did you come to make the leap from Hollywood to the avant-garde?

Le Gai savoir (Jean-Luc Godard, 1969)

Well, the book ended by invoking Godard. 1968 was the year when Godard made his definitive break with mainstream cinema and set off on his long march through the wilderness. At the time I wrote the book, I was not yet very familiar with avant-garde film, although I was interested in Steve Dwoskin's work (which I still admire very much) and I knew Piero Heliczer, who came out of the Warhol circle. It was only after I had finished the book that I really discovered the avant-garde, through North American 'Structural Film'. Michael Snow's *Wavelength* was made in 1967. Ken Jacobs's *Tom, Tom the Piper's Son* was 1969. Hollis Frampton's *Zorns Lemma* was 1970. Then there was a time-lag before their impact was felt across the Atlantic and a new British avant-garde appeared – Malcolm LeGrice's *Berlin Horse* was made in 1970. Chris Welsby's *Wind Vane* was 1972. Peter Gidal's *Room Film* was 1973. There was the same time-lag with my own work.

With your film-making work or with your theoretical work?
Both, but I was really thinking about the theory. Structural Film demanded an interest in theory, which earlier Underground Film hadn't. And Godard's *Le Gai savoir* was itself a film-theoretical film, a film about the nature of film-making.

Perhaps the time-lag might also explain why you needed to add a new 'Conclusion' at the end of the 1972 edition?
Exactly. The new 'Conclusion' to *Signs and Meaning* reflected the impact of post-1968 Godard and Structural Film. It looked forward to the films which I began soon afterwards with Laura Mulvey – *Penthesilea* and *Riddles of the Sphinx*.

Which also involved redefining your theory of the film text, if I can use the jargon of the time?
Yes, I had started to argue that films were indeterminate and that their eventual meaning was produced by the viewer, under certain conditions, rather than being intrinsic to them. I was influenced by a somewhat strange combination of ideas – the Freudian tradition of unconscious meaning, Umberto Eco and the 'open text', even Derrida's idea of 'dissemination'.

You used Godard's films as model examples for your theory.
I looked on his post-1968 films as semiotic machines for making viewers think actively about the world in a new way, rather than as vehicles for communicating a film-maker's own pre-existing ideas to a passively receptive audience.

Yet you still defended auteurism, didn't you, in spite of your admiration for the new Godard? Do you see auteurism the same way today, or would you now give avant-garde film more priority?
I am still an auteurist. I still give priority to the avant-garde.

What does that really imply? An old-style Cahiers *auteurist? How would you formulate the question of auteurism today?*
It is really a question about the 'Movie Brats'.

Whatever do you mean by that? That isn't what I expected!
Well, the auteurist pantheon was essentially a way of ranking Hollywood studio directors. It was developed during the closing years of the classical studio system. But it began to mutate almost as soon as it was formulated, which was around the time that the studio system began to crack. The emphasis switched from Hawks and Hitchcock to Sam Fuller and Nicholas Ray, both of whom had become independent film-makers and ended up in Paris as the studios crumbled away under their feet. That was the situation as auteurism entered the 60s, by which time the French New Wave was already under way.

Cahiers *auteurism was tied to the fortunes of the old studio system. So when the 'New Hollywood' came along . . .*
It went into crisis. That's right. As the 60s progressed, Hollywood began to split apart between an Old Guard and a New Guard, until the Coppola–Lucas–Spielberg generation of 'Movie Brats' showed how it could be restabilised on a new basis. In retrospect, we should probably see this in terms of the crisis of classical Fordism and its replacement by a new post-Fordist industry, a reorganisation of the institution and its production process. Again, it is interesting to look back to the time when the new Hollywood started, say, in 1967. That was the year of *Bonnie and Clyde*, but also of *Wavelength*, as well

Bonnie and Clyde (Arthur Penn, 1967)

as Jim McBride's *David Holzman's Diary*, which was kind of midway between the two. They all carried the signs of an impending change.

I'd like you to clarify that. You're saying that two trends were running in parallel – anti-Hollywood avant-gardism and the rejuvenation of Hollywood itself?
Exactly. Look, 1968 brought us not only Godard's *Le Gai savoir* and *One Plus One*, but also Brian De Palma's *Greetings* and Kubrick's *2001: A Space Odyssey*. In 1969 there was Godard's *British Sounds*, Ken Jacobs's *Tom, Tom the Piper's Son*, Robert Kramer's *Ice*, Sam Peckinpah's *The Wild Bunch* and the Scorsese–Wadleigh duo *Who's That Knocking at My Door* and *Woodstock*. Snow's experimental epic, *La Région centrale*, and Hollis Frampton's *Nostalgia* came out in 1971, the same year as Spielberg's *Duel* and Lucas's *THX-1138*. So the Hollywood 'Brats' (Spielberg, Lucas, De Palma, Scorsese, etc.) came to prominence at exactly the same time as Structural film (Snow, Frampton, Jacobs).

And Godard's turn to the avant-garde was at the same time. So are you claiming that there was a connection between Hollywood and the avant-garde or was it just a coincidence?
I see all those films as representing a concerted effort to reinvent the cinema, whatever their genre was, whether they were made inside the industry or outside it. Similarly I think *Signs and Meaning in the Cinema* could be seen as part of the same cohort, because of the way in which it pays tribute to both Godard and John Ford, just as the Movie Brats did.

That's all very well, but weren't those really quite contradictory tendencies? The fact that they occurred at the same time doesn't make them any more compatible with each other. Sooner or later you had to choose, didn't you?
It didn't seem like that at the time. Who was to guess how wide the gap would grow between Godard or Snow, on the one hand, and Spielberg or Lucas, on the other? I guess it's like the gap between revolutionary and reactionary Modernism.

Or, in this case, Postmodernism?
Postmodernism did emerge around the same time. There could be a connection, couldn't there? But it's a slippery label.

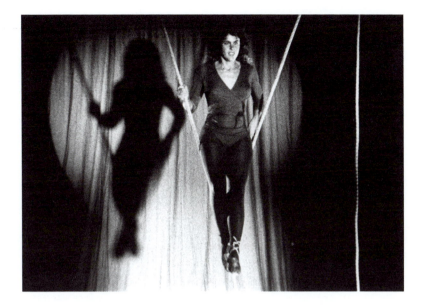

You still didn't quite answer my original question – auteurism or avant-gardism? What about Penthesilea *and* Riddles of the Sphinx, *the films you made with Laura Mulvey at that very time? How did they relate to* Star Wars?

Well, as I have been describing, there was a strange kind of transitional epoch, which started, say, around 1966 (*Chelsea Girls, Masculin-Féminin, You're a Big Boy Now, Blowup*) and ending somewhere in the mid-70s, when Yvonne Rainer's *Lives of Performers* coincided with *The Godfather*, Jon Jost's *Speaking Directly* coincided with *Jaws* and, yes, *Riddles of the Sphinx* coincided with *Star Wars*! But, of course, while I recognise that Coppola and Spielberg and Lucas were undoubted auteurs, I am much more interested in someone like David Cronenberg, who was rooted in 60s experimentalism.

I still think you're being evasive. Which is it to be – auteurism or avant-gardism? OK, Cronenberg, and Lucas's THX-1138 *could be seen as an experimental film. I'll give you Hopper's* The Last Movie *too. But the general trend launched by Lucas and*

Riddles of the Sphinx (Laura Mulvey, Peter Wollen, 1977)

his group was towards the youth-market, high-tech, speed-and-action blockbuster which dominates the industry today. Were you so eager to be rid of The Sound of Music *that you welcomed almost any signs of change or are you claiming that there really was a change for the better, rather than just for the bigger and brasher?*

I think there was a potential change for the better – Hopper, yes; Walter Murch, maybe; but Lucas and Spielberg, no, you're right. In a nutshell, *Star Wars* was *The Sound of Music* all over again. But I would like to rephrase my point in another way, if I can. This key period, from the mid-60s to the mid-70s, was one of genuine renovation, both for avant-garde film and for Hollywood. In the avant-garde, the impetus finally drained away, although important films continued to be made, and I think the long-term result was the incorporation of avant-garde film practice into the art world via video art. In Hollywood, the long-term result was a restabilisation of the industry, in which Spielberg and Lucas emerged as key players and Scorsese as a *grand maître* who never won an Oscar. For one brief, exciting moment auteurism and

The Last Movie (Dennis Hopper, 1971)

avant-gardism made contact – look at *Performance* or *Stereo* – and then, of course, they broke apart again. Inevitable, but a tragedy.

Only a tragedy if you believed in it, I would say.
Well, I still like to imagine there could be an eclectic cinema with that same kind of contact once again.

Let's get back to film theory. Always a safe haven.
So much less controversial!

I have a question about the auteur theory. Your version was unabashedly Structuralist. You took the politique des auteurs *and gave it, so to speak, a Structuralist makeover. Do you have the same reverence for Lévi-Strauss today?*
Well, I'm not a Structuralist today. But I'm not a Post-Structuralist either.

So what are you?
Let me go back to Structuralism first. The Structuralist–auteurist chapter in my book derives directly from the short critical essays which you wrote for *New Left Review*. The problem with those pieces though, as I saw it in 1968, was that their theoretical framework was supplied by Lucien Goldmann and his concept of 'world-view'. Then, not long afterwards, Structuralism and semiology hit Britain in a big way – Claude Lévi-Strauss and Roland Barthes. Barthes's *Elements of Semiology* swept me off my feet, first when I read it in French in *Communications* and then when it came out in translation as a Jonathan Cape pocket-book. Barthes was still a militant Structuralist and so I naturally turned back to reread Lévi-Strauss, who I hadn't looked into since his great ethnographic memoir, *Tristes Tropiques (A World on the Wane)*. Rereading Lévi-Strauss, I saw how your work could be reconfigured by using Lévi-Strauss instead of Goldmann.

It was a productive idea at the time, I must admit. But what do you think about Structuralism now?
Well, in the mid-1970s, I went to work in the Linguistics Department at the University of Essex. It was a strange experience. The faculty members all had

their 'own' languages, in which they were specialists, and I was viewed as the expert on a language called 'Film'. Although there was some interest in semiology there, the main preoccupation was with Chomsky's transformational grammar and the battle over the revisionist critique of Chomsky which was raging at the time.

What was all that about?
Montague logic, generative semantics, things like that. In any case, I got a really thorough grounding in Chomsky's linguistics and the technical arguments for and against it.

So what was the relevance of all that to film studies?
That's what I'd like to explain. The one thing that everyone agreed upon was that Structuralism was utterly irrelevant. Saussure was dead as a doornail. Jakobson was an honoured but superseded pioneer. There were no French linguists worth talking about, least of all Martinet, the leading French Structuralist. In effect, everybody accepted Chomsky's arguments against Structuralism as taken for granted, however much they might differ about Chomsky himself and what should or should not come after him. I was stunned by their curt dismissal of Saussure, whose work was the fundamental starting point for Lévi-Strauss, Barthes, Lacan and even for Derrida. Suddenly, I discovered that Saussure wasn't taken the least bit seriously.

Chomsky's revolution had shifted the nature of the whole field. His work was all about syntax and about sentences, about the rules which mapped meaning on to sentences through their hierarchy of clauses and sub-clauses, through word order and through the morphology of the constituent words. Saussure hardly mentions syntax. Neither do Barthes or Jakobson. They assume that semantic content is mapped directly on to syntactic form in a relatively unproblematic way.

Chomsky's demolition of Structuralism was summed up by his famous example of the inescapable difference between 'John is easy to please' (in which 'John' is object of 'please') and 'John is eager to please' (in which 'John' is subject of 'please'). The two sentences have the same surface appearance, but they have two quite contrary patterns of meaning, one in

which John is pleased and the other in which he pleases. The two sentences may look the same but, in reality, they have these very different underlying structures.

There is no direct relationship between signified and signifier. The deep structure is not mapped mechanically on to its surface structure. Instead, there is a complex system of syntactic rules which transform semantic input into surface output. Saussure didn't deal with that at all. Yet now the question became, 'What do the syntactic rules look like?' For the Structuralists, that question didn't even arise.

True, but nobody has managed to come up with a successful theory of what the syntax of cinema might look like, have they? In fact, as far as I remember, you toyed with the idea of using Vladimir Propp's morphology of narrative as the basis for a film grammar, but you never really explained how narrative came to be transformed into film language.

You're implying that the linguistic model was doomed from the start, that it didn't lead anywhere, and that introducing Propp failed to save the situation. I understand why you might say that, but it's certainly not the conclusion I reached. Yes, I was eventually forced to reject both Saussure and Chomsky as models, but I still believe that film has a grammar. I began to be interested in the way creole languages develop. Creoles are real-world models of how new languages are formed on the ground, historically. And that led me to Talmy Givon's work on functional grammar.

I don't want to sound sceptical, but what made you think you could solve these problems with yet another dose of linguistics? How does that relate to the role of narrative?

Like any other language, film language must have developed historically through a process of 'grammaticalisation'. With verbal language, we can see how this works in the development of creole languages out of pidgins. And a similar kind of process must have taken place with the grammaticalisation of film language. The pressure to grammaticalise clearly had to come from the practical need to tell a story, which then explains why a theory of narrative was needed.

And what does that lead you to in practice?
Well, for example, if we look at the way in which verb forms develop, specifically in relation to storytelling, as Givon has described it, we find that they differentiate first between tense, mode and aspect. Tense signals a departure from the main time-line of a narrative. Mode indicates a shift into the non-factual or doubtfully factual – the subjunctive, the conditional, or even, in some languages, the future. Aspect signals that actions are habitual or ongoing, rather than completed events. In the cinema, flashbacks are tense-like; dream sequences are mode-like; montage sequences are aspect-like. Film also needed to develop ways in which the case roles of participants in an action could be pinpointed, ways in which the semantic shape of actions or happenings was clarified, through the system of master shot, medium shot and close-up. Close-ups of a face, for example, show the case role of 'experiencer', rather than the action-related roles of 'subject' or 'object', as we can see in early Griffith.

How does all this relate to Peirce? By choosing Peirce rather than Saussure as your semiotician of reference, hadn't you already downplayed the importance of the language model?
True, because even then I wasn't convinced that the Saussurean model was adequate for film. Peirce sees language as just one of many sign systems, each operating with different kinds of rules. I think that is plainly true of the cinema. It has a documentary and a pictorial aspect as well as a symbolic or language-like aspect. I was interested in the way that the three main trends in film aesthetics seem to run parallel with the three types of sign which Peirce had isolated - the index, which is existentially linked to its object, like a thermometer reading; the icon, which signifies through resemblance to its object, like a picture; and the symbolic, which has an arbitrary relation to its object, like a word. Realist aesthetics are a projection of the indexical, pictorialist aesthetics are a projection of the iconic, and what we might call 'discursive' aesthetics, with the stress on conceptual meaning, are projections of the symbolic.

Fair enough. A comprehensive aesthetic of the cinema certainly has to deal with all three types of sign and the complex kinds of relationship which can exist between

*them. I wonder whether there isn't the basis for a theory of genre here,
distinguishing documentary, dramatic and essay film.*
Well, I would argue for a combination of all three genres: documentary,
drama and essay, to use the full potential of cinema. *Riddles of the Sphinx* was
intended to exemplify that kind of experimental pan-generic genre.

*So the theoretical aspects of your book are directly relevant to your film-making as
well as to film study?*
Absolutely. At the time I wrote the book, I still had not done any film-making,
but I was writing scripts and it was definitely there on the agenda. And then
the arrival of the new Godard and structural film and experimental narrative,
like Yvonne Rainer's *Lives of Performers*, or Chantal Akerman's *Je Tu Il Elle*,
all set me thinking about film-making in terms of the avant-garde rather than
the industry.

I remember you had been involved in the industry.
Yes. In 1968 I was still involved with screenwriting, with my writing partner,
Mark Peploe, and soon afterwards we wrote the script for *The Passenger*,
which Antonioni directed. After *The Passenger* went into production, I sort of
thought I'd achieved whatever goals I ever had as far as the industry was
concerned – Antonioni, MGM, Jack Nicholson! So I turned to film-making
myself, but as an experimental film-maker, working with Laura Mulvey. We
saw our work as film-makers as closely connected to our work as theorists. Of
course, Eisenstein was the distant model for this, even if he was defeated in the
end.

*Isn't there something defeatist about the whole idea of commitment to experimental
film, an idea that the industry is fundamentally irrecuperable?*
I am tempted to answer 'So be it'! What is wrong with a commitment to
experimental film? To me, the most exciting Hollywood directors always had
an experimental edge. What are the great Hollywood films – Griffith's
Intolerance, Keaton's *Sherlock Junior*, Murnau's *Sunrise*, Sternberg's *Morocco*,
Chaplin's *Modern Times*, Welles's *Citizen Kane*, Hitchcock's *Rope*, Fuller's
Shock Corridor, Kubrick's *2001*, Ridley Scott's *Blade Runner*. They all have an

experimental dimension. I am a great admirer of the few film-makers who have managed to balance a professional career in the industry with an ongoing commitment to experiment. Like everybody else, I have some petty reservations about Peter Greenaway's films – but there is absolutely no doubt in my mind that he set a truly heroic example for others to follow.

Is Eisenstein's example still relevant? He taught in a film school, didn't he, during the lean times of the 1930s? Do you think theory and practice can be combined even in film school?
Eisenstein taught directing in a way which included teaching theory. But that's very rare. In my experience, even the best film schools keep the two apart. They might argue that film-making simply doesn't leave enough time for serious study of film theory, but I think that is just a way of avoiding the issue. In an ideal world, production students would have a solid grounding in history and theory, just as academic students should have a grounding in production. But it isn't going to happen. The division between the two curricula gets more and more engrained each year that goes by.

It matters?
Yes, it does matter. It really troubles me that most students who are doing academic degrees never get a serious chance to make a film – and vice versa, that production students don't have the time or the mind-set to think seriously about film theory.

What are you talking about? Separatism? Philistinism?
The system simply does not work in the way it should. That's why it's so astonishing to read Eisenstein's class lectures. His directing classes did not simply draw on his practical experience, but were crammed full of theory as well – semiotics, aesthetics, art history.

How did that come about? I mean his interest in theory.
Restless curiosity. His background in experimental theatre. And then he must have been influenced by the way Marxism stressed the need for theory as a guide to practice.

But he is unique even among Soviet directors.

Yes but, if you look closely, you will find there is a theoretical dimension to the way in which many great directors approached their work, in Hollywood as well as in Europe. Eisenstein was much more systematic than most, but there are fascinating insights in the occasional writings of Sternberg or Hitchcock, for instance. Academic theorists don't pay nearly enough attention to Eisenstein, let alone the work of other film-makers. But they are well worth studying.

Do you want to revise your account of Eisenstein's career at all, with the benefit of hindsight?

Well, so much more of his writing is available now. But I am not sure that I want to revise the main lines of what I said in *Signs and Meaning*. It still seems accurate to me and, in general, it has been confirmed by all the new publications – the only revisions I might make are shifts of emphasis rather than shifts of substance. But I think the main thrust of new research is still to come. I would assume it will be in the area of political history and its impact on Eisenstein. There must be an

Que Viva Mexico! (S. M. Eisenstein, 1931)

enormous amount of material buried in the former Soviet archives which will throw fresh light on Eisenstein's career. We should eventually be able to reconstruct all the subterranean twists and turns of Soviet policy for the arts and the cinema. We know the public history of all that, but there must be a secret history as well, which will slowly come to light as the files are finally opened.

You drew a clear distinction between Eisenstein's career in the 20s and his career after the consolidation of Stalin's rule, when he was forced to make painful accommodations – not only to continue working, but presumably even to survive.

Yes, I'm surprised he was able to work on *Ivan the Terrible* after producing Wagner at the Bolshoi, during the period of the Stalin–Hitler pact. And then there are his 'pornographic' drawings (Salome, St Sebastian, the crucifixion of Christ). How do they relate to his films or to his homosexuality? How does religion fit in? Eisenstein's private life is still very obscure – it's not on the public record. It is all a matter of anecdote and speculation.

The Mexican work may be crucial, because it was less constrained – he had dropped over the horizon, so to speak.

Exactly. It is a fascinating period in his career – and not only sexually. William Harrison Richmond's book, *Mexico through Russian Eyes*, is full of thought-provoking material. I should like to know a lot more about Eisenstein's conversations with Siqueiros (in which Hart Crane also participated) and the ways in which they influenced each other. Those took place in Taxco in 1932 and apparently they discussed aesthetics, the role of art in politics and the role of folk art. And I am very intrigued by Eisenstein's working visit to the town of Tehuantepec, where he shot part of *Que Viva Mexico!*

Tehuantepec?

The image of the Tehuana woman, from Tehuantepec in the south, was a constant artistic preoccupation in the Mexican Renaissance. After his return from Paris, Diego Rivera was sent down to Tehuantepec by Vasconcelos, the revolutionary Minister of Culture, in order to reassimilate himself into Mexican life, and Tehuana women appear prominently in his great murals in Mexico City. Frida Kahlo adopted Tehuana costume for her self-image of

choice, in self-portrait after self-portrait. Tina Modotti made the pilgrimage to Tehuantepec to photograph Tehuana women. Even Eisenstein's 'caretaker' on *Que Viva Mexico!*, Best-Maugard, did a gouache of a Tehuana.

Perhaps my interest is a bit exaggerated – I co-curated a retrospective show of Kahlo and Modotti as well as writing about Eisenstein – but, a few years ago, I was lucky enough to see a great show in Mexico City tracing the whole history of Tehuana imagery in Mexican art and it began to dawn on me how important it had been to Eisenstein. He was familiar with a whole range of theories about 'primitive matriarchy' (Bachofen, Engels, Lévy-Bruhl and others) and it certainly tied in with both his semiotic and his cultural interests. I think it relates to his interest in James Joyce's *Ulysses* too.

Do you think Eisenstein's theories were themselves a kind of myth which he needed for his artistic work?
I don't think 'myth' is the right term. I think they might fall under the heading of speculations or hypotheses. But then you could say that about Barthes or Eco too. Semiology is still a new field of enquiry and consequently it has to be concerned with hypotheses, rather than established truths. Any new discipline is going to be hyper-conjectural, in comparison with other, more established fields. But that is not a shortcoming. It is a necessity. And it's fun.

And your use of Peirce in relation to the cinema is speculative too?
Look, one of Peirce's books is actually entitled *Speculative Grammar*. I don't have any problem with the speculative. It is an absolutely necessary component of any serious thought. Look at Freud and Lacan! You couldn't be more speculative! Speculation provokes critique and counter-argument and reformulation, which are all part of the process of theory-building. Peirce is very clear about this in his writings on 'abduction', which he sees as a necessary part of theory-building, of equal weight with induction and deduction. 'Abduction' is his term for the process of forming hypotheses and conjectures. It involves an element of guesswork marshalled to explain an otherwise surprising fact. Peirce believed that guessing was an intrinsic part of science, just as crucial as observation or reasoning. You should look at the book Umberto Eco put together with Thomas Sebeok. It is called *The Sign of*

Three, and it is subtitled 'Dupin, Holmes, Peirce'. That is the same Dupin we meet in 'The Purloined Letter'.

Poe or Lacan? And the Holmes is Sherlock?
Precisely, my dear Watson.

So you think theory advances by asking questions, creating conjectures, forming hypotheses by abduction, testing them inductively by asking another question, and so on?
Yes. As Jaako Hintikaa put it, in *The Sign of Three*, we need 'a sharp theory of the question-answer relationship'. Hintikaa sees question-and-answer sequences as 'games played against nature' – nature is our opponent as we attempt to pry out new bits of knowledge, which we can use to formulate further conjectures, which lead to more questions, in a chain of interrogation. I find this emphasis on questioning rather than answering very sympathetic.

Yes, you would. After all, you made Riddles of the Sphinx.
Absolutely. That's a film structured entirely around a series of questions which it asks in order to challenge Lacan's assumption that language is primarily a vehicle for the patriarchal Law, rather than for the matriarchal Riddle. It's about how Lacan's writings themselves need to be questioned rather than presented as the 'Law' – but we are probably straying too far from *Signs and Meaning* . . . which needs to be questioned too! That's your job!

You were saying earlier that Signs and Meaning *should be read in conjunction with viewing your films, weren't you?*
Very true. But writing books and making films remain very different kinds of discourse, each with its particular kind of questioning. Maybe there is a reciprocal relationship. *Signs and Meaning* asks the question, 'What kind of film should we make?', which *Riddles* answers. Then *Riddles* asks, 'What kind of theory should we write?'.

What kinds of questions do you think film theory should be asking us now?
Questions about the avant-garde. And the questions we were talking about

earlier – film pragmatics and film language, the way in which film became grammaticalised.

What do you mean by 'film pragmatics'?
The way in which film language evolved in response to practical needs and problems. If we look at the development of film language during the early years of the cinema, we can see that it responds to the practical needs of narrative.

What drives the pragmatic development of film language? Could you give a concrete example from a particular film?
I shall try to. I'll choose a fairly standard example from the early years of cinema. Let's take a look at André Gaudreault's essay on 'The Development of Cross-Cutting', in Thomas Elsaesser's anthology *Early Cinema*. Gaudreault is discussing a well-known Edwin Porter film, *Life of an American Fireman*. There are two extant versions of this film, one with nine shots, made in 1903, called the 'Copyright' version, and one with twenty shots, called the 'Museum of Modern Art' version. They are identical up to the last two shots of the 'Copyright' version, which were broken down, in the 'Museum' version, into thirteen separate cross-cut segments.

Concretely, in the 'Copyright' version, the next to last shot (Shot 8) shows a continuous series of mini-events occurring in the interior of an upstairs room in a burning house – (a) a woman wakes to find her room filled with smoke, (b) she goes to the window, (c) she staggers back and collapses on her bed, (d) a fireman enters through the door and breaks the window, (e) he lifts the woman up and carries her through the window, (f) he re-enters the room and picks up a child and leaves again through the window, and (g) two more firemen come through the same window with a hose and extinguish the fire.

Then, following that, in Shot 9, the final shot, we see the same rescue sequence from the exterior of the house – (a) the woman appears at the window, (b) a fireman enters the house, (c) firemen place a ladder against the house, (d) the fireman carries the woman down the ladder, (e) the fireman remounts the ladder and the woman despairs, (f) the fireman reappears with her child and the mother welcomes and hugs her.

But, in the later 'Museum' version, the same rescue sequence which is shown in these two single shots (as interior and exterior views) is broken down into thirteen alternating shots (seven from Shot 8 cross-cut with six from Shot 9). This 'alternating' version is generally considered to be a later 'improvement' of the 'Copyright' version, which incorporated the new developments in cross-cutting which we associate with D. W. Griffith.

Gaudreault discusses this film in purely temporal terms. The key concepts, for him, are 'simultaneity' and 'succession'. He argues that there are two simultaneous lines of action in these shots and that cross-cutting works because it provides the means 'to express simultaneity by means of successiveness'. But, in fact, although different aspects of the event may be simultaneous, they are not really separate lines of action. Threat and rescue may be co-occurrent, but the threat motivates the rescue and the more urgent the threat, the more urgent the rescue becomes. There is a logical relationship between threat and rescue. Cross-cutting captures the complex logical structure presupposed by rescue, which involves a succession of sub-actions,

Life of an American Fireman (Edwin S. Porter, 1903)

a multiplicity of participants and an ongoing separation of spaces. The temporal logic of the event is sequential, but the spaces in which it takes place are discontinuous, until we reach the happy end and the rescue is concluded.

You are saying that time and space are semantic features of the narrative – they shouldn't be seen as independent of it?
Exactly. Cross-cutting is a 'linguistic' device which grammaticalises a specific type of narrative action. It gives priority to the internal morphology and development of an action – in this case, the action of 'rescue', which itself presupposes, first peril, then communication, then physical movement between two spaces and two roles (rescuer and rescued). The separation of spaces and the logical succession of sub-actions both derive from the underlying semantic features of rescue from peril. In fact, as cross-cutting developed, it discarded simultaneity. Short segments of logically related action alternate without overlapping at all.

It seems that what you are doing is arguing down from an analysis of the whole narrative in Proppian terms to the morphology of each narrative function subdivided down into constituent actions and sub-actions.
That's right. Propp was correct to point out that narrative is a logical rather than a chronological system. And then each action and sub-action has an inherent case structure or 'valency'. Thus rescue = rescue of x by y from z in such and such a place – or places. Experiencer, patient, agent, ablative, locative. Each action is broken down so that its semantic contours and its case structure are clear. The fire is 'agent' of peril. The firemen are 'agents', or subjects, of rescue. The damsel in distress is the 'experiencer' of peril and then the 'patient', or object, of rescue.

So the development of film language can be viewed as a process of problem-solving – how to clarify the semantic and logical structure of each event within the narrative, in the most economical way possible.
Precisely. If film had developed in a different way – as portraiture, or as landscape, or as diary (all genres which exist under the general heading of 'experimental film'), then the language would have evolved differently. That

is why experimental films are difficult for people to grasp. The fact that they are non-narrative means that they employ, or imply, a different kind of film language. You have to learn it. Experimental films often are abstractly analytic in terms of space and time, and they are not necessarily story-driven.

How does this relate to what you said about film aesthetics? Going back to Riddles, *it seems you wanted to make a film which was both story-driven and yet reacted against narrative syntax. Isn't that some kind of a paradox?*
Yes, it tells a story – or more than one story – but it does not use the conventional film language.

It uses a series of 360-degree pans, each showing a single unbroken sequence, containing one principal action.
In a way, 'it was constructed like a necklace', as Eisenstein said of *Que Viva Mexico!* In fact, it went further than Eisenstein, because we subordinated the action to framing and composition. We de-dramatised even further. We saw the dramatic story as simply an underlying fable which echoed the Oedipus story as seen through the lens of Jacques Lacan and Maud Mannoni. I suppose we wanted to take Eisenstein's idea of 'intellectual montage' into another dimension, into an even more radical deconstruction of mainstream film language.

Why? How do you relate this to your auteurism and your loyal praise of Hollywood cinema – or at least your appreciation of Hollywood's 'pantheon' directors?
There are two ways of answering that. The first is to say that I followed Godard in moving out of the Hollywood orbit after being formed by it. The second is to say that I was very influenced by Godard's example, but I also became increasingly critical of it, as he began to abandon storytelling, or to minimise it. I wanted to retain narrative, but to tell stories in a different kind of way. The first film I made with Laura Mulvey, *Penthesilea*, was in the form of a palimpsest, telling the same story over and over again, each time in a different mode or style. Juxtaposition rather than continuity.

So you rejected Hollywood but you could still retain an interest in storytelling and narrative?

I feel as if you are somehow forcing me into making a confession. My cinephilia, my obsessive love of the great old Hollywood films, never ever left me. I could not rid myself of it, even if I wanted to. In the end, it reasserted itself. At some level, cinephilia simply transcended the politics of art or the aesthetics of the avant-garde. That same cinephilia, after all, was really the basis of my conviction that cinema is an art, that aesthetics is more important than ideology. It explains why I never liked the idea of culture or 'Cultural Studies'. I wanted art and aesthetics.

Can you explain that a bit? How did you see the difference between 'art' and 'culture'? What was it about 'art' that made it a priority for you, and what was it that you distrusted about the idea of 'culture'?

You know, I have never been very explicit about this, but it has been implicit in everything I have ever written about the cinema. I am interested in art and I am interested in ideas, but I have never understood the appeal of 'culture'. I will try and analyse it for you, but I am not sure how successful I shall be. Personal taste gets mixed up with intellectual history!

As you must know, the idea of 'Cultural Studies' comes from England, and it was enshrined in the title of the Birmingham Centre for Contemporary Cultural Studies, founded by Richard Hoggart back in 1961. Hoggart was joined there by Stuart Hall, after he resigned from the editorship of *New Left Review*. Birmingham gave an institutional form to the approach developed in Hoggart's own *The Uses of Literacy* (1957) and, of course, Raymond Williams's magisterial *Culture and Society*, which came out the next year, in 1958.

These two books promoted the idea of 'culture' as the expression of a community's way of life. In both cases, the writers drew on their own childhood experience, growing up in the working class, explicitly with Hoggart, implicitly with Williams – who was more explicit in his novels. I suppose this idea drew on T. S. Eliot and F. R. Leavis, the first of whom was a radical conservative and the second a conservative radical. They both proposed the idea that culture was a way of life, which gave texture and meaning to social existence. They were both extremely suspicious of the commercialised mass culture of the twentieth century and, in Leavis's case at

least, there was also a deep-seated resentment of class privilege and the idea of culture as the property of an élite rather than the people as a whole.

Hoggart's book articulated his attachment to the working-class culture in which he was brought up and his confusion when, as a result of the long-awaited democratisation of the universities, he found himself inducted into the privileged élite. Williams's book, on the other hand, traced the ways in which a battle for the concept of 'culture' had marked British intellectual history, concluding with an attack on mass communications and a renewed call for the revitalisation of a common culture – a 'living culture' – based both on natural growth and on its careful tending.

How did you react? Negatively?

I am afraid I came down on the side both of aestheticism and the mass media. Let's talk about the mass media first – specifically, American cinema. This whole trend of thought – Orwell, Hoggart, Williams – was explicitly and implicitly anti-American. The cultural community they wrote about was traditional and English – or perhaps I should say British, without trying to unravel the distinction. They recognised that Britain was the country with the longest history of proletarianisation and consequently with a working class which had enjoyed, if that's the word, the opportunity and the length of time necessary to create an organic way of life and its own rich culture. This culture was now threatened by a new wave of commercialisation, not from within, as with the rise of the mass circulation press, but from without, with the invasion of the Hollywood film.

Williams held the line against Hollywood with tenacity. He did not denounce the cinema as such. In fact, he was a pioneer in introducing film into the university – at Cambridge where he taught – and he even co-wrote a book about the cinema, *Preface to Film*, with Michael Orrom, a friend who came out of the British documentary movement. But he kept well clear of Hollywood – except for Griffith, I think. After that he looked at Eisenstein and Pudovkin, German silent cinema and then on to Bergman and eventually Godard. I had a completely different view of Hollywood. In effect, I felt that British culture was stifling, from top to bottom, across classes, and my conclusion was that it needed input from abroad to break up its provincialism and insularity. Hence,

my interest in Hollywood cinema and French theory came from the same root. It was a kind of pincer movement – low art from across the ocean, high theory from across the Channel.

What is the burden of this distinction you are making between 'art' and 'culture'? Is it a clear distinction or is there a kind of gradient between the two?
Well, if we accept Williams's definition of culture, then art is clearly distinct. Art means a body of texts rather than a way of life. Actually, I am not so far away from Williams in my views about art – Williams looked on artworks as texts and stressed the primacy of form. Maybe he had a different interpretation of what he meant by 'text' or 'form', but the necessity to distinguish art from culture in that kind of way was still implicit. Also, Williams was eager to reject orthodox views about taste and quality. One of the things he especially liked about I. A. Richards's work, for example, is that Richards would give students texts to read without telling them who the author was. He discovered that their aesthetic response was quite different when the canonical status of a work was not signalled by an authorial attribution.

Then, when Williams wrote about Ibsen, it turned out that he preferred *Ghosts* to *A Doll's House* and vigorously defended this choice, when he was challenged, by arguing that the 'whole mode of composition' was more serious in *Ghosts* and that its form was much more significant, irrespective of whether it was more socially progressive. For Williams, art had a role within culture, but it clearly was not the same thing as culture. Parenthetically, I should add that, for Williams, film was a prolongation of drama, so that Bergman was following in the footsteps of Strindberg. Film was a dramatic art.

Not a visual art? What do you think?
I think film is plainly a polymorphous art. There is a limited sense in which film is a visual art, but it is also a narrative art, a dramatic art, a kinetic art, an auditory art, a performance art and so on. It operates on multiple sensory bands – optical, auditory, even tactile – and with multiple sign systems. That is its great strength as a form.

That it is polymorphously perverse.

If you like. But the point I was making is that art is defined by its formal qualities, by the way in which a text is structured. Film is formally distinct from theatre though related to it. Within the cinema, genres are formally distinct, and so are movements like Expressionism or Poetic Realism or Structural Film, and so are auteurs. At the same time, art, as Williams pointed out, is also the site of a kind of truth – an 'imaginative truth' in his terms. A work of art is a vehicle for a way of viewing the world, a way of framing it thematically – re-situating it, in a unique way, as what I called a 'heterocosm', in the auteurism chapter of *Signs and Meaning*. Thus, we can look at Hawks, for example, and see recurrent stylistic qualities in his films, but also recurrent thematic preoccupations, which together give his work its 'form', in Williams's sense of the word.

Williams ends his book on drama by talking about Brecht. He sees Brecht as having created a new and original dramatic form. Again, at this point, there is a convergence. Williams argued that Brecht's innovation was to transform naturalism by replacing the indicative mode by the subjunctive – in fact, on this basis he eventually called for a Brechtian cinema (or television) which in his words would be 'the combination of three directions, the more mobile dramatic forms of the camera, direct relationship with more popular audiences, and development of subjunctive actions'. That is not so far from my position, except that I would interpret every single one of those conditions in a very different way.

Didn't you call for a Brechtian cinema too? Wasn't that one of your watchwords when you were writing in Screen?

Yes, but Williams's idea was that camera mobility could give film the freedom of the novel and the ability to move into and through open spaces, while still retaining its dramatic form. But in *Riddles of the Sphinx* our project was to use camera mobility to produce an estranged look at the world, which destroyed the possibility of empathy. Brechtian, of course, but very different from Williams. The idea was to use a popular form – storytelling through film – but direct it towards specific subcultures, artistic, political and intellectual. Finally, he defines 'subjunctive actions' as those which ask the question: 'If we did this,

what would happen next?' He is talking about outcomes in possible worlds –
kind of thought experiments. But I think you can only understand this tactic
of Brecht's in conjunction with his theory of the '*gestus*' – the idea that
something was being demonstrated, that he was presenting the audience with
a kind of socio-political diagram, which would provoke them into formulating
questions of their own.

I would like to get back to Hollywood, to mass cinema. How does Brecht fit in with
Hollywood?
Awkwardly, in practice. In theory, there was a close fit. Brecht adored cheap
popular culture. For me Sam Fuller was the Hollywood Brechtian. There
wasn't any direct influence. But Fuller had similar tastes to Brecht – cheap
popular culture, pulp novels, tabloid journalism – which he wanted to redeem,
if that is the word, by using them as a means of attacking crucial and topical
questions of ethics and politics, as Brecht did. Fuller went straight for the
pressure points. His films are like fables of our epoch, and they ask questions.
Run of the Arrow actually finishes with an unresolved plot and a closing
subtitle – 'The end of this story will be written by you' – directed straight at
the audience.

Fuller, yes. And I know there is a kind of Brechtian argument for Sirk. And Brecht
himself admired Welles's work in the theatre. But what about Sternberg? Or
Hitchcock?
Sternberg is more on the side of Breton than Brecht. *Shanghai Gesture* – mad
love, oneirism. The other side of *Cahiers* taste – alongside a taste for B pictures
and pulp fiction – was a taste for the delirious. I always loved films like
Shanghai Gesture, or *Pandora and the Flying Dutchman*. Maybe Charles
Laughton somehow combines the two elements in his *Night of the Hunter*.
That's a really great film. He must have learned something from Brecht.

And Hitchcock?
There is a surrealist side to Hitchcock, for sure – dream films like *Vertigo*,
Marnie, *The Birds*. He knew a lot about surrealism and he talked about it.

And he hired Salvador Dalí to work on Spellbound.

He was a master of the uncanny. And, like Welles, he was fascinated by magicians.

While we are on Hitchcock, I should like to backtrack to the question of Hollywood films and French theory. How did that particular pairing come about, in your view?
Well, obviously the link was *Cahiers* and, before that, there was the whole post-war French fascination with film noir. It takes us right back to the 1920s, to their fascination with jazz and skyscrapers and comic strips. There was a real attraction to the underside of American culture in Sartre's writings as well. And Sartre was a key figure for me, because my interest in French theory itself leads back to Sartre and to Existentialism. In England Laing and Cooper latched on to Sartre as a theorist and the fascination with America showed up simultaneously in pop art and popular music.

Night of the Hunter (Charles Laughton, 1954)

On the subject of American popular culture, there is something else I should like to stress. In England, cinephilia ran concurrently with the discovery of American music – I mean Chuck Berry, Little Richard, Muddy Waters, John Lee Hooker, Howling Wolf. Discovering *Run of the Arrow* and *Underworld USA* was the same kind of experience. In the music world this led to the Rolling Stones and the Beatles and all that. In the art world, it was the time of British pop art – Richard Hamilton made conscious allusions to Hollywood. And Pauline Boty. The unlikely aspect of it was the way in which this Americanophilia leapt the tracks from pop into the New Left. *New Left Review* covered Sam Fuller, as you know, but also John Lee Hooker and the Rolling Stones and even William Burroughs.

That's true. I was partly responsible for that. I think the point with the Rolling Stones was that they took what they got from black blues singers like John Lee Hooker or Howlin' Wolf or Muddy Waters and then returned it to the United States in a new, mutated form. This never really happened with film. Film was too tainted with the idea of a 'national cinema', whereas popular music wasn't. Although I suppose that if you looked back to the heroic days of British cinema – to Carol Reed and Michael Powell – you could argue that they were 'mutating' Hollywood and sending it back home in a new guise.

In any case, the Old New Left supported a concept of a national cinema which rejected directors like Michael Powell. If you look at the documentaries which Karel Reisz and Lindsay Anderson made in the 1950s, they were extremely hostile to 'trashy' popular culture and especially to Hollywood.

Anderson liked John Ford for his sentimental nationalism and for his masculine sentimentality.

Exactly. The shift only came about after the change of guard in 1962 when Edward Thompson and Raymond Williams and the older generation departed into the gloom. *NLR* had a 'national nihilist' streak in those happy days, a wonderful leaning towards dismissing everything English.

You put a pantheon of ten Great Hollywood Directors (Chaplin, Ford, Fuller, Hawks, Hitchcock, Lang, Lubitsch, Ophuls, Sternberg, Welles) at the end of the

first edition of Signs and Meaning. *It disappeared from the second edition.*
Why was that? Change of heart?

Death of the author? In a way, yes. Basically, I felt that Barthes's and
Foucault's famous pronouncements on this subject were, well, ridiculous.
They were extreme tropes, generated by their theories of text and discourse.
All the same, I still felt called upon to revise my own section on auteurism and
give it a Post-Structuralist gloss, pointing out the difference between the
manifest 'author' and the latent 'author', so to speak. The author became a
kind of effect of the text, which is not so far wrong in itself, but also served to
occlude the question of the relationship between the actual author and the
textual 'author effect'. I'm sorry about that. Sam Fuller may not knowingly
have become 'Sam Fuller', but you couldn't have the latter without the former,
and there were real determinations between the two. Biography is relevant to
issues around authorship. But then so is textuality.

What would your pantheon be now, nearly thirty years later?

The old one was too conventional, wasn't it? Let's try something different,
with a completely new set of names: Sirk, Siodmak, Lupino, Tashlin, Kubrick,
Polanski, Cronenberg, Demme, De Palma, Hopper. And I seemed to have
overlooked Scorsese and John Woo. I could go on debating the list with myself
for months. All the same, I still think that pantheons are of value. And I am in
favour of the idea of the canon, although naturally I prefer revisionist and
dissident canons. The canon should be open to the *film maudit*, the film
without a future. The Surrealist canon was a great influence on me, when I was
still at boarding school – Swift, Sade, Poe, Desbordes-Valmore ... down to
Jarry, Vaché and Roussel. I never did check out Desbordes-Valmore though.
I still don't know who that was.

Why do you like the idea of the canon?

It's simply a shorthand for a methodical and principled taste. It seems perverse to
me to refuse to ask which work is good and which is bad. When you make a film,
you ask yourself whether a cut is good or bad, whether a way of delivering a line
is good or bad, whether a camera movement is good or bad. Production mainly
consists of judgments about value and quality. Critics and theorists shouldn't try

to insulate themselves from a discourse which is so intrinsic to art practice. After all, our natural response after seeing a film at the cinema is to talk about whether it was good or bad. On the other hand, canons shouldn't be frozen. We should go on fighting over them, in a passionate and informed and reasoned way, but that is another matter. I strongly believe we need to make judgments of taste and then defend them with rational arguments, as Shaftesbury recommended over two centuries ago. Maybe that means a new aesthetics.

Isn't the canon debate really about identity politics?
Well, it's about what has been 'hidden from history'. All I want to claim is that when we set out to revise the canon, we should be able to argue our position on aesthetic grounds. Of course, we should reinstate Dorothy Arzner and Ida Lupino. We should look again at film-makers like Bill Gunn, who made *Ganja and Hess* in 1970. And we should look seriously at 'hidden' areas of world cinema too – Bombay and Mexico City and Cairo. Kamal Amrohi's *Pakeezah* is a great masterpiece, comparable at the very least with Max Ophuls's *Lola Montès*. I think that Paul Leduc's *Latino Bar*, made in Venezuela, is the great film of the last decade. And then there's Ousmane Sembene, Lino Brocka, Glauber Rocha – what more need I say?

And top ten lists are a kind of shorthand for a shorthand?
Exactly. They are a kind of polemical condensation of a canon which is a condensation of a whole aesthetics – with a personal twist, of course. Actually, my favourite list was the one I was asked to do on sports films for a Finnish film magazine called *Filmihullu*, which means 'Film Crazy'. I started with Hellmuth Costard's amazing football film, in which the camera stays on Georgie Best through the whole of one match. He only touches the ball a few times, but at one of them he scores a goal. You don't see the ball go into the net. You only realise what happened when his team-mates throw themselves all over him.

What were the others?
Satyajit Ray's chess film. Godard's *Sauve qui peut*, which has some weird Swiss sport. Greenaway's *Drowning by Numbers* ...

Wait! Let me be a bit more classical! Hitchcock: Strangers on a Train. *And Hawks*: The Crowd Roars. *Now let's really change the subject. New media. Any closing comments?*

I think there is the same kind of excitement about new possibilities now that there was with experimental film in the 1960s and 70s. I am talking about the potential of new media for generating new forms of art, of course. I am not interested in cyberspace, except as a mode of textuality. What is its semiotic structure? What are its forms of discourse?

Signs and meaning in the digital age?

The ultimate aftermath of 1968 – the final disintegration of the 'Public Sphere', perhaps. The triumph of the 'Society of the Spectacle'. The Situationists vindicated! Well, vindicated negatively. 1968 was an emblematic

Strangers on a Train (Hitchcock, 1951)

moment which spectacularised the idea of change itself, but, as always, history plays strange tricks and the change which came wasn't the one that had been expected. It was the end of Fordism, the end of Keynesianism, the end of classic social democracy, the beginning of a new world order, constructed around a string of world cities linked by a lattice of electronic communications which facilitated a sweeping reconfiguration of world capital.

Was Marx vindicated? And all his discredited theories about the organic composition of capital and the immiseration of the proletariat proved correct?
It looks that way, doesn't it?

And the links between aesthetic and political avant-gardes?
We probably need to ask whether there are any avant-gardes at all? In the public consciousness, at least. Unless we want to say that the avant-garde has mutated into MTV and high-style advertising.

So you have mixed feelings about current trends in art? What about current trends in the universities?
I have become much more attached to history and to the writing of history. I enjoy reading Shaftesbury and Lessing and Schiller. I reread Eisenstein and Kracauer and Arnheim. I don't consider them irrelevant. When the future is unclear, it's good to delve back into the past and see what looks new amid the old, what can be salvaged in an unexpected way, what gives a new twist to our perception of the present. *Signs and Meaning* discusses Lessing and emblem books and medieval *tituli*. Thinking theoretically is inseparable from thinking historically.

Who was Shaftesbury? What exactly can you learn from him?
Well, Shaftesbury was an English virtuoso who died in Naples in 1713. He was educated by John Locke, the philosopher, who was his tutor. Locke had been the political adviser and speech-writer for his father. Shaftesbury always insisted on the need for a rigorous theory of taste. He was reacting against the doctrine of the *je ne sais quoi*, which he associated with French court aesthetics. He wanted, as he put it, 'to dissect the *je ne sais quoi*'. And in his *Second*

Characters, which he was writing at the time of his death, he preceded Lessing in distinguishing between the semiotic systems of narrative and visual representation. There is a clear line which runs from Shaftesbury to Lessing and then on to Arnheim's *A New Laocoön*, which sets out to theorise the relationship between sound and image in the cinema. Finally, Shaftesbury consistently stressed the links between aesthetics, ethics and democratic politics.

And old films are as important as old theories?
Yes. Why do you think we have suddenly become so interested in early cinema? It's more than archaeology. It is to regain a sense of cinema as potential, not yet frozen into the world spectacle. It is to imagine a renaissance.

But can cinema ever be as central as it seemed to be in the 60s? Debates about cinema don't seem to be as important as they used to. Aren't digital media going to change everything?
Not long ago, when I was thinking about the rise of multi-channel television and the new media, I wrote a piece saying that Hollywood film might become an extinct art like stained glass or fresco or tapestry, which were once dominant in their day. I think I was being over-rhetorical. Digital technology is being absorbed into the cinema. For the time being, at least, it has revitalised Hollywood, helping to create more and more action-packed spectacle, an extravagant technological sublime. It has shifted the cinema away from the indexical towards the iconic register, perhaps.

That sounds right. Away from realism and towards spectacle. While retaining narrative as its deep structure.
Retaining it but speeding it up. Compressing duration. In contrast, in a kind of dialectical reversal, I expect to see new experiments, new concepts, new cinematic art forms, new alternatives to Hollywood and, to accompany them, new modes of theory. In short, new signs and new meaning in a new cinema.

That must be the cue for your slow walk into the sunset.
Music. Roll end credits!

Booklist (1972)

Barthes, Roland, *Elements of Semiology* (London: Jonathan Cape, 1964).

Bazin, Andre, *What is cinema?* (Berkeley, CA: University of California Press, 1967–71).

Clements, Robert J., *Picta Poesis: Literary and Humanistic Theory in Renaissance Emblem Books* (Rome: Edizioni di storia e litteratura, 1960).

Eisenstein, Sergei M., all his works, especially *Film Form: Essays in Film Theory* (trans. Jay Leyda) (New York: Harcourt, Brace & Co., 1949) and *The Film Sense* (trans. Jay Leyda) (New York: Harcourt, Brace & Co., 1942).

Erlich, Victor, *Russian Formalism* (The Hague: Mouton Publishers, 1955).

Freud, Sigmund, all his works, especially *The Interpretation of Dreams: The Standard Edition of the Complete Psychological Works of Sigmund Freud*, vol. IV and V (1900) (trans. James Strachey) (London: Hogarth Press, 1953).

Godard, Jean-Luc, *Godard on Godard* (ed. Tom Milne) (London: Secker & Warburg, 1972; New York: Viking Press, 1972). Also the scripts of his films.

Graham, Peter (ed.), *The New Wave* (London: Secker & Warburg, 1968; New York: Doubleday & Co., 1968).

Heath, Stephen, Colin MacCabe and Christopher Prendergast (eds), *Signs of the Times: Introductory Readings in Textual Semiotics* (Cambridge: Granta, 1971).

Hermerén, Göran, *Representation and Meaning in the Visual Arts: A Study in the Methodology of Iconography and Iconology* (Lund: Scandinavian University Books, 1969).

Jakobson, Roman, various writings, especially 'The Metaphoric and Metonymic Poles' in *The Fundamentals of Language* (The Hague: Mouton Publishers, 1956, 1971); 'Quest for the Essence of Language' in *Diogenes* vol. 13, September 1965: 21–37 (Montreal: Casalini); 'Linguistics and Poetics' in *Style in Language* (ed. Thomas Sebeok) (Cambridge, MA: MIT Press, 1960).

Lane, Michael (ed.), *Structuralism: A Reader* (London: Jonathan Cape, 1970).

Lemon, Lee T., and Marion J. Reis (eds), *Russian Formalist Criticism: Four Essays* (Lincoln, NE: University of Nebraska Press, 1965).

Lévi-Strauss, Claude, various writings, especially 'A Structural Study of Myth' in *Myth: A Symposium* (ed. Thomas Sebeok) (Bloomington, IN: Indiana University Press, 1955), and 'The Story of Asdiwal' in *The Structural Study of Myth and Totemism* (ed. Edmund Leach) (London: Tavistock Publications, 1967).

Macksey, Richard and Eugenio Donato (eds), *The Structuralist Controversy: The Languages of Criticism and the Sciences of Man* (Baltimore, MD: Johns Hopkins University Press, 1972).

Metz, Christian, *Essais sur la signification du cinéma* (Paris: Klinckseick, 1971), translated as *Film Language: A Semiotics of the Cinema* (trans. Michael Taylor) (Oxford: Oxford University Press, 1974).

Panovsky, Erwin, various writings, especially 'Style and Medium in the Moving Pictures' in *Film: An Anthology* (ed. Daniel Talbot) (Berkeley, CA: University of California Press, 1959).

Pasolini, Pier Paolo, *Pasolini on Pasolini: Interviews with Oswald Stack* (ed. Oswald Stack) (London: Secker & Warburg, 1969).

Peirce, C. S., 'Speculative Grammar', 'Letters to Lady Welby' and 'Existential Graphs' in *Collected Papers* (Cambridge, MA: Harvard University Press, 1958).

Propp, Vladimir, *Morphology of the Folktale* (Bloomington, IN: Indiana University Press, 1968).

de Saussure, Ferdinand, *Course in General Linguistics* (trans. Wade Baskin) (London: Peter Owen, 1960).

von Sternberg, Josef, *Fun in a Chinese Laundry* (New York: Macmillan, 1965).

Tudor, Andrew, *Theories of Film* (London: Secker & Warburg, 1974; New York: Viking Press, 1974).

Wollen, Peter (ed.), *Working Papers on the Cinema: Sociology and Semiology* (London: BFI Education Dept, 1969).

A number of magazines are also of interest. See especially *Semiotica* (The Hague: Mouton Publishers); *Screen* (London: Society for Education in Film and Television); *Afterimage* (London: Narcis Publishing); *Twentieth Century Studies* vol. 3, 'Structuralism' (Canterbury: University of Kent). The French review *Communications* (Le centre d'études des communications de masse, Paris) is invaluable, as are *Cahiers du cinéma* (Paris) and *Cinéthique* (Paris).

Acknowledgments (1969)

We should like to thank the Novosti Press Agency for their help in illustrating the Eisenstein chapter: the photographs of his production of *The Wise Man* were provided by them, as were the photographs of Stanislavsky's production of *Armoured Train 14-69*, and the set for Meyerhold's production of *Dawns*, and the portrait of Stanislavsky and Max Reinhardt. They also gave us their permission to reproduce the four drawings by Eisenstein. The Trustees of the British Museum kindly permitted us to reproduce the Toulouse-Lautrec poster, and the prints by Sharaku, Daumier and Hogarth.

Ullstein Bilderdienst provided the Brecht photos. The photograph of Kabuki theatre was kindly supplied by the Japanese Embassy.

We should also like to thank the various companies, stills from whose films appear in this book, especially: Anouchka Films *(La Chinoise, Made in U.S.A.)*, British Lion *(Saga of Anatahan)*, Columbia *(Only Angels Have Wings, His Girl Friday, Lady from Shanghai)*, Contemporary *(Time in the Sun, Kino-Pravda, La Règle du jeu, Toni)*, Ganton *(Maciste the Mighty)*, MGM *(Mrs Miniver, On the Town)*, Paramount *(The Devil is a Woman, Vertigo, Hatari!, The Man Who Shot Liberty Valance, The Emperor Waltz, Donovan's Reef, To the Last Man)*, Rank *(Henry V, The Mummy)*, Republic *(The Bullfighter and the Lady)*, Twentieth Century Fox *(Gentlemen Prefer Blondes, My Darling Clementine)*, United Artists *(The Prowler, Scarface)*, Universal *(All That Heaven Allows)*, Warners *(The Searchers, The Rise and Fall of Legs Diamond, Land of the Pharaohs, Cheyenne Autumn, A Midsummer Night's Dream, Gold Diggers of 1933, Air Force)*, and the British Film Institute for the cover picture from *Herostratus*. Finally the author would particularly like to thank Brian Darling for allowing him to look through his collection of *Esprit*.

Editorial Note (2013)

Signs and Meaning in the Cinema was number nine in the Cinema One Series, edited at the British Film Institute by Penelope Houston and Tom Milne (*Sight and Sound*) and Peter Wollen (Education Department).

The first edition of *Signs and Meaning in the Cinema* was published in 1969 by Secker & Warburg; the second edition in 1970 by Thames and Hudson. These two editions were identical: both ended with a 'Conclusion' (1969), plus two appendices: 'Style and Stylistics' (1969) and 'Pantheon Directors' (1969).

In 1972, the third edition ('new and enlarged') was published by Secker & Warburg. It jettisoned the original Conclusion and two appendices, and replaced them with a new 'Conclusion' (1972) and 'Booklist' (1972).

In 1998, with the fourth, expanded edition, published by the British Film Institute, the 'Booklist' (1972) was discarded. Here, Peter Wollen chose to include 'The Writings of Lee Russell', a series of short articles on Sam Fuller, Jean Renoir, Stanley Kubrick, Louis Malle, Budd Boetticher, Alfred Hitchcock, Josef von Sternberg, Jean-Luc Godard and Roberto Rossellini. These were originally published in *New Left Review* from 1964–7.

In addition, the fourth edition included an 'Afterword'(1997), an interview where Lee Russell talked with Peter Wollen about *Signs and Meaning in the Cinema*. The 'Acknowledgments' were included, with minor adjustments, in all the editions (1969, 1970, 1972, 1998).

For this fifth, and final, edition, everything that was in the previous four editions is included. It is hoped that the curious reader will be able to trace not only the history of the development of Peter Wollen's thinking through its manifestation in the various iterations of *Signs and Meaning in the Cinema*, but also the unfolding of the discourse of cinema, from aesthetics through theory to history.

Index

List of Illustrations

The Devil is a Woman, Paramount Productions; *The Passenger*, © Compagnia Cinematografica Champion; *October*, Sovkino; *All That Heaven Allows*, © Universal Pictures Company; *Maciste the Mighty*, Jolly Film/Gallus Film/Compagnie Industrielle et Commerciale Cinématographica/Paris Films/Dubrava Film; *Rodan*, Toho Co. Ltd; *The Emperor Waltz*, © Paramount Pictures; *The Mummy*, © Hammer Film Productions; *The Nut*, Douglas Fairbanks Pictures Corporation/United Artists; *Que Viva Mexico!*, Mexican Picture Trust; *Kino-Pravda*, Kul'tkino; *The General Line*, Sovkino; *Strike*, Proletkult/First Studio Goskino; *Battleship Potemkin*, First Studio Goskino; *Silly Symphony*, Walt Disney; *Ivan the Terrible*, Mosfilm/Alma-Ata Studios; *Scarlet Street*, © Universal Pictures Company Incorporated; *Vertigo*, © Alfred Hitchcock Productions/Paramount Pictures Corporation; *Brute Force*, © Universal Pictures Company; *The Prowler*, © Eagle Productions Inc.; *The Bullfighter and the Lady*, Republic Pictures Corporation; *Only Angels Have Wings*, © Columbia Pictures Corporation; *The Searchers*, C.V. Whitney Pictures Company; *The Rise and Fall of Legs Diamond*, © United States Productions; *Land of the Pharaohs*, © Continental Company Ltd; *His Girl Friday*, © Columbia Pictures Corporation; *Hatari!*, © Paramount Pictures Corporation/© Malabar Productions Inc.; *Gentlemen Prefer Blondes*, © Twentieth Century-Fox Film Corporation; *Scarface*, © The Caddo Company; *My Darling Clementine*, © Twentieth Century-Fox Film Corporation; *The Man Who Shot Liberty Valance*, © Paramount Pictures Corporation/John Ford Productions; *Donovan's Reef*, © Paramount Pictures Corporation/John Ford Productions; *Cheyenne Autumn*, © Ford–Smith Productions; *A Midsummer Night's Dream*, © Warner Bros.; *Henry V*, Two Cities Films; *Gold Diggers of 1933*, Warner Bros.; *Die Nibelungen*, Decla Filmgesellschaft; *The Cabinet of Dr Caligari*, Decla Filmgesellschaft; *Greed*, © Metro-Goldwyn Pictures Corporation; *City Girl*, Fox Film Corporation; *La Règle du jeu*, Nouvelle Édition Française; *Citizen Kane*, © RKO Radio Pictures; *Mrs Miniver*, © Loew's Incorporated; *Viva L'Italia!*, Tempo Film/Galatea Film/Francinex; *Bicycle Thieves*, Produzioni De Sica S.A.; *The Flowers of St Francis*, Rizzoli/Produzione Film Giuseppe Amato; *La Passion de Jeanne D'Arc*, Société Genérale de Films; *The Saga of Anatahan*, Daiwa Productions; *Lola Montès*, Gamma Film/Florida Films/Union-Film GmbH; *Kon-Tiki*, Ole Nordemar Artfilms; *To the Last Man*, Paramount Pictures; *My Best Girl*, © Pickford Corporation; *On the Town*, © Loew's Incorporated; *The Lady from Shanghai*, Columbia Pictures Corporation; *Made in U.S.A.*, Anouchka Films; *The Crimson Kimono*, Globe Enterprises; *Dr Strangelove*, © Hawk Films; *Vie privée*, Production Générale de Films/Compagnia Cinematografica Mondiale; *The Tall*